THE DIGITAL BIOMEDICAL ILLUSTRATION HANDBOOK

THE DIGITAL BIOMEDICAL ILLUSTRATION HANDBOOK

MIKE DE LA FLOR

CHARLES RIVER MEDIA, INC.

Hingham, Massachusetts

Publisher: Jenifer Niles
Cover Design: The Printed Image
Cover Images: Mike de la Flor

CHARLES RIVER MEDIA, INC.
10 Downer Avenue
Hingham, Massachusetts 02043
781-740-0400
781-740-8816 (FAX)
info@charlesriver.com
www.charlesriver.com

This book is printed on acid-free paper.

Mike de la Flor. *The Digital Biomedical Illustration Handbook.*
ISBN: 1-58450-337-8

Library of Congress Cataloging-in-Publication Data
De la Flor, Mike.
 The digital biomedical illustration handbook / Mike de la Flor.
 p. cm.
 ISBN 1-58450-337-8 (pbk. with cd-rom : alk. paper)
 1. Medical illustration—Vocational guidance. 2. Computer graphics. I. Title.
 [DNLM: 1. Medical Illustration. 2. Computer Graphics. 3. Vocational Guidance.
 WZ 348 D349d 2004]
 R836.D4 2004
 610'.22--dc22

 2004017444

Printed in the United States of America
04 7 6 5 4 3 2 First Edition

For my children, Larry and Christina.
Remember that anything is possible.

*Medical illustrators
draw what can't be seen,
watch what's never been done,
and tell thousands about it
without saying a word.*

CONTENTS

PREFACE

Welcome to *The Digital Biomedical Illustration Handbook.* If the title or cover art on this book have enticed you to take it off the shelf, then you probably have some interest in science, medicine, or digital art—maybe you are fascinated by all three. As you thumb through the pages you may wonder exactly what this book is about. Is it about painting with Photoshop CS, is it about modeling and animation with 3ds max 6, or is it about digital medical illustration? The fact is that this unique book covers all three subjects, but in the process puts a whole new spin to the old phrase, "Art as Applied to Medicine." This book is about *Digital* Art as Applied to Medicine.

The book is organized into two sections: an introduction to medical illustration followed by practical application tutorials. In the first part you will learn about the historical figures and events that shaped medical illustration into what it is today, how medical illustration has changed in the last 20 years, the training many medical illustrators go through to learn their craft, and you will gain some insight into the working relationship between artist and physician.

The second part has seven tutorials: four Photoshop CS tutorials and three 3ds max 6 tutorials. These in-depth tutorials are organized as complete projects from start to finish, and cover research, sketches, design, and the digital techniques used to paint, model, or animate. Each chapter gradually introduces you to specific digital painting or modeling tools and techniques. For example, Chapter 5, "Surgical Illustration," covers working with Photoshop layers, selections, stock brushes, and filters, while Chapter 9, "Medical Illustration for the Web," focuses on box modeling for real-time 3D with 3ds max 6.

In addition to introducing digital painting and 3D modeling tools and techniques, every chapter focuses on a distinct specialization within medical illustration. For instance, in Chapter 7 you will learn how medical

artists create legal exhibits, in Chapter 8 you will discover veterinary illustration, and in Chapter 11 you will travel into the microscopic world of cells and molecules and find out about conceptual molecular and cellular animation.

But there is more, besides the tutorials and the introductions to medical illustration specializations, each chapter has a project overview that includes detailed information about the clinical or scientific subjects of each project. For example, in Chapter 6, "Editorial Medical Illustration," you will learn about brain anatomy, and in Chapter 10 you will learn about eye anatomy and intraocular lenses.

ABOUT THE TUTORIALS

The tutorials in this book are complete projects, with three distinct goals: to help you gain experience with Photoshop CS and 3ds max; to expose you to digital illustration concepts; and to give you insight into the world of the medical artist. The focal point of each tutorial is centered on a real-world project that a practicing medical artist may encounter. For example, in the Photoshop tutorials you will create a surgical illustration for an atlas, an editorial illustration for a magazine, and medical-legal exhibit for courtroom display.

The tutorials in this book do not necessarily have to be done in sequence (though that is recommended if you are a beginner). Each chapter is independent of the other chapters and the tutorials within them can be accomplished in any sequence. Not all of the tutorials start at the same place. The earlier tutorials have you begin from scratch with nothing more than a blank 3ds max 6 or Photoshop document and walk you step-by-step to the finished art or animation. Other tutorials are more focused, such as the animation tutorials in Chapter 10, which begin at a specific point in the process which allows you to concentrate on the task at hand.

The tutorials are designed to provide you with basic skills needed to create digital biomedical illustrations and animations, and a foundation from which you can develop your own style. The tutorials are not meant to replace the software manuals. In fact, you may want to have them handy as you work through each chapter. The tutorials in this book are also not a substitute to dedicated practice on your part.

WHAT'S ON THE CD-ROM

Sometimes discerning the details in the screenshots in the book can be a challenge, so all of the figures in the book are also on the CD-ROM in a large format. Also all of the files necessary to complete the tutorials are found on the CD-ROM. For example, on the CD-ROM you will find the Photoshop files and in some cases the brush presets (.abr) needed to get started with the digital painting tutorials.

The last three chapters in the book cover 3D modeling and animation, which can be challenging to follow even in expertly written tutorials. So to make things easier, you will find incremental files on the CD-ROM. For instance, to assist you in modeling the human eye in Chapter 10, there are ten 3ds max files that contain milestones in the modeling process. If you get stuck in the modeling process simply save your work and open the appropriate file to study how things work. For more information on the contents of the CD-ROM read Appendix D.

WHY PHOTOSHOP CS AND 3DS MAX 6

Photoshop CS and 3ds max 6 were chosen as the tools for the tutorials in this book because they are very popular tools within their respective computer-graphics genres. Photoshop is without a doubt the industry standard tool for digital imaging, and 3ds max 6 is the most widely used 3D modeling and animation program. Once you have gained experience with Photoshop CS and 3ds max 6 you will have a digital toolset that is in demand in the computer-graphics industry. In addition, the skills and concepts you learn in this book can be applied to many illustration genres like technical illustration or natural science illustration, and also provide a solid foundation from which you can explore similar programs like Painter™, Cinema4D™, and Lightwave™.

ABOUT THE AUTHOR

Mike de la Flor (Houston, TX) is a freelance medical illustrator and writer. He is the author of the recent *Carrara Studio 3 Handbook* (Charles River Media 2003) and contributing writer for *3DWorld Magazine*. He is also an adjunct instructor at Kingwood College where he teaches computer-graphics. Mike has served as staff illustrator for the Division of Immunology and Organ Transplantation at the University of Texas Health Science Center in Houston, the University of Texas Medical Branch at Galveston, and Baylor College of Medicine. He has been a professional member of the Association of Medical Illustrators since 1992. For more information visit *www.delaflor.com*.

1

A Brief History of Medical Illustration

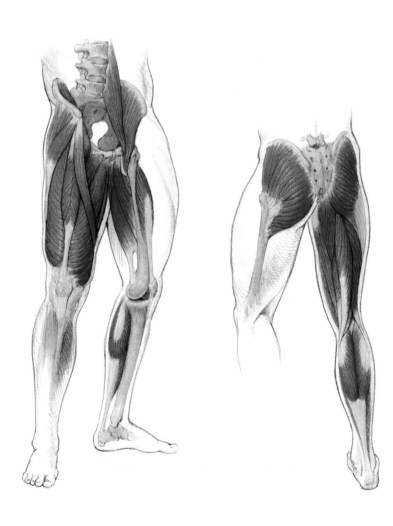

1

"Life is short, but the art is long . . ."
Hippocrates (460–375 B.C.E.)

The rich and complex historical relationship between art and medicine could easily fill the pages of many books. Throughout history, artists have been an integral part of the advancement of the sciences. The artist's ability to create a tangible image of an idea, concept, or discovery has been indispensable in communicating that idea to other individuals.

Among surviving cave paintings around the world, one cannot overlook the recurring theme of anatomical drawings. These ancient drawings range from simple, symbolic outlines that describe the animal's form to paintings that may indicate the specific location of organs. Paleolithic paintings may have been used to teach novice hunters where to aim their spears to quickly bring down their prey or perhaps to point out the edible parts of an animal. The 30,000-year-old cave painting from Pindal, Spain, seen in Figure 1.1, was created to convey information from one individual to another and from one generation to the next. This basic purpose—to preserve and pass on information—is the same in modern medical illustration.

FIGURE 1.1 Anatomical drawings of animals and humans were common in ancient cave paintings (tracing of cave painting).

ANTIQUITY

Ancient Egypt

Although the medicine of the ancient Egyptians was riddled with magic, they have to their credit many physiological observations such as pulse in the extremities and the importance of semen in pregnancy. They also conceived of pathways in the body that carried air, blood, and nourishment and developed methods for clinical diagnosis.

The Egyptians compiled numerous papyri (scrolls) on the subject of medicine. The Ebers Papyrus (1550 B.C.E.), filled with practical and magical treatments for disease and injury, is the best-known example of ancient Egyptian medical literature. The academic traditions established by the ancient Egyptians in recording their medical knowledge was continued and expanded by the Greeks and eventually led to the first true medical illustrations.

Classical Greece

Hippocrates of Cos (460–375 B.C.E.), Father of Medicine, and his contemporaries were undoubtedly responsible for the foundation of science and medicine as empirical disciplines based on observation rather than divination. Their intense interest in the beauty and structure of the human body led the ancient Greeks to the first serious investigations into physiology and anatomy.

From the many prominent figures of classical Greece, Aristotle (384–322 B.C.E.), Father of Biological Science, comes to the forefront. Aristotle was among the first to dissect and study animal anatomy. He was the first to establish an anatomical nomenclature and is also credited with one of the first anatomical illustrations.

Soon after its occupation by the Romans, Greece began to decline as a center of learning, but across the Mediterranean Sea in the Egyptian city of Alexandria, medical progress and classical Greek thought continued.

Alexandria

Founded by Alexander the Great, in 331 B.C.E., Alexandria became the center for scientific investigation. In the Ptolemaic Medical School, human anatomy was a focal area of fascination and study. In an environment in which discovery and individual thought were encouraged, human dissections become routine. It was during this time at the Ptolemaic Medical School that the first true medical illustrations were produced. The anatomists, Herophilus (b. 300 B.C.E.) and Erasistratus, Father of Physiology (b. 310 B.C.E.), used illustrations in their anatomical lectures and manuscripts. The remnants of their works, which were preserved by Arab

intellectuals after the decline of Alexandria, have references to numerous illustrations.

The great age of discovery that began in ancient Egypt and flourished in classical Greece ended tragically in Alexandria when the city was systematically destroyed in the early part of the Christian era. A period of intellectual and artistic freedom was not seen again until the advent of the Renaissance.

THE MIDDLE AGES

The span of 12 centuries that followed the decline of Alexandria was an intellectual malaise. During this time, Christian and Islamic authorities outlawed human dissections, and classical Greek thinking and knowledge was banned in some places and ignored, except by a few who studied and preserved it. During this time, little new medical or scientific knowledge was gained, and the visual arts stagnated.

Claudius Galen (129–209 A.D.)

Though Galen lived before the middle ages, his work on medicine and anatomy heavily influenced medical knowledge for a thousand years after his death. Galen, a great clinician, prolific author, and anatomist, is said to have written hundreds of books on medicine, anatomy, and natural science, some undoubtedly illustrated.

Galen's ideas were a mix of his medical training, observations from numerous dissections of animals (the information from which he erroneously applied to humans), and religious beliefs. Because of his religious ideas, Galen's medical teachings were thought to be absolutely correct and complete by the church. Contradicting Galen's teachings was considered heresy and cost many independent medical thinkers their lives. This arrogance crippled the advancement of medicine for many centuries.

Medieval Medical Illustration

Many medical manuscripts were produced during the medieval period. However, for the most part, they were copies of Galen's surviving works or copies of the remnants of the classical Greek works. The art that accompanied these copies was representative of the flat, stiff, iconic art of the period. Perspective and depth were little understood.

The medical art in medieval manuscripts was produced by reading the preserved works of Galen and classical Greece—not by personal investigation. The art included at best fanciful, diagrammatical representations of human anatomy. It is clear that these artists never saw the inside of a human body themselves. See Figure 1.2.

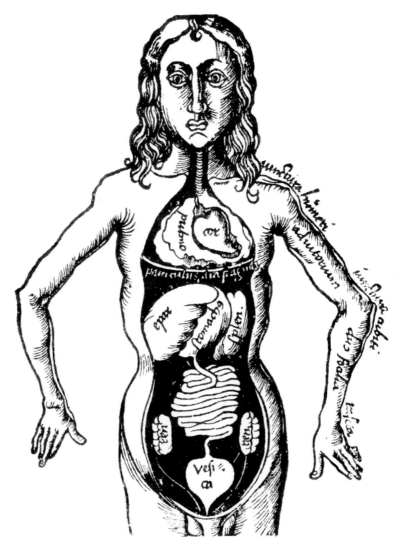

FIGURE 1.2 Medieval illustration was usually stiff and diagrammatical and not drawn from direct observation.

THE RENAISSANCE

The Renaissance was a grand rebirth of independent thought and expression and empirical observation that deeply affected social mores, the sciences, and the arts. By the fourteenth century, Europe had emerged from its slumber, and for the first time in centuries, certain autopsies were permitted by the church. Soon, dissections of human bodies, for the sole purpose of investigation and teaching, began to occur.

Renaissance artists, moved by a desire to realistically depict the human body in their art, dissected human cadavers right along side physicians and anatomists to better understand the underlying structure of the human body. This common goal between artist and physician later developed into a collaboration of talents that produced the first illustrated anatomy books.

Invention of the Printing Press

Around 1440, Johann Gutenberg of Mainz developed one of the greatest technological inventions of all history, the movable-type printing press. By the end of the fifteenth century, the printing press had been refined, and printing houses existed in all the major learning centers of Europe. It is estimated that in the fifteenth century alone, over 38,000 editions of books were produced. The printing press made possible an explosive availability of information that created a flourishing industry overnight and made learning popular.

Woodcut engravings were used for reproducing illustrations in books in the mid-fifteenth century. First used to duplicate the stiff figures of medieval manuscripts, the woodcut engraving would later become a critical method of art reproduction in scientific and anatomical books. The printing press, the woodcut engraving, and the passions of the Renaissance fueled a newly rediscovered need for learning, understanding, and information.

Leonardo Da Vinci (1452–1519)

Leonardo Da Vinci was a gifted scientist as well as a talented artist. One of the many subjects that Da Vinci studied was human anatomy. In this endeavor, Da Vinci dissected dozens of human cadavers. In his notebooks, Da Vinci created some of the most beautiful and accurate medical illustrations of his time, as seen in Figure 1.3.

Sadly, Da Vinci's anatomical work was lost for hundreds of years and remained unpublished until the twentieth century. Therefore, the influence of Da Vinci's work on the history of art and medicine is only speculative. Da Vinci planned to publish a book on anatomy, but his death at the age of 67 prevented this. Had Da Vinci succeeded in publishing his work during his lifetime, it may have accelerated the progress of medicine and medical art tremendously.

It is possible that Andreas Vesalius may have studied Da Vinci's anatomical illustrations before they were lost. If this is true, Da Vinci contributed to the inspiration of a great medical mind and in a sense did influence the history of art and medicine.

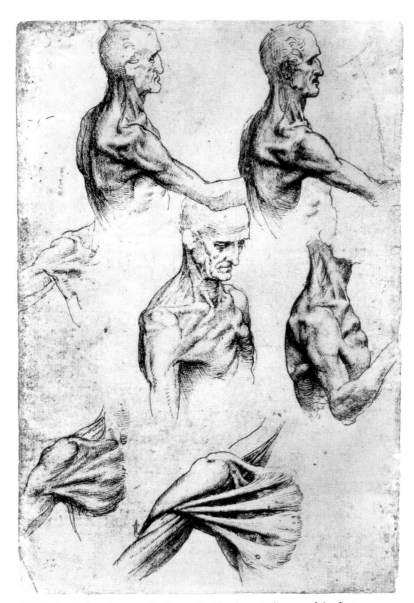

FIGURE 1.3 A giant in art and science, Da Vinci created some of the first anatomically accurate medical illustrations.

Andreas Vesalius (1514–1564)

As a student and later as a professor, Vesalius took a new approach to anatomy: he descended into the pit of the anatomy theater and dissected human cadavers himself (Figure 1.4). In previous years, anatomy professors

would preside over a human dissection reading from Galen's works without ever touching the cadaver. A servant would do the actual cutting. Interestingly, whenever the observed anatomy disagreed with Galen's teachings it was often dismissed as an abnormality.

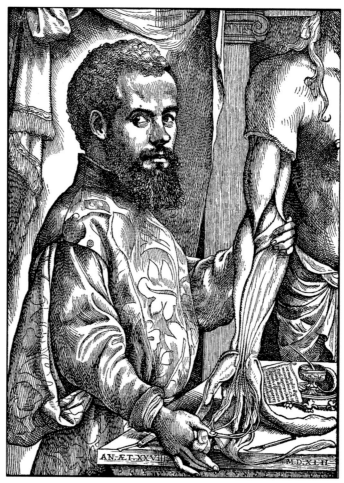

FIGURE 1.4 Vesalius revolutionized medical education and was personally responsible for many advancements in medicine.

By age 23, Vesalius had earned the degree of medical doctor and days later he accepted the position of professor of surgery at the University of Pauda in Italy. Vesalius taught anatomy from dissections he prepared himself, and readings from Galen's work were noticeably absent. Vesalius began using anatomical charts and diagrams to assist him with his lectures. The charts were enthusiastically received by all who saw them. Encouraged,

Vesalius published his anatomical diagrams. Initially, he published six diagrams in 1538 titled Tabulae Anatomicae. See Figure 1.5.

FIGURE 1.5 Vesalius's early diagrams were well received and motivated him to publish more illustrations.

The publication of Vesalius's De Humani Corporis Fabrica Libri Septem (called De Fabrica for short) in 1543 was a triumphant leap forward in the investigation of the structure of the human body and medical art. For the first time in medical history, a single collection of illustrated books contained accurate (for the time) human anatomical information from direct observation.

The primary vehicle for conveying anatomical information in De Fabrica is the illustrations. The text and labels were laid out so as not to interfere with the beauty or information of the illustrations. Amazingly,

certain illustrations even solicited viewer participation, in that they required pieces to be cut out and assembled. Figure 1.6 shows that Vesalius realized the great importance of well-drafted and accurate illustrations and gave them center stage in his book.

FIGURE 1.6 Vesalius' De Fabrica was innovative in its use of medical illustration as a vehicle for education.

Vesalius commissioned Joannes van Calcar, possibly Titian, and other artists to produce the illustrations for De Fabrica. Vesalius supervised the production of the illustrations and worked closely with the artists to reach a level aesthetic beauty in combination with scientific accuracy that had never been achieved before. This innovative collaboration between scientific and artistic minds culminated in one of the greatest medical books ever produced and set a precedent for quality that is still admired today.

De Fabrica was an instant success and made Vesalius a legend in his own time. Years later, Vesalius published a second edition of De Fabrica, correcting errors and adding new information. Vesalius lectured at different universities and was the physician to several courts, but he never again produced anything like De Fabrica. At the young age of 50, Vesalius died on a pilgrimage to the Holy Land.

Post-Vesalian Medical Illustration

In the decades after De Fabrica, physicians and artists such as Juan De Valverde (1525–1587), Bartolomeo Eustachio (birth date unknown, –1574), Volcher Coiter (1534–1576), Andriaan van den Spieghel (1578–1625), Bernhard Albinus (1697–1770), and many others published illustrated anatomical books that were partially based on Vesalius's work, but more importantly, these new books were based on the principle that accurate medical illustrations created from direct observation were critical in conveying medical and anatomical information.

The enthusiasm created by Vesalius and other anatomists spilled into the seventeeth and eighteenth centuries. The study of medicine and anatomy, no longer confined to Italy, flourished in universities and medical schools across the European continent. New discoveries in anatomy came quickly and were presented as illustrations in numerous printed works by the now-famous scientists such as Fredrik Ruysch (1638–1731), Giovard Bidloo (1649–1713), and William Cowper (1666–1709).

MODERN MEDICAL ILLUSTRATION

While medical illustration began in Europe, it is in America that it was refined and established as the standard media for medical education. In the first half of the twentieth century, individuals such as William Didusch, Ralph Sweet, and Tom Jones made significant contributions to the development of medical illustration and the advancement of medical education, but the acknowledged "father of modern medical illustration" is a German immigrant named Max Brödel.

Max Brödel (1870–1941)

When Brödel arrived in America at the turn of the twentieth century, he was immediately put to work creating illustration for Dr. Howard Kelly of the Department of Gynecology at what was then the new Johns Hopkins medical school in Baltimore, Maryland. Although Brödel was a trained and experienced artist, his initial efforts in medical illustration were difficult, because he had little knowledge of science and medicine. However, under Dr. Kelly's tutelage, and Brödel's own rigorous self-teaching, he soon became an accomplished medical illustrator. For over a decade, Brödel perfected new illustration techniques and illustrated a number of medical books for Dr. Kelly and other physicians at Johns Hopkins. See Figures 1.7 and 1.8.

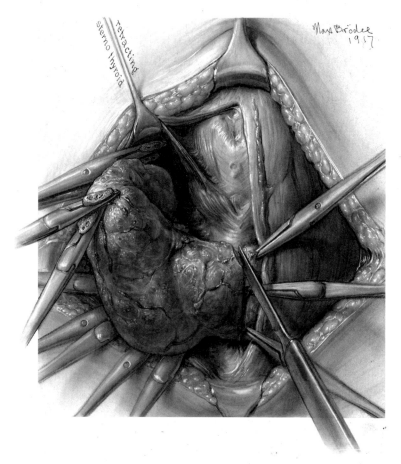

FIGURE 1.7 The Operation for Exopthalmic or Hyperplastic Goitre, *The Johns Hopkins Hospital Reports*, Vol. XIX, pp 71–257, (c. 1920). Reprinted with permission from the Johns Hopkins University School of Medicine. Original art in the Max Brödel Archives, Art as Applied to Medicine, The Johns Hopkins School of Medicine.

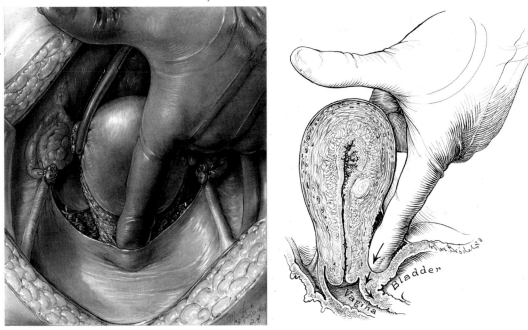

FIGURE 1.8 A Simplified Technique for Abdominal Panhysterectomy, Edward H. Richardson, MD, FACS, *Surgery, Gynecology and Obstetrics,* Feb, 1929, pp 248–256 (c. 1929). Reprinted with permission from the Johns Hopkins University School of Medicine. Original art in the Max Brödel Archives, Art as Applied to Medicine, The Johns Hopkins School of Medicine.

Recognizing the unique training in science, medicine, and art required by medical illustrators, Brödel and Dr. Thomas Cullen developed an idea for an educational program to train medical artists. With an endowment from Henry Walters, a Baltimore philanthropist, the department of Art as Applied to Medicine at Johns Hopkins was established in 1911. Brödel became the director of the first educational program in the world whose sole purpose was to train medical artists.

In the following 30 years, Brödel trained many medical illustrators, who themselves went on to establish new medical illustration educational programs at other universities, head departments of biomedical illustration, and work in medical schools and hospitals all over the world.

Frank Netter (1906–1991)

No history of medical illustration is complete without mentioning the accomplishments of Dr. Frank Netter. One of the best-known medical artists of the twentieth century, Netter was a trained surgeon who also had a passion and talent for art. Netter is known for his many brilliant medical illustrations but is best remembered for the remarkable series of books that he illustrated for what was in the 1940s the CIBA Pharmaceutical Company

(today it is Novartis). The CIBA Collection of Medical Illustrations is an 8 volume, 13 book set that beautifully details human anatomy and pathology in thousands of color plates, as seen in Figure 1.9. Mention Netter to physicians, and they will fondly remember the days when as medical students, they used his work to learn their craft.

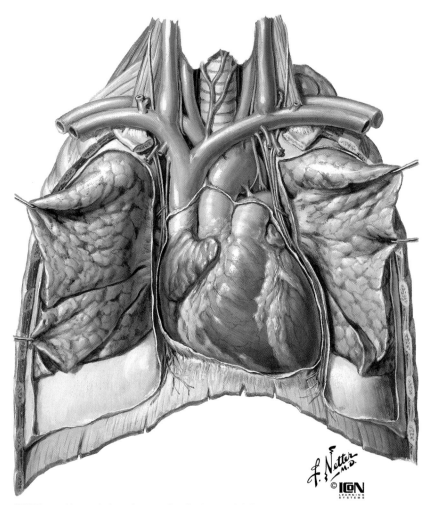

FIGURE 1.9 Netter is best known for the beautiful illustrations he created for the CIBA Collection of Medical Illustrations. [The Heart, the Netter Collection: Volume 5, Plate No. 5, p. 6, (c. 1979)]. Reprinted with permission from Icon Learning Systems. All Rights Reserved, © Icon Learning Systems.

The Association of Medical Illustrators

By the 1940s, medical illustration had become an established and growing profession. Medical illustrators numbered in the hundreds and worked in diverse venues throughout the country. A group of medical artists felt that

it had become necessary to form an organization to preserve and promote the standards of medical illustration and to allow cooperation between artists. As a result, in 1945 the Association of Medical Illustrators (AMI) was established.

Today, the AMI is an international organization with a diverse membership of medical artists, educators, advisors, and administrators. While its core goals have remained the same for nearly 60 years, it is a much more varied organization today. The AMI offers its membership continuing education courses, certification, and accreditation to medical illustration education programs. The AMI also publishes the Journal of Biocommunication, a scholarly journal filled with articles, reviews, and artwork. Every year the AMI organizes a five-day meeting at which medical artists and other people involved in biocommunications come together to learn, share, and find work. The highlight of every meeting is the Salon, at which medical artists display their artwork and compete for prestigious awards. See Figure 1.10.

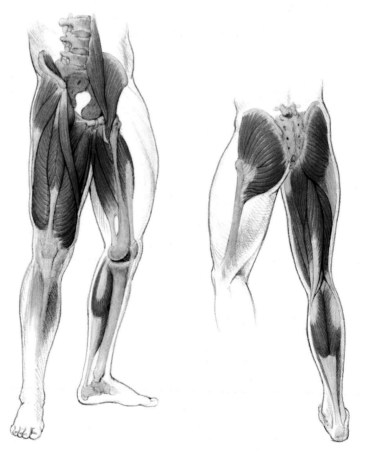

FIGURE 1.10 Leg Muscle Anatomy. © 2004 Reprinted with permission from R. Spencer Phippen.

CONCLUSION

From cave paintings to computers, art—specifically medical art—has been one of the main vehicles through which man has passed on his accumulated knowledge on how to stave off disease and recover from injury. As we have seen in this chapter, medical illustration has a history that reaches back hundreds if not thousands of years. However, it was in the early twentieth century in America that modern medical illustration was developed and refined by Max Brödel and many other notable people. Today there are thousands of skilled medical illustrators working all over the world. In the next chapter, we will discuss the current state of medical illustration and its future.

2

MEDICAL ILLUSTRATION TODAY

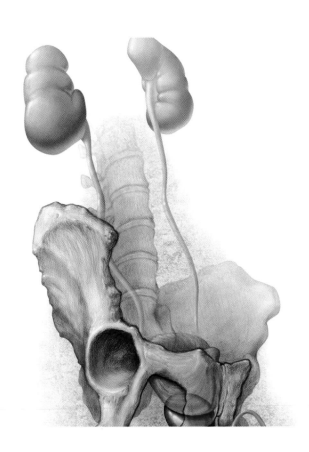

A s we have seen, medical illustration has a rich history, but recent advancements in digital media technology and economic changes have had a profound impact on the current state of the industry and possibly on its future. The goal of the medical artist has always been to visualize, conceptualize, and clearly communicate medical and scientific information to healthcare professionals and the public. However, the methods used to achieve this goal have changed due, in large part, to the proliferation of the computer.

DIGITAL MEDICAL ILLUSTRATION

Through the years, medical illustration has adapted to many technological innovations, but digital technology is not an *innovation* to be adapted to; digital technology is nothing less than a rapid paradigm shift in the methods with which medical illustration is produced. In the last 10 years (some would argue 20 years), medical artists have had to accept, sometimes begrudgingly, that their clients have come to expect digital art as the final product. The days of delivering airbrushed illustrations, pen & ink drawings, paintings, cel animations, and analog slides as final products are quickly becoming outdated.

Today, medical art buyers expect medical illustrations to conform to the new standards in digital media. Ubiquitous programs like Adobe Photoshop® and Adobe Illustrator® are beginning to replace airbrushing, continuous tone, and pen & ink illustration. Many consider multimedia programs like Macromedia Flash™, Macromedia® Director®, and Microsoft Power-Point® to be the new standards in interactive presentations. 3D illustration and animation software, such as 3ds max™ and Cinema4D™ have replaced traditional animation techniques. Consequently, many medical artists are faced with a "sink-or-swim" situation in which they have to become experts in the ever-changing field of digital media technology.

The Bottom Line

Advances in media are usually gradual, taking years to effect change. By comparison, the "digital revolution" has stormed all aspects of communications overnight. Why has digital media technology become the norm? The bottom line is time and money. Computer programs such as Adobe Photoshop have streamlined the production, reproduction, and the storage of art. If two skilled illustrators were timed in the production of a similar illustration, one using an airbrush and one using Photoshop, the time difference would be negligible (all variables being equal). Now ask both illustrators to change the overall color of a large part of the illustration or

to change the design of the illustration. After a few mouseclicks the illustrator using Photoshop will have completed his task, while the airbrush illustrator will still be trying to mix colors, cut masks, or unclog his airbrush. Since revisions, small and large, are a time-consuming and an integral part of the art production workflow, computer programs like Photoshop save time and money.

Beyond the practical advantages of digital art production, medical artists are faced with a rapidly changing world in which almost all media has become digitized. For example, publishers (the main market of medical artists) today use programs like QuarkXPress™ to lay out books, journals, and other publications. It is far more economical in terms of time and money for the publisher to simply drag and drop an expertly prepared digital image into a layout than to have to send an airbrushed illustration to be scanned, color corrected, and then dropped into the layout. Printing companies have moved from using offset printing presses that use photomechanical plates to digital printing presses that print directly from digital files. Another economic consideration in the proliferation of digital art is that it can easily be repurposed. An illustration created in Photoshop can be converted to CMYK for print, resampled and put on the Web, dropped into a digital video, or added to a CD-ROM-based presentation—all with a few mouseclicks. In our world of tight schedules and diminishing resources and budgets, any technology that increases the bottom line soon becomes the norm.

Is Digital Art Better?

There was a time when digital art was not considered art, and *real* artists didn't take it seriously. This attitude may have said more about the innate human quality to resist change than about whether digital art is art or not. Early digital art may have been snubbed simply because it did not look like traditional art. For almost two decades, digital artists have struggled to change the slick, plastic, "computer-generated" look into a more natural look, but as is often the case with new technologies, the ability to create natural looking digital art did not exist or was not affordable. However, today hardware and software that can produce digital art indistinguishable from traditionally produced art is readily available. So whether digital art is art or not is no longer an issue of how it looks as it is an issue of personal preference.

Successful medical artists are not successful because they have the latest version of Photoshop or a super fast computer. They are successful because of natural artistic talent and training in the traditional skills, such as drawing, design, composition, observation, life drawing, figure drawing, lighting, and color theory. Medical artists need solid art skills, plus a

background in the basic medical sciences to produce good art in any medium. Today, many medical artists blend their skills in traditional art with their expertise in digital media to produce a new hybrid or mixed-media art that is part traditional and part digital. So is digital art better? It is not necessarily better, but it has become a practical and economic necessity. The fact is that computers are recently added tools in the medical artist's arsenal, making medical artists today not only talented artists and effective communicators but also expert digital artists.

THE CHANGING WORKPLACE

Beginning in the early twentieth century with Max Brödel, medical illustrators worked almost exclusively in departments within institutions and universities. Over the next 70 years, medical illustration changed little, and the medical artist's main place of work remained centralized departments within academia, but as we will see, budgetary constraints and rapidly changing technologies have led to significant changes in where and how medical illustrators work.

The Disappearing Biomedical Communication Department

In the late 1980s, the long-standing trend of job security for medical illustrators within academia began to change as a result of belt-tightening and reduced federal funding to colleges and universities. To make things worse, changes that came with managed healthcare in the 1990s also affected the cash flow of clinical departments within universities, typically one of the largest clients of biomedical communications units. This lack of funding appeared to directly affect the ability of biomedical communication departments to keep up with changing technology, maintain staff, and compete with outsourcing.

Today, the number of biomedical communication departments within universities has decreased dramatically throughout the United States. In 1990, the Houston-Galveston area in Texas, which houses the Texas Medical Center (the largest medical center in the world), had five active and large biomedical illustration departments employing dozens of medical artists. Today, only one full-service biomedical illustration department remains.

While there are still opportunities for the medical artist to work in academics, the result of the economic changes has been that both universities and medical artists have been forced to change the way they do business. Many medical colleges have restructured their biomedical communications units, or they have been absorbed into other departments within the college. At present, only well-funded clinical departments

within medical colleges that have lost their biomedical communications units can afford to hire staff medical artists and medical writers to take care of their communications needs. The rest of the departments have been forced to outsource medical illustration services or to do without. Where once there were many large centers of biomedical communications, today there are small pockets of medical artists or isolated medical artists working within academia. The trend of biomedical department closings brought on by reduced funding has effectively decentralized medical illustration services.

Medical Illustration as an Industry

While many biomedical communication departments no longer exist, there is still a great demand for biomedical illustration services. The demand from academia, coupled with an increasing demand for medical and scientific content from the lay media and the legal community, has created a tremendous opportunity for entrepreneurial medical artists. In recent years, there has been a tremendous growth in the number of organized companies that provide medical illustration services to a variety of clients.

There aren't any "Microsofts" or "General Electrics" within the emerging medical illustration industry yet, but medical illustration companies such as Blausen Medical Communications (see interview with Bruce Blausen later in this chapter), Hurd Studios, and A.D.A.M are small but growing businesses. These small businesses and many others are not only filling the void left by the disappearing biomedical illustration unit but are expanding what was typically considered medical illustration by embracing new technologies like 3D illustration and animation, the Web, and interactive new media. Today, medical illustration companies provide employment for a large portion of medical illustration graduates.

Medical Illustration Freelancers

Freelancing is not new to medical illustration; in fact, Max Brödel (one of the pioneers of medical illustration) initially worked on a contract basis for Johns Hopkins, before he was hired as a full-time employee. Medical art buyers often choose to work with freelancers, because freelancers can provide the same level of medical expertise and artistic talent with the added advantage of flexibility in scheduling and cost, as well as the ability to develop affordable custom content.

Some of the larger medical illustration companies can also develop custom content, but it might be more expensive because that is typically not their specialty. Medical illustration companies often rely on reselling a large inventory of stock medical illustrations; for example, the same 3D

heart will be sold over and over to different clients. On the other hand, freelancers provide clients with affordable, one-of-a-kind, custom illustration and content. No matter how big medical illustration companies become, there will always be room for the little guys.

What You Can Expect to Earn as a Medical Illustrator

According to the Association of Medical Illustrators (AMI), upon graduation, the average starting salary for a medical illustration graduate with a master's degree is approximately $40,000 a year. The salary range for medical illustrators who have been out of school and have more experience is approximately $45,000–$75,000. Medical illustrators working in administration or who are faculty generally make somewhat higher salaries.

The income of an individual is directly related to the perseverance, talents, skills, and luck of each. Certainly those working in salaried positions may have a cap to their salary. However, those working as freelancers or in their own businesses within the industry are limited in income only by their creativity in marketing, and the niche they create within the market.

CHAPTER INTERVIEWS

We have interviewed a variety of medical illustrators working in different fields and markets. In this chapter, we'll chat with Michael King, a staff medical artist at the Mayo Clinic; Peg Gerrity, a freelance medical artist based in Houston, Texas; and Bruce Blausen of Blausen Medical Communications, a company specializing in 3D medical illustration and animation. This collection of diverse medical artists will provide varied viewpoints on the industry.

Most of the illustrators we talked to concerning the past and present state of the industry felt that the industry has changed dramatically. The field of medical illustration is no longer a small, tight-knit group of individuals sitting at their drafting boards; instead, it appears to be growing and becoming more diversified. The addition of affordable computers and software, and the Internet, are opening up new fields and opportunities for medical illustrators.

MICHAEL KING

Michael King is a staff medical illustrator at the Mayo Clinic, Rochester, Minnesota. Figures 2.1 and 2.2 show examples of his work.

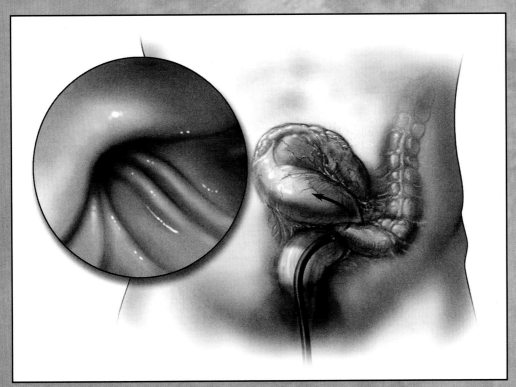

FIGURE 2.1 Excerpt from a surgical series on repair of colonic torsion by Michael King. © 2004 Reprinted with permission from Mayo Foundation For Medical Research.

How long have you been a medical Illustrator?

I have worked as a medical illustrator for 16 years.

Where did you get your training?

I have an AB degree in studio art/art history from Oberlin College and an MFA from the University of Michigan, where I trained with Gerald Hodge. I was a special graduate student at Johns Hopkins University and did internships at the Annenberg Center in Rancho Mirage in California and at the Arizona Heart Institute.

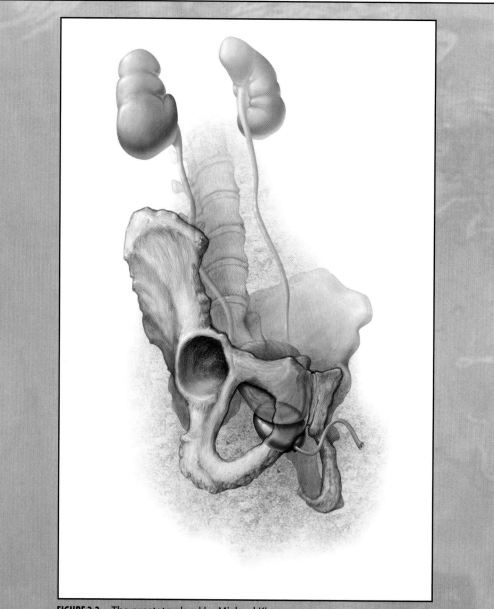

FIGURE 2.2 The prostate gland by Michael King. © 2004 Reprinted with permission from Mayo Foundation For Medical Research.

Where are you working now, and for how long?

I work in the Section of Illustration and Design at the Mayo Clinic in Rochester, MN. I've been here since 1992.

What type of artwork do you do there?

A wide variety of medical illustration. We currently have five staff illustrators, each of us with different interest and abilities. The majority of the work that I do is for printed patient education materials. I usually interact with staff writers and medical editors, but because I also illustrate for primary sources, I'll work with surgeons and research scientists.

What medium do you prefer to work in?

Just about all of my work is done with some kind of computer application, like Photoshop, Illustrator, and Painter.

What is your pay range?

Let's put it this way—I didn't pursue this field as a means of getting rich! However, I believe if you're creative, maintain high artistic standards, and/or have entrepreneurial skills, you can enjoy a lucrative career. Talent, hard work, perseverance, and luck all factor into one's success. Having said this, the pay ranges are quite wide.

Do you do any freelance work?

I do very little freelance work. As a salaried employee, I'm comfortable earning what I do, and I enjoy having free time to pursue other interests.

Who are your clients?

My clients are the in-house staff physicians, surgeons, medical writers, patient educators, producers, nurses—anyone who walks in the door.

What do you like about being a medical illustrator?

I like drawing and studying animals. I enjoy being given a directive to explain a concept that's not easily visualized and then trying to fuse fine arts aesthetics into the piece.

What do you think about the state of the industry?

Generally speaking, it's much more commercial than it used to be, and there is a larger than ever market for visuals. Computers have made it much easier for all kinds of people to create and publish graphics, so the quality is mixed.

How do you think things have changed in the industry over the past 20 years?

Styles, media, formats, audiences, and employment opportunities have changed dramatically. Computers, the Internet, and health care costs are

just some of the significant catalysts for dramatic change. Until the early 1990s, academic programs focused on the fundamentals of light on form, traditional rendering media, and the study of anatomy and surgery. Today, the medical illustrator's design skills, his or her understanding of medicine, and the ability to keep learning seems to be more crucial than ever.

How have those changes influenced you?

Because I'm in a fairly unique situation, I don't think I've been influenced by a lot of the changes. I've learned to use the computer, the Internet, and would like to continually improve. I find it's important not to let the capabilities of the new media guide you away from the fundamental principles of art and design.

Any suggestions for those who are hoping to be a medical illustrator?

I think that the field of medical visualization, imaging based on mathematical data, could have a big effect on the field. Creativity and education are important prerequisites for the field. It's more than drawing skills.

PEG GERRITY

Peg Gerrity is a freelance medical illustrator based in Houston, Texas. Figures 2.3 and 2.4 show examples of her work.

How long have you been a medical Illustrator?

Fourteen years—since 1989.

Where did you get your training?

University of Illinois, Chicago.

Where are you working now?

Freelance—I own and operate my own medical illustration studio.

What type of artwork do you do there and for how long?

Mostly advertising, editorial, and patient education illustration. Sometimes medical-legal illustration and textbook illustration.

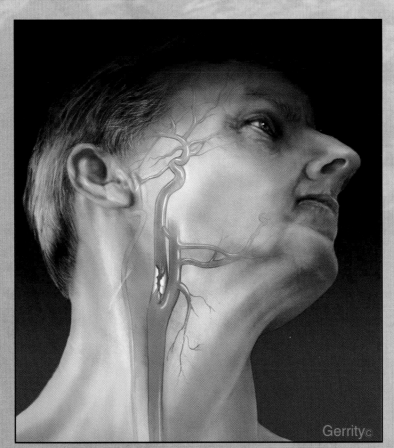

FIGURE 2.3 Atherosclerosis by Peg Gerrity painted in Photoshop. © 2004
Reprinted with permission from Peg Gerrity.

What are the advantages or disadvantages to being a freelancer?

The best part, I think, is having control of your destiny. If someone doesn't get the project done on time or market the business properly, you have no one to blame but yourself. When I need work, I have the power to contact clients directly and see what's cooking. The biggest disadvantage I can see is not having other artists to knock around ideas with, but that can be an advantage, too, because everything is completely original.

How do you market your work?

First, through my own Web site; second, through Serbin's Medical Illustration sourcebook; third, Indexed Visuals; fourth, direct calls to previous clients; and fifth, I do an occasional trade show.

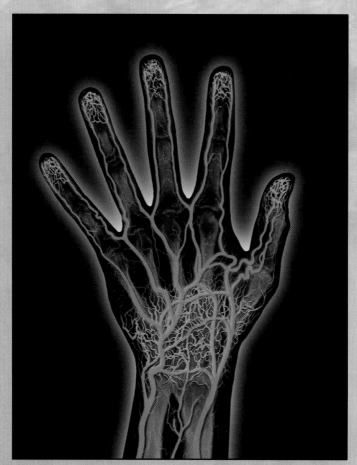

FIGURE 2.4 Arteries of the Hand by Peg Gerrity painted in Photoshop.
© 2004 Reprinted with permission from Peg Gerrity.

Is your work steady?

Right now, it is very steady. Was a bit slow this time last year.

Do you tend to work more in a specific area, for example editorial, advertising?

Advertising and editorial mostly.

What medium do you prefer to work in?

Traditional airbrush or hand painting reworked in Photoshop.

Can you clue the readers in on what a freelancer might earn?

Range depends upon the usage of the work. Currently, for one-time usage of newly commissioned editorial or cover editorial art, I generally ask for $2,500 but may accept as low as $1,600, if it is an established client. Advertising illustration is usually a buyout, so I currently ask for about three to four times my editorial fee. Typical jobs might run between $8,000 and $12,000. Stock art sales I already have in my archives can run from $480 to $4,000 per image, depending upon the usage.

Who are your clients?

Advertising agencies and journal publishers most of the time, but I've gotten lots of re-use (stock sales) from a wide variety of clients.

What do you like about being a medical illustrator?

Drawing all the cool-looking ultrastructural anatomy.

What do you dislike about being a medical illustrator?

It can be a bit stressful.

What do you think about the state of the industry?

I think it is strong, especially with Internet marketing and sales.

How do you think things have changed in the industry over the past 20 years?

The Internet and groups like Indexed Visuals have helped medical illustrators maintain control of their stock images. Direct sales of stock art (between artist and buyer) have changed the way we lease our rights and the contracts we sign. Illustrators are much more careful about the contracts they sign, knowing that they can make resale money only if they maintain their copyrights.

How have those changes influenced you?

I've never been one to transfer my rights anyway, but the IV and the Internet have encouraged me to upload and make available over 400 stock images that had previously been sitting in a box in my closet.

Any suggestions for those who are hoping to become a medical illustrator?

Keep and register your copyrights! Never lease or transfer more rights than are absolutely necessary and then make sure you protect those rights through registration.

BRUCE BLAUSEN

Bruce Blausen is CEO of Blausen Medical Communications (BMC). Figures 2.5 and 2.6 show examples of his work.

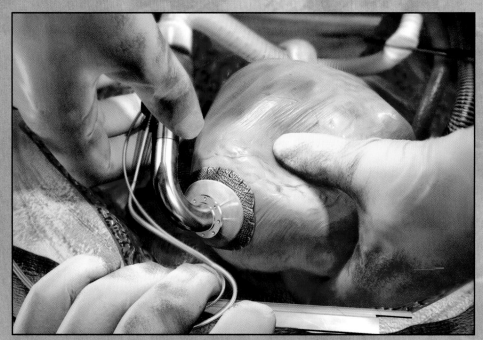

FIGURE 2.5 Heart surgery to implant a left ventricular assist device by Adam Questell done in 3ds max. © 2004 Reprinted with permission from Blausen Medical Communications.

What does your business do?

Blausen Medical Communications is an integrated communications firm, which specializes in medical and scientific illustration, animation, design, and marketing. We have two fairly separate divisions that serve different client needs.

One division develops custom, high-end 3D medical animation and illustration. Over the last 13 years, we have developed the largest library of medical and scientific animation in the world. We leverage this considerable content to develop a range of digital media, including interactive CDs and DVDs, videos, Web sites, educational kiosks, etc. We also develop relevant print and marketing materials that work in concert with our digital media.

Our second division is involved in the licensing of our stock animated medical atlases. Pharmaceutical companies, hospitals, human resource companies, and others use these atlases for educational purposes. For example, one company may use them to educate patients, while another may use them to inform employees about on-the-job injuries.

FIGURE 2.6 Liver and immune cells for a Hepatitis animation by Dan Jarvis done in 3ds max. © 2004
Reprinted with permission from Blausen Medical Communications.

What do you specialize in?

We specialize in the creation of high-end, 3D animations and illustrations that are extremely affordable, medically accurate, and have a cutting edge creative look and feel. We sell to eight diverse vertical markets—college publishing, bio-manufacturing, pharmaceutical portal, consumer medical portal, medical legal, broadcast television, healthcare education, and employee wellness.

What is your educational background?

I have two degrees from Pennsylvania State University: one in art and the other in biology. After Penn State, I worked at the Presbyterian Hospital in Pittsburgh doing laboratory research in the field of diabetes. I then went on to Johns Hopkins University School of Medicine, where I earned a master's degree in medical illustration. My thesis traced the embryological development of the heart using three-dimensional animation software.

How long have you been a medical illustrator?

Seventeen years.

What was your past experience as a medical illustrator?

I began my career as a medical animator at the University of Texas Health Science Center, Houston. I created animations for Dr. Red Duke's healthcare news reports that were broadcast into 42 television markets. Two years later, I joined American Medical Video as a medical art director and was ultimately promoted to senior producer of a half-hour program that aired bimonthly on Lifetime medical television. I eventually left to build Blausen Medical, and American Medical Video became my biggest client our first year.

How long have you had your business?

Thirteen years.

How many employees do you have?

Fifteen employees.

Are all of your employees medical illustrators? If not, what other qualifications do they have?

The majority of the Blausen Medical team is composed of medical illustrators/animators, but we also have designers and programmers, editors, and administration staff.

What do you look for when hiring an employee?

We look for a creative individual that has a passion for medical illustration and believes that this is what they want to do for the rest of their life. We want someone who is hard working, dedicated, loves what they do, and doesn't mind putting in long hours. They must think out of the box, and be eager to learn and improve themselves and their craft. Software and hardware change rapidly, and there is a constant learning curve. You must want to create medical animation, love science, and be comfortable being on the cutting edge of technology.

Do you create any traditional illustrations?

No. Our company is creatively positioned to utilize today's software in developing new ways to conceptually explain concepts that get lost in traditional illustrations. There are great traditional illustrators out there, but we do not play in that space.

What type of computer programs and equipment does your company use?

Blausen Medical uses Adobe software products including Photoshop, After Effects, and Illustrator. All of our 3D work is in 3ds max. Our hardware includes PCs, Macs, editing systems, and digital broadcast systems.

Do you think that all styles are acceptable in the industry or is there one medium that is preferred?

Currently, there is a definite preference for real life, hi-tech look and feel. If you are a traditional illustrator you are going to starve. The issue with medical illustration is, and always has been, that it is an educational medium. In the educational process, the closer you can come to accurately portraying reality, the greater chance that a complex concept can be conveyed to both professional and consumer audiences. For example, you can't illustrate a beating heart but you can animate it. Many medical illustrators create very pleasing, aesthetic illustrations that fail to accurately fully educate, not because of their talents but because of the limitation of the media. The more you can depict reality, the more effective you will be. 3D animation gets the job done. If you are a traditional illustrator, your workload will continue to decrease, but if you embrace computers and technology, you will have a better future. It's not just about producing a good-looking product, it is about the process of education.

What is the average pay scale for some of your employees?

On the average, $45,000–$50,000, but our pay scale is based on experience and ability.

Can you reveal your company's income?

Gross billings $1.4 million and an additional $4.3 million in contractual sales over the next three years (the licensing of our 3D atlases through our distribution partners).

What do you think about the present state of the industry?

I believe that there is a huge opportunity—a much bigger opportunity than ever existed in the field. Yet at the same moment, one aspect is diminishing. Think of it like this, at one time you could go to the corner mom-and-pop shop for your groceries. Now, groceries are all in huge chain-owned stores. The field of medical illustration is the same way. For a long time, the local illustrator could do all that you needed. Now, medical illustration is turning into a large industry. If you are working by yourself, the opportunity to win a large contract is slim.

There are half a dozen companies emerging as the leaders in this industry. Blausen Medical Communications in Houston is one, specializing in 3D medical animation.

How do you feel the industry has changed over the past 20 years?

The biggest problem with medical illustration was that there was a large middle class—you really didn't have a high or low end of the spectrum. Everyone was averaging the same amount of money, doing the same amount of work—all operating as independents. Everyone was helpful. Now people have come into the profession and have looked at it more from a capitalist viewpoint. What is the market? How can I capture greater market share? How do I price things? Members of the Association of Medical Illustration have always worked together to price things accordingly, which served as a guideline. Others have come along and said, "I will price imagery according to a business model and with the guidance of investors, not based on what the practices are of others in the industry." The field has turned from a "love-in" community to more of a corporate environment.

How do you feel the industry will change in the future?

I believe the industry will continue to become more corporate and service oriented. Companies with large collections and volumes of scientifically accurate material will own the industry. Hospital systems, pharmaceutical companies, medical schools, publishing companies, etc. all want material that is accurate, has clarity of concept and ease of use but aren't necessarily concerned about a particular style. The medical-legal field is a good example of the future of our industry—most law firms used to hire independent illustrators to create depictions of a case. Now, the medical-legal field is looking for affordable educational, scientifically accurate animations that depict scenarios of complex concepts that a simple illustration cannot, specifically content that can be purchased on a licensing basis. Companies we serve want fast service, so if you do not have a vast library from which to work, you are at a disadvantage.

What do you like about medical illustration and your business?

I love the dynamic nature of the business. The art, the software, the science—it is always changing. It helps to know that through your work, you can alleviate fears and concerns that people are harboring. Our work educates patients and their caregivers and can make a basic health condition seem less daunting, and its treatment a little less scary.

What do you not like about medical illustration and your business?

The business of medical illustration was too rigid and the leaders during the '70s and '80s lacked vision of what the industry could become. They were artists, not businessmen. There was an opportunity to grow the field; instead, it has left itself open to be cannibalized by a few large corporations.

How much and what type of marketing do you do, and has that changed over the years?

We have had the good fortune to have clients that have recommended us to colleagues, and the reputation of the breadth and accuracy of our work has served as our marketing effort. We have been in business for quite some time now, and because our audience is fairly small, we know, or have access to, most of our target market. Advertising on a large scale is pointless. We like developing personal relationships with clients and use the basic tools of a Web site and interactive brochures to follow up with potential clients. If your work is good and you meet and ultimately exceed your clients' expectations, they will be your best marketing ambassadors.

What advice would you give to those coming up in the industry or those wanting to begin a career as a medical illustrator?

Learn 3D animation, editing, programming, and keep up to date with the latest in software such as After Effects. Embrace computer technology. Clients will always have something new that they want to explain, and it has to be not only current and creative but clear and educational. Lastly, recognize that you are in a service-based industry and during slow periods, begin to create a product that you can either sell or license. Although it may fail the first several times, it will ultimately succeed and provide you with an additional source of income that will allow you to grow your business.

CONCLUSION

The industry is growing and changing, offering many opportunities to different individuals and companies. As technologies and research increase, so will the demand of medical illustration. The introduction of computers and 3D have created even more of a market and opportunities for medical illustrators affording them advancement in salaried positions, as freelance artists, and as business owners.

CHAPTER

3

BECOMING A
MEDICAL ILLUSTRATOR

The name mandarinfish is said to be derived from the brightly colored, silk Mandarin Chinese robes of the 19th century. They resemble blennies or gobies, and are often called mandarin gobies for that reason, though gobies and blennies are not in the same family of fish. Mandarinfish are small(growing to an average 2.4 cm), shy, and bottom-dwelling. They can usually be found searching for small crustaceans or other invertebrates on the cluttered reef bottom or on coral heads. Mandarinfish are found in much of the western Indo-Pacific, including the Philippines, Indonesia, Australia, and New Guinea.

Mandarinfish
Synchiropus splendidus

A rtists are usually drawn into the field of medical illustration through a passion for art and science. Biomedical communications in general, and medical illustration in particular, is a rewarding but demanding field that requires specialized training. As such, obtaining an education in biomedical communication is rigorous and challenging. Just being a good artist is not sufficient: a person wanting to enter medical illustration should be a keen observer, curious, creative, intelligent, versatile, disciplined, and have a love for learning and a desire to continuously improve his skills. Graduate and undergraduate programs in medical illustration hone the natural artistic talent and communication skills of the student, train him in the latest computer technology, prepare him for business, and educate him in basic medical sciences such as human anatomy, comparative anatomy, histology, pathology, and embryology.

CHOOSING A SCHOOL

Preparing to become a medical illustrator can begin as early as high school. High school students should focus on taking college preparatory courses with a strong emphasis in art and science and develop a strong and diverse portfolio. Graduate and undergraduate medical illustration programs not only fine-tune artistic skills but also thinking and observation skills. Students in medical illustration programs attend some of the same science and medical courses as students who are training to be physicians, thus achieving a high level of education in medicine and science. To receive pertinent information about prerequisites for undergraduate or graduate medical illustration programs, contact the universities listed in this chapter. Undergraduate students preparing for a master's degree in medical illustration may want to tailor their academic work with their chosen graduate program in mind. Some common undergraduate prerequisites may include:

- Undergraduate science courses in comparative vertebrate anatomy or vertebrate morphology with dissections of a mammal, human physiology, histology, embryology, invertebrate anatomy, and cell biology.
- Undergraduate art courses in advance figure drawing from life, advanced life drawing from the nude model, advanced drawing and painting from life, photography basics including darkroom experience, color theory, graphic design, and sculpture. Students must also be able to render from life, with a strong focus on contour, perspective, form values, light and shadow, and rendering texture detail. Students must have a strong understanding of perspective and must be able to render color accurately in still life studies.
- Computer courses in graphics programs such as Adobe Illustrator and Photoshop, Macromedia FreeHand®, and ProCreate Painter™; 3D programs such as 3ds max™ and Lightwave™; and Web development programs such as Dreamweaver.

Portfolio Review

All the colleges offering graduate and undergraduate programs in medical illustration require a portfolio for admission. Portfolios can be presented as 35 mm slides, videotape, computer disk/CD-ROM, or in a traditional binder format. Check with your university of choice to see what form of portfolio is preferred and for requirements or suggestions for its content. Generally, portfolios should include approximately 20 samples that show a variety of work, including figure drawings, paintings and drawings from life, and graphic design layouts that include typography and visual images. Paintings and drawings should exhibit form, texture, and depth.

GRADUATE PROGRAMS IN BIOMEDICAL COMMUNICATIONS

The Department of Art as Applied to Medicine at Johns Hopkins University, established by Max Brödel in 1911, was the first accredited degree program for medical illustration in the United States. In 1959, a two-year graduate program leading to a master's degree in medical and biological illustration was established at the same school. In subsequent years, six additional accredited programs that offer degrees in medical illustration have been established in the United States and Canada. Admissions standards into the programs require average or above average GPAs and good scores in the GRE and GMAT exams. Some schools also require letters of recommendation and other more rigorous requirements. The number of applicants admitted into some programs is sometimes limited to as little as three people a year. The current schools offering degrees in biomedical communication are:

- University of Toronto, Division of Biomedical Communications.
- The Medical College of Georgia, School of Graduate Programs.
- University of Illinois, Department of Biomedical Visualization.
- Johns Hopkins University, Department of Art as Applied to Medicine.
- University of Michigan, Program in Medical and Biological Illustration.
- The University of Texas Southwestern Medical School, Dallas, Biomedical. Communications Graduate Program.
- The Rochester Institute of Technology offers both a baccalaureate degree as well as a master's degree from the College of Imaging Arts and Sciences. At this time, the only university that offers a baccalaureate degree in medical illustration.

Certification and Continuing Education

After a medical illustrator has completed his training, the Association of Medical Illustrators (AMI) offers certification for a Certified Medical Illustrator (CMI). Certification is earned after passing a series of examinations and a rigorous portfolio review. Once certification is earned, it can be maintained by taking continuing education courses and exhibiting competence throughout the career as a medical illustrator. Although certification was developed to show competency, it is not a requirement to be able to work in the field.

SPECIALIZATION

Upon graduation, some medical artists may specialize in different areas of medicine such as transplant immunology, ophthalmology, or cardiology. Some focus on a specific art medium, such as pen & ink, 3D illustration, and animation, and others become known for their expertise in areas of illustration such as surgical, marketing, or editorial. Each medical artist receives the same basic training but usually gravitates toward specialties through personal preference and job experiences.

Some schools are beginning to offer programs with areas of specialization. For example, the University of Toronto is offering a specialization in biomedical 3D illustration and animation and biomedical new media, such as video, CD-ROM, and Web site content. Specialized training in digital media will increase in demand as the growth of technology continues.

CHAPTER INTERVIEWS

The following interviews are provided to give you insight into the training of a medical illustrator from the point of view of the instructors and students. These interviews have been edited for length.

JAMES A. PERKINS

James A. Perkins, MS, MFA, CMI, is Assistant Professor and Assistant Director, Medical Illustration Program, Rochester Institute of Technology (RIT). Mr. Perkins has been an illustrator for 12 years and an instructor at RIT for 6 years. Figures 3.1 and 3.2 show examples of his work.

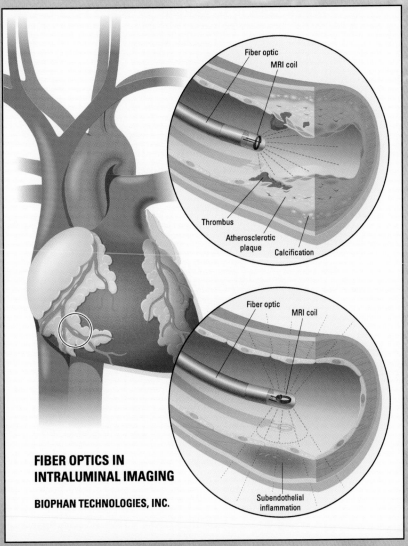

FIGURE 3.1 Biophan Technologies Intraluminal Imaging by Jim Perkins drawn in Adobe Illustrator. © 2004 Reprinted with permission from Jim Perkins.

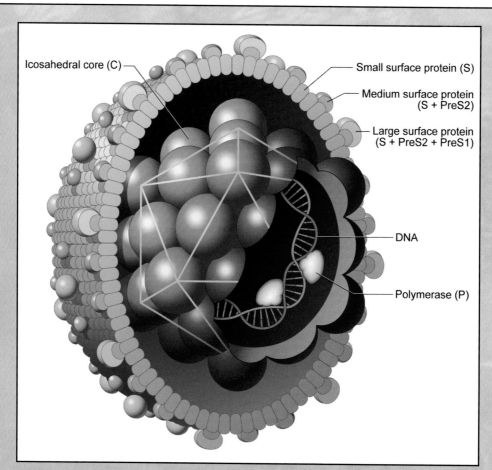

FIGURE 3.2 Hepatitis B virion by Jim Perkins. Drawn in Adobe Illustrator. © 2004 Reprinted with permission from Jim Perkins.

What is your past experience as a medical illustrator?

After graduating from RIT in 1992, I spent two years working for Design Pointe Communications, an illustration, design, and prepress firm in Atlanta. Mostly I did illustration work for medical publishers but also dabbled in design and desktop prepress work. Then I worked for Medical Legal Illustrations, a subsidiary of ADAM Software in Atlanta, doing medical legal exhibits. This company eventually broke away from ADAM and changed management to become Nucleus Communications. I helped them with the transition and continued to work for Nucleus through 1998 when I came to RIT. I've also had a successful freelance business for about 10 years.

What do you look for in students who are applying to the Medical Illustration Program?

Excellent drawing skills, command of various media, some sense of design, and a strong aptitude for coursework in the sciences.

What does the school look for in a portfolio review?

Schools look for evidence of very strong drawing skills, especially the ability to draw natural objects from direct observation. We especially like to see portraits, figure drawing, hands and feet, and drawings of other natural objects from direct observation. We like to see mastery of several different media including traditional and digital techniques, line, tone, and color, wet and dry media, and some evidence of design and composition skills.

How many students are admitted to the program each year?

Approximately 10 students are admitted into the undergraduate program and 5 into the graduate program. The number of admitted students varies quite a bit depending on the number and quality of applicants.

What medium do you work in when doing your own medical illustration work?

I've used a number of traditional and digital media over the years, but now I do almost all of my professional work in Adobe Illustrator. I also do molecular illustration work, which involves molecular visualization software (Chime™, Rascal™, WebLab Viewer™) and 3D modeling programs (Cinema 4D XL™ and Strata Studio Pro™).

Are all styles acceptable in the industry, or is there one style that is preferred over another?

There is room for all styles and media, but certain markets seem to prefer certain ones. Here are some examples that I've encountered in my own work. The majority of medical publishers prefer that work be submitted as Adobe Illustrator EPS files. This is written right in the "Illustration Guidelines" provided by major publishers such as Elsevier (Saunders, Mosby, Churchill-Livingstone) and Lippincott, Williams & Wilkins. They prefer work produced in vector format directly in Illustrator, but will also accept Photoshop or hand-drawn work that has been placed into Illustrator for labeling. A few publishers are still interested in ink work, although many artists are now doing all of their black-and-white line art in Illustrator as well (e.g., see some of the beautiful "digital ink" by Tim Hengst and John Nyquist).

Editorial and advertising markets go for the slick, highly rendered look of traditional airbrush or Photoshop. Artwork created in 3D programs

(Maya, 3ds max, etc.) is becoming more popular in these markets as well. There seems to be rapid growth in the use of 3D animation in broadcast media, e.g., producing 3D "fly-throughs" for the Discovery Channel, The Learning Channel, and PBS.

Some companies are involved primarily in the production of content for Web sites. For obvious reasons, they work exclusively in digital media including Illustrator, Photoshop, Flash, as well as specialized Web applications such as Dreamweaver, Fireworks, and After Effects.

What is the average pay scale for those graduates?

Starting salaries range from $35,000 to $55,000, depending on location and other factors. It's hard to say how much a typical graduate earns after being on the job for a few years.

What do you think about the present state of the industry?

When the economy was bad for the last few years, the job market and freelance prospects seemed to be getting much tighter, although our graduates still had an excellent placement record. With the economy recovering, new jobs are opening up faster than I've ever seen. Perhaps all of those companies were holding off on hiring new people until the economy turned around. Now the floodgates have opened.

I do have some concerns about the future of the industry. For example, we've been fighting with publishers and other entities for many years over control of our intellectual property rights. There's been a little improvement—I've actually found several publishers who don't demand work-for-hire—but most of the big publishers continue to offer unfavorable terms.

I've also started to hear about foreign companies, primarily India, offering custom and stock medical art far below market prices. I fear that we may see an efflux of jobs to foreign competitors, much like the IT field has seen.

TIFFANY GAGNON

Tiffany Gagnon is a graduate student at the Rochester Institute of Technology in the Medical Illustration Program. Figures 3.3 and 3.4 show examples of her work.

How difficult has your study to be a medical illustrator been? Was it what you expected?

To be honest, I didn't know what to expect coming into this program a few months ago. I knew that graduate-level study was going to be more difficult

The name mandarinfish is said to be derived from the brightly colored, silk Mandarin Chinese robes of the 19th century. They resemble blennies or gobies, and are often called mandarin gobies for that reason, though gobies and blennies are not in the same family of fish ÉMandarinfish are small(growing to an average 2.4 cm), shy, and bottom-dwelling. They can usually be found searching for small crustaceans or other invertebrates on the cluttered reef bottom or on coral heads. Mandarinfish are found in much of the western Indo-Pacific, including the Philippines, Indonesia, Australia, and New Guinea.

Mandarinfish
Synchiropus splendidus

FIGURE 3.3 Mandarin fish by Tiffany Gagnon drawn in Adobe Illustrator. © 2004 Reprinted with permission from Tiffany Gagnon.

than undergraduate level, however, I was unsure of how much medical illustration would differ from my undergraduate major of ceramics. It is definitely more challenging but equally as rewarding. Medical illustration is the perfect mix of my mutual science and artistic interests; being able to study and explore both simultaneously has allowed me, in a sense, to overlook the difficulty of the program and to really enjoy the experience.

What is the most difficult thing in your study?

The most difficult thing for me is adjusting to thinking about the educational value of the work I create. In my undergraduate training, it was expected almost that your work not be lifelike, accurately proportioned, or educational. Here it is exactly the opposite; those factors are some of the

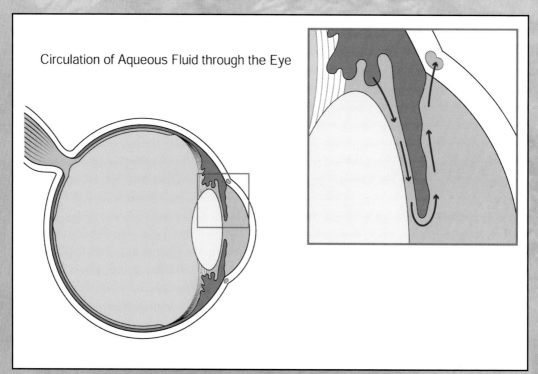

Circulation of Aqueous Fluid through the Eye

FIGURE 3.4 Aqueous Circulation by Tiffany Gagnon drawn in Adobe Illustrator. © 2004 Reprinted with permission from Tiffany Gagnon.

most important things a medical illustrator has to think about when creating an illustration.

What do you like the most?

I love the science aspect of the program, particularly human gross anatomy. It is very interesting to me to learn about and to understand how the human body works and then to actually see it in the cadaver.

Why did you go into medical illustration?

There are many reasons that I have chosen medical illustration but it all comes down to the basic fact that I love to study the sciences and that I love to use my artistic abilities; medical illustration allows me to do both at the same time. It also interests me to think that I can use my illustrations to teach someone else about the sciences and perhaps help them to love them as much as I do.

What made you decide on the university that you are attending?

An alumnus of the Institute first recommended RIT to me. After many visits to the school, meetings with the professors, and e-mails about the program, I was sold on the school, the program, everything. I was intrigued by the fact that the professors were practicing medical illustrators and knew I would gain an invaluable amount of knowledge from them and their experiences in the field. I looked at many of the other programs available for medical illustration but this one seemed to fit me perfectly.

What direction would you like to go with your medical illustration career?

I am interested in the medical-legal field at the moment; however, I anticipate being exposed to many other aspects of medical illustration in the next few years. I expect that I may find myself altering my expected course if I discover something else in the field that interests me more!

When did you decide to study medical illustration? What made you decide?

A few years ago, I took a week long workshop in biological illustration. It was taught by a medical illustrator who recognized both my love for science and my artistic abilities and suggested the field to me. It was the first I'd heard of it; it sounded like something I might be been interested in, so I researched the field, contacted several practicing illustrators, and looked into educational programs. My conversations and research discoveries led me to where I am today. The field of medical illustration fits my interests perfectly; it allows me to take science and art and merge the two together.

CONCLUSION

Preparing to become a medical artist is a challenging but rewarding experience. Medical artists today enjoy the foresight of people like Max Brödel who paved the way in education and set high standards in the endeavor of applying art to medicine and science. The graduate and undergraduate programs in North America prepare students to enter the competitive field of biomedical communications, but it is up to the individual to draw on his love of art and science, discipline, and talents to meet the academic and career challenges within the field.

THE MEDICAL ILLUSTRATOR/PHYSICIAN COLLABORATION

BY SCOTT WELDON, M.A.

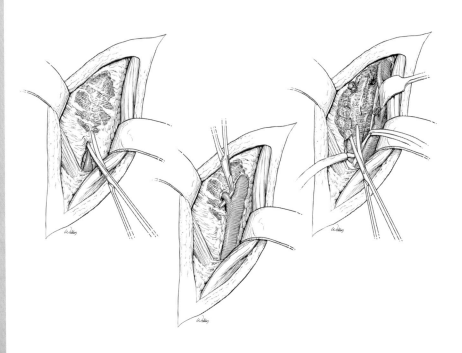

Medical illustration is all about telling a medical story in pictures. Requests to tell visual stories come to the medical illustrator from a wide variety of clients within the medical community and related fields. One of the most common working arrangements is collaboration between an illustrator and a physician. This is a specialized model of a typical illustrator/client arrangement, whereby the physician provides the story and the medical illustrator translates it into an effective graphical form. In this type of project, the key to success lies in developing a good working relationship with the physician and appreciation of the unique characteristics of this partnership in storytelling.

The aim of this section is to provide a brief overview of a typical working relationship between medical illustrator and physician. We will emphasize the importance of communication, describe the systematic step-by-step approach to a project, and suggest a conceptual framework that you can apply to your own collaborative projects.

COMMUNICATION

At the beginning of every medical illustration project, both physician and artist have their own preconceived mental models of the artwork. These mental models are usually crude and general, but they incorporate key concepts, perspectives, and graphical messages that each side wishes to bring to the project. Through good communication, these disparate mental models are transformed into an effective illustration.

Physicians have busy schedules and short attention spans. They seldom appreciate the amount of careful planning and exchange of ideas that have to take place to generate an effective visual story. Your best approach to developing good rapport with the physician is by establishing mutual respect. Listening is the essential first step. Your job is to capture the physician's mental model of the planned illustration and see how it corresponds with yours. So listen and don't interrupt. Treat the physician with respect and understanding regardless of the quality of his mental model. To garner his respect, provide relevant feedback but do not criticize. Discuss portfolio samples in a manner that not only establishes your capability to provide effective solutions but also brings the physician closer to understanding your own mental models and your style of graphical expression.

Inexperienced illustrators may be surprised to discover that the foundation of effective communication is a detailed written agreement outlining all aspects of the project. This is not a mere formality but an essential tool. It serves as a substrate that enables you to discuss all facets of the project including schedules, compensation, usage rights, and the precise expectations of both parties. Use the agreement to define methods and

means of communication. Study and understand the way the physician communicates and adapt to his style to enhance the partnership and streamline the project.

The Golden Rule of good communication is brevity. Physicians are usually short on time. Be concise and remain focused in all correspondence with the physician unless the rapport lends itself to a more informal communication style.

Don't hesitate to voice objections or to critique an idea that you consider bad. The physician's mental model may be perfectly clear to him, yet conveying it to others is problematic because it requires further clarification or a different perspective. He will usually appreciate your opinion and expertise. A physician may request a revision or change to an illustration that he thinks is simple, but in your world it may mean many unplanned additional hours of work. You must be forthright and honest and explain obstacles and technical difficulties in a nontechnical language that the physician understands. He needs to know how long it would take and how much additional effort and/or money it may cost.

RESEARCH AND REFERENCE MATERIAL

To tell a nonfiction story, you need to know the facts inside out. Researching and collecting reference material for a project gives you the factual basis on which to base your visual story. For our purposes, a reference is any text, illustration, or graphical idea that helps describe the story (or part of it). In an ideal world, the physician would have a collection of well-organized reference material and would be happy to share it with you from the initial meeting. Therefore, upon initial contact and even before the first meeting, encourage the physician to collect references related to the project. At a minimum, ask for a textual description of what he wants. If possible, ask for a relevant example of a similar or related illustration. In addition, images from medical atlases depicting a comparable operative situation or perspective, journal articles, photographs, operative reports, patient scans, sketches by the physician, or props (such as surgical instruments) are all valuable adjuncts.

Regardless of the wealth of information provided by the physician, and especially when there is a lack thereof, you need to research all possibilities of locating useful references. Medical illustrators already have a knowledge base of useful information resources and references from past experience, as well as formal training in researching and developing new references. This background allows for a focused research effort that will yield the best results. Begin the search with the obvious sources such as anatomical and surgical atlases, and then gradually expand to medical texts or materials derived from previous similar projects. Photocopy or

mark pages that could provide important information, gradually developing a collection of reference material for the project.

An outstanding and immediately available secondary resource is the Internet. Use any of the leading Web search engines for both text and images, starting with a very specific search and then gradually expanding to explore alternate avenues to useful reference material.

When your search begins producing predominantly redundant or useless results, you know you have reached a critical mass. If at this point there are still questions, you may need to contact a colleague. Other medical illustrators can be an extremely valuable resource of material, references, or advice, and the importance of networking with peers cannot be overemphasized. However, tap this source sparingly and make a point of not becoming an annoyance or appearing less than competent among your peers. Based on the references accumulated, begin to plan various options for conveying the message effectively.

The Workflow

How do you translate a mental model and a collection of references into an effective illustration? There must obviously be a systematic framework in place to ensure that the project goes forward in a linear fashion. For our purpose, workflow is a logical sequence of steps that begins with an idea (or story) and ends with a medical illustration that expresses that idea (or tells the story). Figure 4.1 depicts a typical workflow algorithm for a medical illustration print media project.

With minor modifications, this basic framework can also be applied to the development of Web content, interactive multimedia, or animation. With a large project such as a book, it is useful to handle sections or chapters as smaller, separate projects. These subunits are managed simultaneously, when possible, allowing parallel progress on the entire project.

Meetings

Meetings with the physician are your main tool for managing the workflow. Use them to monitor progress, introduce new material, solve problems, and establish benchmarks for subsequent stages of the project.

Schedule conflicts, geographical distance, and other obstacles can make it difficult to hold face-to-face meetings. Effective alternatives are e-meetings, via the Internet, video-conferencing, or similar new technologies that enable not only interaction but also collaboration and file transfers. However, this type of communication can be cost prohibitive. As an alternative to an e-meeting, you can correspond via e-mail and attach files for review. This method should be used sparingly, because a lack of face-to-face interaction could potentially dissolve any rapport that may

FIGURE 4.1 Workflow algorithm for a medical illustration print media project.

have been established. E-meetings and e-mail correspondence are best used as adjuncts, not substitutes, for direct face-to-face communication.

Signing on the Dotted Line

The signature of approval is the catalyst that propels the project along the workflow from one stage to the next. Once the physician approves the product, verbal acceptance is not enough. A formal signature of acceptance is the prerequisite to progress into the next phase. This prevents misunderstandings and "moving in circles" through an endless process of

revision. More importantly, the requirement of a signature holds the physician to task and forces a more focused review of the product with close attention to detail. The outcome will be an accurate and effective illustration. In addition, a significant change after approval in a freelance environment is an infringement of the working agreement that translates into additional payment.

Graphite on Paper

Once the initial meeting has taken place and reference material has been collected, it's time to begin translating the assignment into a preliminary sketch. Rendering should be minimal at this stage, to avoid wasted effort. Well-developed surface textures, highlights, detailed shading, and the like should be delayed until preparation for the final phases. Instead of investing effort in detail, focus on arranging the elements in a manner that best tells the story.

Make notations on sketches at various times during the project. To that end, maintain the integrity of the original sketch and make your notations on photocopies. If there are questions or comments for the physician, write them on the copy. In subsequent meetings, answers to questions and other feedback will be written on the same copy. This helps you remember all pertinent questions and recall the answers.

Use templates to expedite your work. Templates may be general or specific, depending on their potential for reuse. A good example of a general template is making copies of sketches that contain anatomical regions or perspectives that can be used again in other illustrations with only minor adaptations. Either photocopy the sketch at that time and file the copy, or file the sketch and continue working from the copy. Sketches of instruments or the surgeon's operating hands are also useful general templates. By working on tracing vellum, these sketches can be repurposed at many angles, and the vellum can be flipped to represent the opposite hand or an instrument from the opposite side. In some instances, a series of sketches can be based on a single specific template. For example, the project may require illustrating a specific surgical approach consisting of a sequence of operative steps that gradually expose an anatomical structure. The incision edges and surrounding anatomy can be established as a template, and subsequent steps can be progressively developed on the same image without redrawing it. See Figure 4.2.

A frequently encountered critical obstacle is when the artist has a question about a sketch that blocks further progress, but the physician is not available to help resolve the issue. In this case, your best move is to sketch the key components or the story as you understand them. The important principle here is to at least make an effort. While the attempt may

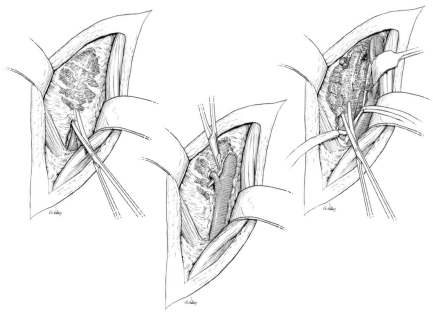

FIGURE 4.2 The three illustrations are part of a larger series depicting progressive steps in a neck dissection for traumatic injury. The series was developed from a specific template comprised of the cut edges of skin and fat, the retractors, and with the anatomy from each preceding step. Illustrations by Scott Weldon created in Adobe Illusrator. © 2004 Reprinted with permission from Baylor College of Medicine).

be wrong, it often provides crucial insight into how the problem should be approached, paves the way for a new approach to thinking about the story, or provides a hint on how to effectively convey the message.

Reworking the Sketch

The dark secret behind every successful and effective illustration is a process of multiple iterations. A basic premise of the creative process is that nobody gets it 100% right the first time. Changes and repeated modifications are not only inevitable but also an inherent part of the project. The need for change is not a sign of failure but a fundamental characteristic of the workflow.

One round of revisions is standard at each phase of a project. Some sketches may require a second revision, and occasionally more. If this is the case, build on the previously established rapport to assure the physician that his corrections are fully understood and will be made to his satisfaction.

Compared to the early planning meetings, a significantly shorter time is required to review a sketch revision. Take advantage of this opportunity to maximize time efficiency and combine the review of other material during each meeting.

The Final Product

Whether the final product is line art for a medical journal or a full-color editorial illustration for a magazine cover, the workflow process is the same. If the previous stages have been managed correctly, revisions should be minor and limited to stylistic or rendering issues. By this point, the story is firmly established and agreed upon. Therefore, any significant change that pops up at this stage merits a closer look to determine the cause, as it often indicates a basic flaw in the process. This flaw or obstacle must be identified and corrected in future projects. One example of a fundamental flaw is serious miscommunication, and steps should be taken to correct it to avoid further problems.

TIME MANAGEMENT

The ability to multitask between various projects while maintaining effective working relationships with physicians and completing each task on target hinges on good time management. To effectively manage your time, you must monitor and document what you are doing. Each aspect of a project should be meticulously recorded on a spreadsheet with appropriate column headings for meetings, research, sketching, revising, and logistical times (such as travel). Keeping track of time spent on the various aspects of a project is also an educational experience. It gives you a solid idea about the amount of work that actually goes into a project, and how different aspects weigh against others in terms of time investment. Gradually, this process will establish realistic time frames that will help you accurately predict deadlines for subsequent projects.

The second principle of effective time management is prioritization. The ability to balance multiple projects requires decisions on a hierarchy of priority among projects. It is a fact of life that some projects take precedent over others. Projects vary in their time-sensitivity and horizon. Be sure you know the real deadline of the project. The physician may want a project completed by a certain date, but the real deadline is two weeks later. So it comes down to want versus need, and whose project takes priority. This is often a political game to be played very carefully. You cannot keep everyone happy all the time, but you may be able to satiate them by setting and achieving intermediate goals. If the rapport is strong, you can be honest about the time burden, and you will often find that the physician is more flexible than you expected. You must communicate with the physician that he is important, but that more time allotted will translate into a better product. Keep track of all ongoing projects and monitor your progress in each.

Remember that the cardinal sin is not meeting a real deadline. When you take on a project, it is implied in the agreement that the project will

meet the deadline. If you may not be able to meet the deadline, don't take on the project. If you do, make sure that, whatever your other commitments are, you meet the real deadline.

Finally, don't forget to expect the unexpected, and build enough slack into your planned timetable to enable you to complete the project despite unforeseen obstacles. For all our planning and relying on past experience to predict future performance, variables inevitably will arise to make life interesting. The list of potential obstacles is long: the physician is not able to respond as often as planned, the revision process gets out of hand, we get sick or have a family emergency. While it is not uncommon for some projects to exceed time expectations, the well-prepared illustrator makes provisions for such contingencies.

CONCLUSION

The key message of this section is that you have to invest as much effort into fostering a good working relationship with a physician as you do in creating the illustration. Establish rapport through good communication from the very beginning, then nurture and develop the communication as needed. Rely on the physician's reference materials, your training and experience, and access to relevant information resources to streamline research and reference collection. Construct and follow a systematic step-by-step framework to manage the workflow of the collaborative project. Good time management will translate into a more efficient and productive partnership.

The benefits of a successful illustrator/physician collaboration are long-term clientele, an enhanced reputation, and sometimes even a personal friendship. The most important aspect of this working relationship is that you are enabling the physician to communicate to the world a story that helps people get better.

SURGICAL ILLUSTRATION

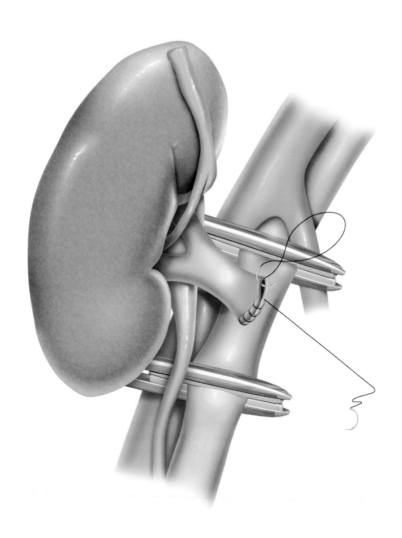

Next to anatomical illustration, surgical illustration is the oldest and most common application in medical illustration. Centuries before photography, artists were recording surgical procedures using woodcuts, copperplates, and lithography. With the advent of the modern offset printing process in the twentieth century, medical artists were free to use most any art technique or medium. Popular media for creating surgical illustration have included painting with airbrushed watercolors and gouache, colored pencils, carbon dust, and cell-vinyl paints, among many others. Today, traditional drawings are often mixed with digital art, as seen in Figure 5.1. However, producing color or continuous tone illustrations can be time consuming and expensive to print, so the most common technique used to create surgical illustrations is pen & ink. Pen & ink illustrations are still popular with medical artists because of their ease of use, and they are popular with publishers because the finished art is inexpensive to reproduce in books. See Figure 5.2.

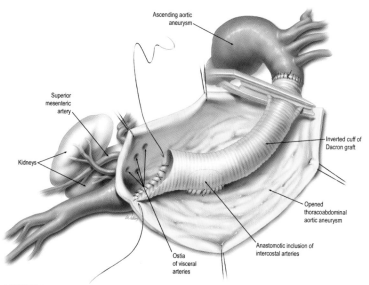

FIGURE 5.1 Surgical illustrations have long been produced with traditional media, but today are often produced with digital media. Surgical technique to manage an aortic aneurysm. Painted with Photoshop by Scott Weldon, after Carol P. Larson. © 2004 Reprinted with permission from Baylor College of Medicine.

The aim of surgical illustration is to teach. Occasionally, a surgical illustration will appear as part of an advertisement in a journal, as part of a journal or book cover design, or one may even creep into mainstream media. However, for the most part, surgical illustrations accompany text in medical books and journals and teaching materials such as lecture

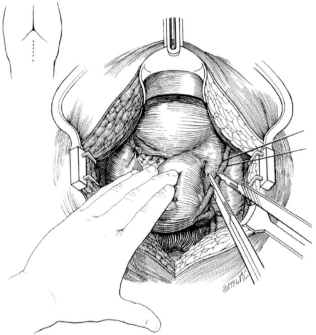

FIGURE 5.2 The most popular and cost-effective method for creating surgical illustrations has been pen & ink. From a series on hysterectomy by Michael Cooley. Pen & Ink. © 2004 Reprinted with permission from Michael Cooley.

slides or surgical instrument manuals. Surgical illustrations instruct healthcare professionals on the clinical use of new surgical instruments, new surgical techniques, and the implantation of new medical devices. Sometimes surgical illustrations are used to help plan the course of a surgical procedure that is about to occur for the first time, sort of a practice run on paper. Other venues in which surgical illustrations appear are medical legal exhibits to educate jurors and patient education materials to help patients understand their healthcare options.

Surgical illustrations are generally simple in design and layout and often very literal in content. Adding elaborate backgrounds, fanciful typography, or special lighting effects would only serve to detract from the focus of the illustrations, which is to teach. However, this does not mean that surgical illustrations have to be boring. In fact, some of the most beautiful medical illustrations are surgical in nature.

Though surgical illustration and surgical photography are both used to depict surgical techniques, illustration is far more capable of creating a self-explanatory picture, because simply copying what is seen in the surgical field is often not adequate for education. The surgical field can often

be cluttered, and the anatomical structures that are of importance during the surgical procedure may be blocked from view by the surgeon's hands, surgical instruments, gauze, or covered with blood, fascia, fat, or other tissues. Thus, the medical artist is required not only to use his imagination to accurately visualize what can't be seen but also to use his skills in draftsmanship and communication and his knowledge of clinical anatomy to selectively emphasize anatomical structures, leave out unnecessary details, and focus on only the important details of the surgery. See Figure 5.3.

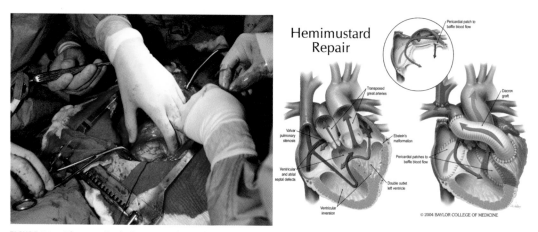

FIGURE 5.3 The surgical photograph on the left is of the same procedure illustrated on the right. You can see that even though the illustration is stylized, it can tell the whole story by itself. Hemimustard Repair by Scott Weldon, painted in Photoshop. © 2004 Reprinted with permission from Baylor College of Medicine.

Programs such as Photoshop, Painter, Illustrator, and Freehand have revolutionized surgical illustration. Today, publishers expect medical artists to deliver high-resolution digital images ready to be dropped into a layout. Though the images may be digital, the actual art does not have to be. For example, an illustrator may create his work with traditional techniques and then scan the artwork, effectively converting it into digital images. However, no matter how careful one is about scanning artwork, the original quality is lost to one generation of copying, then when the art is printed, there is additional quality loss. It is possible to create artwork that compensates for the expected loss of quality during reproduction, but often to avoid this problem many medical artists simply create their art as digital images from the start.

TUTORIAL

RENAL TRANSPLANT

PROJECT OVERVIEW

In this tutorial, we'll use Photoshop to paint a step in a series of surgical illustrations depicting a renal transplant. Surgical illustrations are commonly created in black and white continuous tone or line art, because these techniques are more economical to print. However, occasionally publishers will print full color illustrations in surgical atlases, as is the case with this series of illustrations.

The goal of the series of illustrations is to show the standard surgical techniques used to transplant a donor kidney into the recipient. Specifically, to show the donor kidney placed in the illiac fossa, anastomosed to the external illiac vessels, and the donor ureter implanted using the Leadbetter-Politano technique. See Figure 5.4.

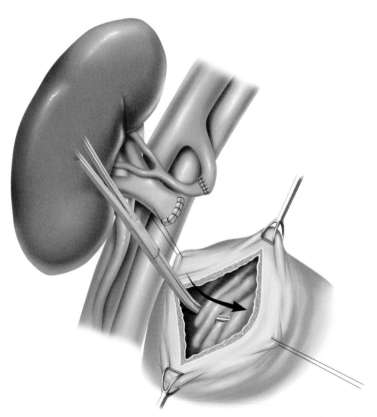

FIGURE 5.4 The goal is to show the common surgical technique for renal transplants.

GATHERING REFERENCE MATERIALS

To ensure accuracy in surgical illustrations, medical artists will often prep for surgery and join the surgeon in the surgical room to photograph or to take notes and sketch during the procedure. Being part of the surgical team is exciting and is the best way to get the information needed to create accurate surgical illustrations. Medical artists who observe surgery are thoroughly trained in the same sterile techniques to which surgeons, nurses, and other surgical personnel adhere.

When observing the surgery is not possible, there are many other methods to carry out the research needed to create the surgical illustrations. The next best thing to being there is talking to someone who has seen the procedure. Speaking to the surgeon before getting started usually yields much of the information needed. Checking with the surgeon during the illustration process ensures accurate illustrations. Other reliable sources of information are surgical film/video, surgical photographs, x-ray photographs, MRI and CT scans, and preoperative and postoperative reports. As a last resort, the medical artist can do some research from other medical books or journals, but simply copying illustrations from other sources creates the possibility of copying errors.

CREATING THE PRELIMINARY SKETCHES

Though the drug treatments that follow renal transplantation to prevent acute or chronic organ rejection are still evolving, the surgical techniques of transplanting the organ itself have long been established. Thus, renal transplantation is routine surgery for end-stage renal disease. Variations in surgical technique depend on many criteria, such as the donor; the donor organ; the recipient's age, anatomy, or disease; and the surgeon. Though transplant surgery is complex and requires a high level of training, skill, and experience from the surgical team, the surgery itself can be broken down into a series of steps. The challenge to the medical artist is to determine which series of steps will most efficiently convey the purpose of the illustrations. It is undesirable and may be impossible to create illustrations for every step of any surgical procedure.

The steps that will be illustrated in the series are: 1) venous anastomosis, 2) arterial anastomosis, and 3) ureteroneocystostomy; tunneling, and 4) ureteroneocystostomy; implantation. The first illustration will incorporate a figure drawing that shows the location of the transplant and the incision. The renal transplant surgery was divided into these steps because they illustrate important milestones in the surgery. However, to keep things moving, the following Photoshop tutorial will focus on the first step of the series.

As with any illustration project, the sketches begin as quick drawings or thumbnails. Gradually, the sketches are refined into more detailed sketches. Most of the information that will be in the final art is determined during the sketch phase. While there is no absolute method for creating the sketches, the idea here is to provide clear, visual information to the client that he can approve or note revisions on before the final art is produced.

Deciding how much of the surgical field, what anatomy, and what instruments are depicted is an important part of the process. In the end, only what is necessary to tell the story is included. Each step in the series of illustrations goes through the same stages of approval. Figure 5.5 shows all four finished panels as sketches that will be used to paint the final art.

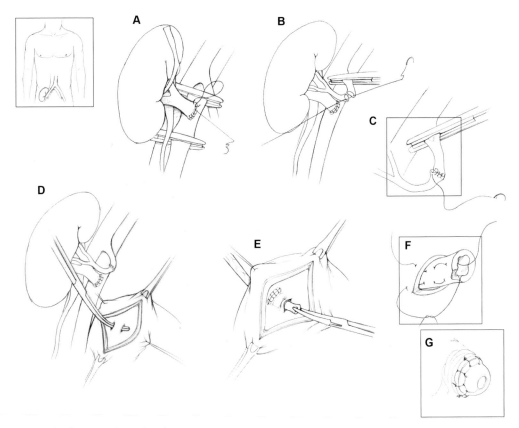

FIGURE 5.5 The four panels as sketches.

PAINTING A SURGICAL ILLUSTRATION

The steps in this process are straightforward; each sketch is scanned and then used as a guide during the painting process. The illustrations will be created at 300 ppi and in RGB color. Each illustration will vary in size but average about 8 x 10 inches. Note that to keep things simple, only the first step in the series will be painted in this tutorial.

This series of illustrations has several elements, such as the kidney and the blood vessels, that are repeated from one illustration to the next. This convenient occurrence makes creating the art much easier and speeds up the project. If these illustrations were being created using traditional illustration techniques, each element would have to be re-created for each step, but because Photoshop is being used, the repetitive elements can be easily copied and reused.

Getting Started

The sketches are used only as guides during the painting process and will not be any part of the final art, so the default settings of your desktop scanner for scanning grayscale photos will work just fine. The only setting that needs attention during scanning is the image resolution, which should be set at 300 ppi.

ON THE CD

1. Open the file renal_tx.psd found in the Chapter 5 folder in the accompanying CD-ROM. This file is empty but has the correct document specs for the tutorial. Next, open the renal_sketch.tif file and drag and drop or copy and paste the sketch from its source document into the renal_tx.psd document. To drag and drop, make sure that both files are visible and simply select the Move tool in the sketch file, click once anywhere, and drag the sketch over the renal_tx.psd window. The scan should now appear in its own layer within the renal_tx.psd document (Figure 5.6).

2. Before using the scanned sketch as a painting guide, it must be prepared so that it will not interfere with the painting process. Select the layer with the scan, choose Adjustments from the Image menu, and then Brightness and Contrast from the submenu. Increase both the Brightness and the Contrast until most of the gray disappears, then set the Mode of the layer to Multiply, as in Figure 5.7. Finally, set the layer opacity to about 65 percent to turn the black lines dim gray.

3. Creating digital paintings using Photoshop brushes is analogous to using a real airbrush. When airbrushing, artists will almost always use some method of masking. Masking allows the artist to control where color is applied and which areas remain covered to protect them from over spray. To accomplish the same thing in Photoshop, paths are used to create selection areas or masks. With the Paths

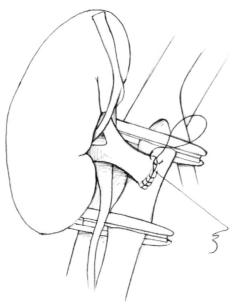

FIGURE 5.6 The sketch placed in the Photoshop document.

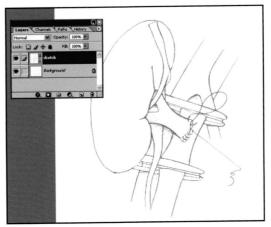

FIGURE 5.7 The sketch is prepared for use as a painting guide.

palette active (Windows:Paths) select the Pen tool from the Toolbox. The Pen tool should be set to Path mode in the Options bar. Create paths around each part of the illustration. For example, create paths for the shape of the kidney, the arteries and veins, and the ureter. Name each path according to what it is outlining. See Figure 5.8. With the paths created, precise selections can be made to manage the

application of color in the selected areas. It is a good idea to practice using the Pen tool, but if you want to skip this step and you are using the renal_tx.psd file, all the paths needed for the illustration are already in the Paths palette.

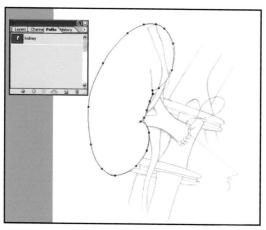

FIGURE 5.8 Using the Pen tool, paths are created for each part of the illustration.

Creating Layer Sets and Painting

Now that the prep work is complete, painting the illustration is easier and faster. The next steps cover using selections created from paths, layers, stock Photoshop brushes, and filters to apply colors and effects to complete the kidney. Photoshop layers allow absolute control over where colors are applied and how they appear. Layers also help keep elements of the illustration separate so that adjustments, effects, or experimentation can be applied to part of the illustration without affecting the whole illustration.

Layers keep the base color, shadows, highlights, and sometimes textures of each element separate. For example, the kidney, arteries, veins, and ureter will each have their own set of layers. By keeping the color, shadows, and highlights separate, the final appearance of each element can be precisely controlled. However, having numerous layers in the Layers palette can get confusing so from the start we'll use Layer sets to keep the layers logically organized. Before moving on to the next step, save the file.

1. Create a new Layer set (Layer:New:Layer Set) and name it Kidney. Now within the Layer set, create three new layers called kidney base, kidney dark, and kidney highlight. Create the layers in the order listed so that the base color is at the bottom, the shadow layer is in the middle, and the highlights are on top, as seen in Figure 5.9.

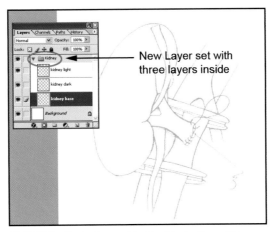

New Layer set with
three layers inside

FIGURE 5.9 Each element in the illustration will have
its own set of layers to help keep things organized
and easy to revise.

2. To create a selection around the kidney based on the Kidney path
 switch to the Paths palette and click once on the path's icon or name
 while pressing on the Ctrl key (Command). Alternatively, you can
 press the Load path as selection button at the bottom of the Paths
 palette (red circle). See Figure 5.10.

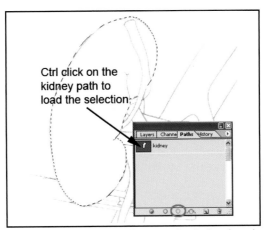

Ctrl click on the
kidney path to
load the selection.

FIGURE 5.10 The kidney selection is loaded and ready.

3. Switch back to the Layers palette and make sure the kidney base
 layer is the active layer (if you are not sure, click on it). Now open the
 Color Picker for the foreground color and select a very warm gray, al-
 most light brown (for example, R175, G129, B113) and fill (Edit:Fill)

the selection. See Figure 5.11. Gray or brown are not very lively colors, but the truth is that until the donor kidney has blood flowing through it once more, it is a drab color, and the warm gray color will indicate this fact nicely. Color is often used to indicate different tissues, before and after conditions, diseases, or diagnoses, or to focus attention on a specific element in the illustration.

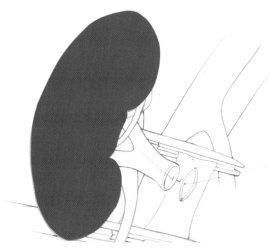

FIGURE 5.11 The base color for the kidney is a warm gray, which helps to indicate that there is no blood flowing through it.

4. The lighting for illustration comes from a strong light in the upper-left corner and a weaker fill light in the middle right, creating sharp highlights and soft shadows. The three-dimensional shape of the kidney will gradually emerge as the shadows and highlights are painted. In the Color Picker, choose a cooler, darker version of the warm gray color (in the R103, G66, B55 range). Select the Brush tool, and from the Brushes Preset Picker, choose any soft round brush. In the Option bar, leave the Mode as Normal, set the brush opacity to about 40 percent, and activate the airbrush mode by clicking on the Airbrush icon in the Options bar. If you are using a drawing tablet, open the Brushes palette and make sure that Shape Dynamics and Other Dynamics are checked and that the Control is set to Pen Pressure, as seen in Figure 5.12. Selecting Pen Pressure will allow you to better control the size and amount of paint each brushstroke applies.

5. Kidneys are cylindrical in shape, so keep that in mind while painting. With a soft round brush selected, press the right bracket key to increase the brush tip size to about 120 pixels. (The left bracket key decreases the brush tip size.) In the kidney dark layer, start painting

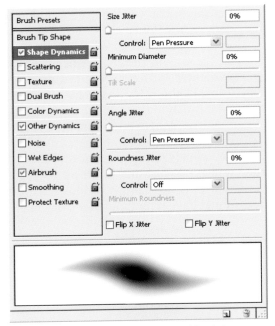

FIGURE 5.12 When using a drawing tablet, it is important to set the brush properties correctly.

around the edges to create a smooth blend between the shadow color and the base color. See Figure 5.13. The shadows don't have to be created in a single stroke; you can slowly build up the values with

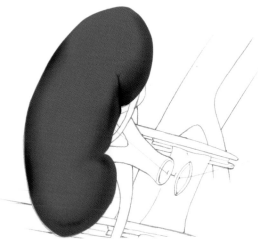

FIGURE 5.13 The dark colors and shadows are gradually painted in their own layer.

several strokes. Use your judgment and artistic license to determine how dark or how much shadow you want to create. Notice that the shadows around the right edge and bottom of the kidney don't extend all the way to the edge. This is because a reflected light effect will be painted in these areas to complete the illusion of a three-dimensional kidney. Use the Erase tool set to about the same properties as the Brush tool to remove any over spray.

6. When you are done with the shadows, switch to the highlight layer. Select a lighter version of the base color and start to paint the lighter areas to emphasize the roundness of the kidney. Gradually build up the highlight colors, and finish by adding almost pure white brush strokes with a small brush to indicate the highlights. At this point, you should have something that looks like Figure 5.14.

FIGURE 5.14 The basic kidney with some darks and lights painted.

7. While the kidney looks three dimensional, it's a bit stiff, which is a common problem with computer-generated art. The quickest way to fix this is to use a Photoshop filter to add randomness. Create a copy of the kidney base color layer and move it above the kidney highlight layer. Next, from the Filter menu choose Artistic and then Sponge. Set the Sponge filter properties to a small brush, and midrange Definition and Smoothness, then press OK. The Sponge filter will create mottled texture. The filter effect will look funny at first. To complete the effect, knock back the filter by setting the layer mode to Overlay and the opacity to 35 percent. This will blend the base color, shadows, and highlights with the texture, as in Figure 5.15. Experiment

with the layer and filter properties to get the look you want. The texture is added not just to give the illustration a more natural look, but because the texture of a real kidney is not perfectly smooth. As the rest of the illustration progresses, the kidney will be revisited to make adjustments. While in any type of illustration you have some range

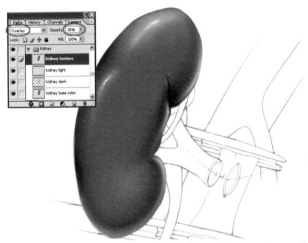

FIGURE 5.15 The Sponge filter breaks up the smoothness of the kidney and gives the kidney a more natural appearance. Then the layer that has the Sponge filter effect is set to an opacity of 35 percent and to Overlay mode.

of artistic license, that range is a bit narrower with surgical illustration, because the goal is education, not decoration.

The techniques used in painting the kidney will be reused in painting the rest of the illustration. Each anatomical part, such as the veins and arteries, will have paths that outline them, the paths will be used to create selections, and finally each section will be painted in layers.

Painting the Blood Vessels and the Ureter

The renal vein, artery, and ureter of the donor kidney are painted next. Notice that in this illustration, the renal artery is reflected, or flipped over, so that there is a clear view of what is underneath. To emphasize the fact that the kidney is not anastomosed to the recipient's circulatory system, the renal artery and vein will be painted with more neutral colors compared to the colors of the recipient's blood vessels. The donor kidney is usually harvested with a layer of fat that completely surrounds the

renal blood vessels and the base of the ureter. In this illustration, that fat is omitted to give the clear view of the anatomy.

1. Create a new layer set and then the layers, Renal vein base color, Renal vein dark, and Renal vein highlight. While it may seem like overkill to use three layers, in the long run it will be easier and faster to make the inevitable corrections and revisions. Next, locate the Renal vein path in the Paths palette and make a selection. With the Renal vein base color layer active, fill the vein selection with a tan color (R220, G150, B120), as in Figure 5.16a.

2. After the selection is filled in its own layer, select a large soft round brush, adjust the brush opacity to about 30 percent, and build up the shadow colors of the renal vein. The renal vein is cylindrical in shape, but with no blood in it, it is somewhat flattened. See Figure 5.16b. Switch to the Renal vein light layer and with a lighter version of the base color, start to build up the light and highlight areas. The renal vein has to reach down to the iliac vein so it curves down; this is indicated with the highlights. See Figure 5.16c. Note that the kidney is now casting a shadow onto the renal vein. As you begin to add more structures, keep in mind that shadows are going to become an important element in creating a realistic illustration.

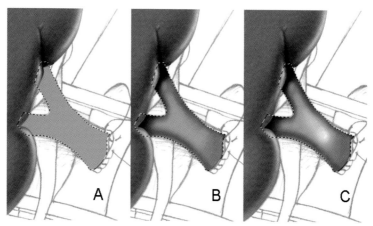

FIGURE 5.16 a) Fill the renal vein with a base color. b) Paint the dark colors and shadows in their own layer. c) Add highlights.

3. In this illustration, the donor renal vein is shown in the process of being sutured to the recipient's iliac vein. Part of the renal vein is shown already sutured, and roughly half of it is shown still to be sutured. See Figure 5.17. Painting the vein in the process of being sutured adds interest and movement to the illustration. One of the things that a medical artist has to understand is what type of sutures are used in the surgical procedure being illustrated. Each type of suture leaves a distinctive pattern in the tissues themselves, much like

different types of stitching leave different patterns in cloth material. In the case of the venous anastomosis, the renal vein is sutured to the iliac vein with two continuous sutures, one on each side.

Sutures

FIGURE 5.17 The sketch shows the renal vein in the process of being sutured.

4. When continuous sutures run through tissues, they create a running "pucker" on each edge being sutured. This is easily illustrated by painting what looks like little balls running along the edge of the tissues being sutured. The dark side of the pucker is painted in the renal vein dark layer and the light side or highlights are painted in the renal vein light layer, as seen in Figure 5.18. This will look funny

FIGURE 5.18 The effects of the continuous suture are represented as little balls or puckers along the edge of the suture line.

without the puckers along the iliac vein edge and the sutures, but it will come together when everything is painted.

5. The renal artery and the ureter are painted in the same way as the renal vein. However, the renal artery is a slightly warmer and redder color than the renal vein, and the ureter is a yellow color. See Figure 5.19. In reality, however, the ureter is not yellow, nor are the veins and arteries blue or red, and tissues that are drained of blood are generally a drab color and may even become partially transparent. Medical artists sometimes use an accepted color palette to illustrate different tissue types. For example, arterial blood is red; venous blood is blue or purple; nerves are yellow or white; livers, kidneys, and spleens are dark brown; and gastrointestinal organs are pink, bone white, or warm tan. These colors help to differentiate tissues, making illustrations consistent and easier to understand.

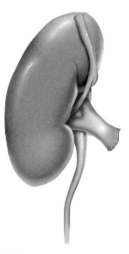

FIGURE 5.19 The renal artery
and the ureter are painted in
the same way as the renal vein.

6. The external iliac artery and vein are the only blood vessels left to paint. Usually arteries are illustrated as a very saturated red, but for this illustration, a lighter red is used. The color variation gives this illustration a distinctive look. Fill the iliac artery with a pastel red—almost salmon—to start its painting process. As with the structures painted thus far, the iliac artery will have a layer set with a dark layer and a highlight layer. One particular characteristic of arteries is that after a split (or bifurcation) occurs, the artery downstream of the bifurcation is smaller. In this case, the external iliac artery has the hypogastric artery split off from the medial side, so the iliac artery downstream of the hypogastric is smaller (it may be hard to notice

because in the finished illustration the iliac artery is behind the iliac vein). See Figure 5.20.

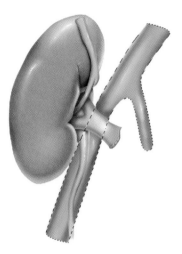

FIGURE 5.20 The painted iliac artery.

7. The external iliac vein is a bit more work to paint, because it is clamped in two places. The clamps temporarily cut off blood flow so that the surgeon can work in the area. The iliac vein naturally sits behind the iliac artery, but in this illustration, it has been dissected and brought forward. To paint the vein, three different paths were created, one for each section. However, all three paths were made into one selection and painted at the same time using the multiple layer technique. See Figure 5.21. The base color for the vein is not the typical

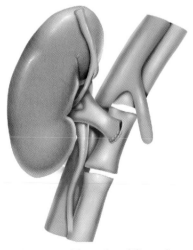

FIGURE 5.21 The painted iliac vein.

blue seen in many medical illustrations, but a pastel blue or warm purple. Note that the clamped areas have been painted to show the tension and bulging at the clamps.

8. To complete the iliac vein, create the suture "puckers" on the cut edge of the iliac vein, next to the end of the renal vein, as seen in Figure 5.22. This will all come together when the sutures are added.

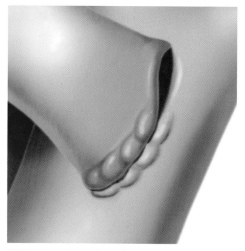

FIGURE 5.22 Paint the tell-tale puckers created by the sutures where the iliac vein is sutured to the renal vein.

9. Once the blood vessels are painted, make sure all the shadows are added. For example, the renal vein casts shadows on the ureter and the iliac vessels. Adding shadows gives the entire illustration depth, which makes it more realistic and interesting, as seen in Figure 5.23. Having separate layers for each structure now pays off, because adding the shadows, sometimes in between structures, is easily accomplished.

Painting the blood vessels is a straightforward process. Each blood vessel has a path that is used to create a selection area. The selection area masks off the illustration so that only that area will accept brushstrokes. Several layers are then used to manage the different colors of each blood vessel. This is not the only way to paint illustrations in Photoshop as will be shown in other chapters, but it is very effective in keeping things organized and simplifying future revisions.

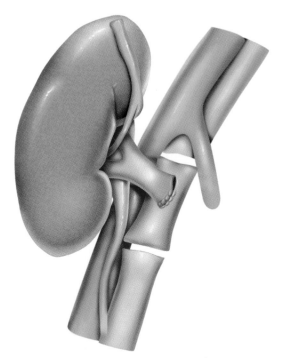

FIGURE 5.23 Add cast shadows to give the illustration depth.

Adding the Clamps and Sutures

Sometimes surgeons have different preferences for the instruments they use. The clamps shown in this illustration are standard padded vascular clamps. The clamps' metallic surface is easily painted with Photoshop's soft round brushes. All other layers are hidden while painting the clamps so it is easy to focus. After some time of producing medical illustrations, artists often have a collection of actual surgical instruments that can be used as reference for an illustration.

1. Create a new layer for the clamp. The outline of the clamp is created with paths, from which a selection is made, and then the selection is filled with the blue-gray base color (R150, G160, B180). See Figure 5.24. The clamps are straight (horizontal) while they are being painted, because it is easier to make brush strokes from left to right than at angles.

FIGURE 5.24 The clamp starts out as a filled selection.

2. Figure 5.25 shows the metal highlights. The white highlights are painted with a soft round brush. To get the variation in opacity and thickness, open the Brush Preset palette and turn on Shape Dynamics and Other Dynamics. In the Other Dynamics option, increase the Opacity Jitter to about 40 percent and set the menu to Pen Pressure. Alternatively, you can adjust the brush Opacity in the Options bar. The strongest highlights are at the corners, and the rest are wispy brush strokes that will become part of the reflections.

FIGURE 5.25 The highlights are painted with a soft round brush.

3. Next, the dark reflections are painted with the same brush. The color is a darker version of the base color. The dark reflections generally fall in between the highlights and follow the same direction. To add a little interest, set the Foreground color to maroon red and lower the brush's Opacity to about 20 percent. Then paint a few red brush strokes to simulate the reflection of the surrounding tissues. See Figure 5.26.

FIGURE 5.26 The dark reflections are dark blue, but there is some red mixed in to simulate the reflections of the surrounding tissues.

4. The pads are created using the same techniques we have practiced so far. First, a selection is made and then filled, this time with beige (R220, G215, B200). See Figure 5.27.

FIGURE 5.27 The pads are filled with beige.

5. To complete the pad, add shadows and highlights, as in Figure 5.28.

FIGURE 5.28 Pad details are painted.

6. Finally, position the newly painted clamp in the sketch using the Transform tool to rotate and move. The clamp's layer should be above the layers for the iliac vein. At first, the clamp won't look correct because it overlaps the vein. To fix the overlap, we'll mask, or hide, part of the clamp with a Layer mask. Layer masks are extremely useful in compositing images together. To apply a Layer mask, make sure that the clamp layer is selected and, from the Layer menu, select Add Layer Mask and choose Reveal All from the submenu. Note that a new white square appears next to the layer thumbnail. The small square is called the Layer Mask thumbnail. Click once on the Layer Mask thumbnail; notice that the Foreground and Background colors are reset to black and white. In the Layer Mask thumbnail, you can only paint with black or white. Black hides pixels and white reveals them. While the Layer Mask thumbnail is active, select a small, hard round brush and paint over the area of the clamp that is over the vein. It should begin to disappear. See Figure 5.29.

7. To create the second clamp, make a copy of the first clamp by right-clicking on the first clamp's layer and choosing Duplicate Layer from the pop-up menu. Move the second clamp into position and use a Layer mask to hide the part that overlaps the vein.

We'll get Photoshop to do most of the work in painting the sutures, because drawing them one by one and getting them to look straight and smooth can be difficult. Drawing a smooth thin line with a drawing tablet can be difficult enough, so don't even try it with a mouse. The trick here is to create the sutures using the Stroke Path command from the Paths palette.

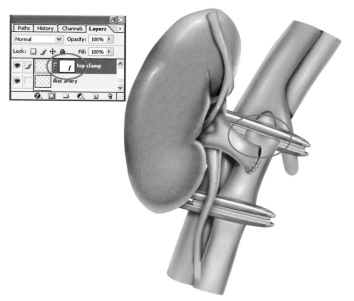

FIGURE 5.29 The new clamp is moved into position, and a Layer mask is used to place the part of the clamp that overlaps the vein.

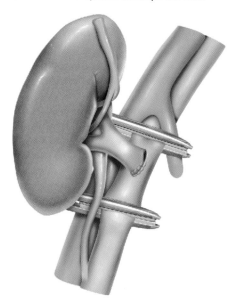

FIGURE 5.30 The vascular clamps in place.

1. With the Pen tool, trace each suture. Make sure that all sutures are one path. See Figure 5.31. Name the new work path "sutures."
2. Create a new layer also named "sutures," make it active, and make sure it is above the layers that contain the rest of the anatomy.

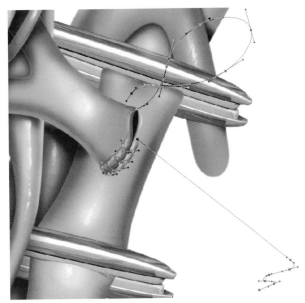

FIGURE 5.31 Outline the sutures on one path with the Pen
tool.

Switch back to the Paths palette and click once on the sutures paths.
Don't create a selection; just make the paths visible, as in Figure 5.31.

3. Set the size of the Brush tool to about 4 pixels, set the brush opacity
 to 100 percent, and make the Foreground color black. Back in the
 Paths palette, choose Stroke Path from the Paths fly-out menu. See
 Figure 5.32. From the Stroke Path dialog box, choose Brush and click
 OK. Figure 5.33 shows that Photoshop automatically strokes each
 path perfectly.

FIGURE 5.32 The Stroke Path command from the
Paths palette.

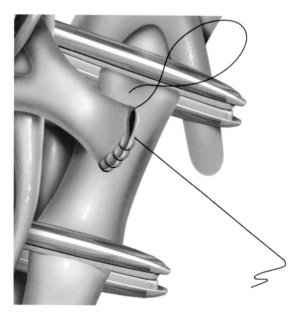

FIGURE 5.33 The Stroke Path command automatically paints perfect sutures.

4. The surgical needles are very small in this illustration. Each needle starts by having a path created with the Pen tool, and the entire needle is painted in one layer, as in Figure 5.34. In actual surgery, the

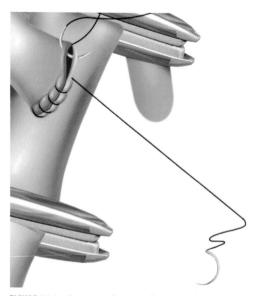

FIGURE 5.34 Because the needles are very small, they are painted on one layer.

needles are passed through the tissues using a needle holder, because the needles are often too fine to be held with the fingers. In this illustration the needle holder has been omitted to keep things clear.

5. This illustration does not show the anatomical start or end of the iliac vessels or where the ureter ends; that information is not the focus of this step in the series. But the abrupt ending of the iliac vessels and the ureter makes it seem as though the whole structure is disembodied. To fix this problem, the vessels and the ureter will fade into the background. Fading structures at the ends implies that they continue but are not shown in their entirety in the illustration. Photoshop has several tools that work nicely to fade the structures; for example, the Layer Mask command, but because the Layer Mask tool works only one layer at a time and the illustration has many layers, this isn't very efficient unless most layers are flattened. In this case, however, a new layer is created above all the anatomy, then a large soft round brush loaded with pure white is used to simulate the fade.

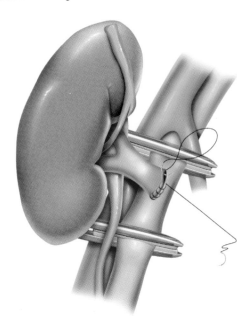

FIGURE 5.35 The vessels and the ureter are faded into the background with a soft round brush.

Painting the Figure Inset and Adding Labels

The only thing left to do is add the inset that shows the location of the transplant and the initial incision. To accommodate the figure inset, use the Image:Canvas Size command to add space to the left side of the canvas. An

additional 3.5 inches or so should be enough. The figure inset is created much the same way as the rest of the illustrations. The figure is traced with paths; each path is then used to create a selection, which is then painted. The figure is filled with a base flesh color, and then highlights and shadows are added very quickly with loose brush strokes. Since the figure inset is not the main focus of the illustration its colors are not as saturated. The box, created with the Edit:Stroke command, helps to set the inset apart from the surgical illustration. See Figure 5.36.

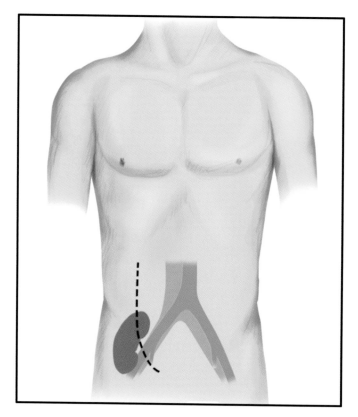

FIGURE 5.36 The figure is painted with quick brushstrokes and with softer colors since it is not the focus of the illustration.

Often labels and call-out lines or leader lines are added by the publisher's layout artist once the illustrations are placed in the book layout. However, in this case, the labels and call-out lines will be added with Photoshop. If the publisher wants the labels added during the illustration process, they will provide guidelines as to acceptable font faces and sizes. In this illustration, the font is Arial and the size is 15 points. Adobe has

improved the Text tool in Photoshop CS so that it is easy to use and very similar to text tools in other graphics programs and word processors. Note that each string of text created in Photoshop is placed in its own layer. The call-out lines are drawn in their own layer using the Line tool, which draws perfectly straight lines. Once the Line tool is selected, in the Options bar, set the Width to about 4 pixels and make sure that the Fill Pixels option is on. See Figure 5.37.

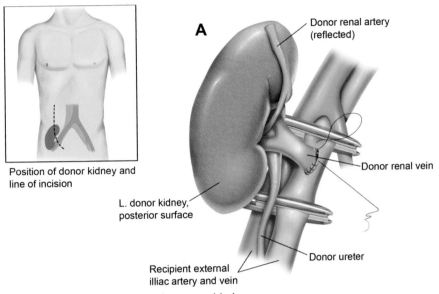

Position of donor kidney and line of incision

A

Donor renal artery (reflected)

Donor renal vein

L. donor kidney, posterior surface

Donor ureter

Recipient external illiac artery and vein

FIGURE 5.37 Labels and call-out lines are added.

Once the anatomy has been labeled, as in step A, it is not necessary to keep repeating the same labels over and over in subsequent illustrations. Only when new content is shown does it need to be labeled. Add labels only as needed; too many labels or leader lines will clutter up the illustration. Remember that the illustrations are part of a chapter that also explains what is in each illustration.

CREATING THE REST OF THE ILLUSTRATIONS IN THE SERIES

The rest of the illustrations in this series share common elements and painting techniques with the first illustration. For example, step A in illustration 1 and steps B and D in illustrations 2 and 3 all share the kidney, renal blood vessels, ureter, and the iliac blood vessels. So there is no point in painting the same thing twice. With Photoshop, it's simple to copy the common elements and make revisions instead of starting from scratch.

Each illustration contains new information, so there are new elements to be created.

Painting the Second Illustration

The second illustration shows the arterial anastomosis; in other words, the suturing of the donor renal artery with the recipient's hypogastric artery. With some variations, the second illustration shares many elements with the first illustration. Step B depicts the entire surgical scene; the venous anastomosis is shown completely and the arterial anastomosis is about to begin. The inset emphasizes the focus of the illustration and shows the arterial anastomosis almost completed, as seen in Figure 5.38.

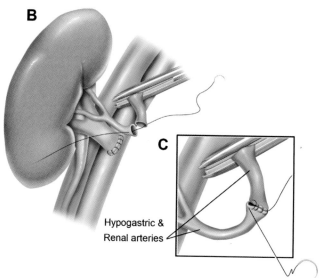

Hypogastric &
Renal arteries

FIGURE 5.38 The second illustration is very similar to the first but focuses on the arterial anastomosis.

Painting the Third Illustration

The third illustration, step D, shows the donor kidney completely anastomosed to the recipient's blood vessels and the start of the ureteroneocystostomy, in other words, the implantation of the donor ureter to the recipient's urinary bladder. In the third illustration, the kidney is shown with its normal color, because circulation has been restored. The renal artery and vein are also the same color as the recipient's iliac artery and vein.

The recipient's bladder is shown with an incision at the apex that is being retracted with Babcock forceps and sutures. The forceps create a tunnel under the bladder mucosa via blunt dissection. The bladder itself is shown with its serosa (top most layer) intact. Often the bladder is illustrated without the serosa, revealing its muscular layer. The bladder is painted a warm-beige color to distinguish it from the other anatomy. See Figure 5.39.

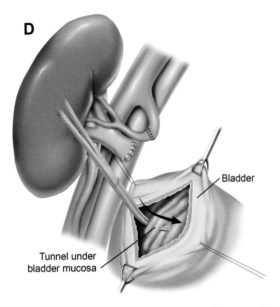

FIGURE 5.39 The third illustration shows the start of the ureter implantation process.

Painting the Fourth Illustration

This illustration shows the last steps in the ureteroneocystostomy, namely the donor ureter is shown being pulled through the mucosal tunnel in step E. Steps F and G show the tip of the ureter as it is anchored to the bladder mucosa. The tip of the ureter is tacked down using interrupted sutures. Of course, there is much more to the surgical procedure, for example, the bladder incision and the main incision is sutured closed, but those steps, and others not shown throughout the series, are in essence assumed by the reader and do not need to be illustrated.

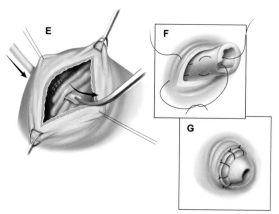

FIGURE 5.40 The fourth and last illustration shows the final steps in implanting the ureter.

Conclusion

Throughout the centuries, the aim of surgical illustration has always been education. Though some aspects in the process of creating surgical illustrations have not changed, such as doing research to assure accuracy, the methods used to create surgical illustrations have drastically changed, especially in the last 10 years. Today, publishers expect surgical illustrations to be delivered in a digital format ready to be placed in design and layout programs like QuarkXPress. In response, many medical artists today have put aside their traditional tools and now use programs like Photoshop to create digital artwork from scratch. See Figure 5.41.

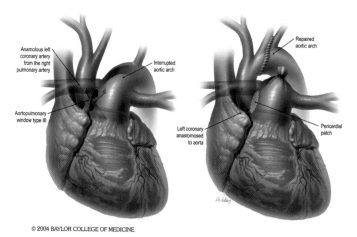

© 2004 BAYLOR COLLEGE OF MEDICINE

FIGURE 5.41 Digital paintings have become the preferred method for delivering artwork. Repair of multiple congenital heart defects by Scott Weldon. Painted in Photoshop. © 2004 Reprinted with permission from Baylor College of Medicine.

6

EDITORIAL MEDICAL ILLUSTRATION

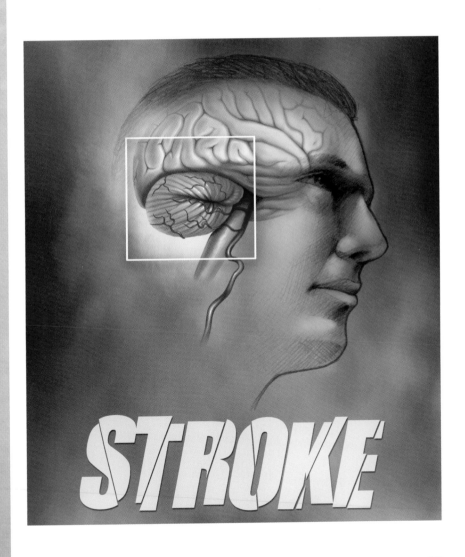

INTRODUCTION TO EDITORIAL MEDICAL ILLUSTRATION

Traditionally, medical illustration is produced for instructional purposes like textbooks or academic journals. However, editorial illustration has brought medical illustration out of academics and into the public eye. Editorial illustration encompasses a wide range of types of art, from cartoons to highly detailed illustrations to abstract and conceptual art. However, the common thread running through all editorial illustration is that it makes a point by visually summarizing the content of a publication or article. For example, a journal cover illustration might recap the content of the main article for that issue, or a book cover illustration might elaborate on the subject of the book. However, to most artists, art directors, and editors, editorial illustrations are generally the illustrations that accompany a news or informational article and are not necessarily instructional. In addition to summarizing content, editorial illustrations are designed to grab and focus the attention of the reader. Sometimes editorial cover art is aimed at getting the reader to purchase the periodical. See Figure 6.1.

FIGURE 6.1 Osteoporosis by Spencer Phippen. © 2004 Reprinted with permission from R. Spencer Phippen.

Medical illustrations that are editorial in nature adhere to the same conventions as any other medical illustration, so accuracy remains the most important aspect of the illustration. However, the design aspect of editorial illustration becomes an important element, as editors are frequently looking for an illustration that is not only educational and accurate but also eye-catching. As such, medical artists are free to design illustrations that incorporate interesting lighting effects, dramatic color combinations, textures, unique layouts and rendering techniques, remarkable camera angles, new mix-media techniques, and even typographical elements.

TUTORIAL CEREBELLAR STROKE

PROJECT OVERVIEW

The goal of this project is to create a color editorial illustration to accompany an article on cerebellar strokes. Unlike other types of stroke that may be brought about by age or disease, cerebellar strokes are usually caused by injury to the vertebral artery. The article will be published in a lay periodical, so the audience will be the general public. The challenge here is to create an illustration that can be easily understood and grab the attention of the audience while still maintaining scientific accuracy.

GATHERING REFERENCE MATERIALS

It is always important to make sure that the content of the illustration is accurate. Often, medical artists rely on anatomy books and atlases to do basic anatomical checking. For this illustration, all the information needed to produce an accurate illustration can be found in a trusted anatomy book. *Clemente's Anatomy, A Regional Atlas of the Human Body*, was used to work out the anatomical details of the illustration.

DEVELOPING A DESIGN

Medical artists are not only skilled illustrators, but when working with art directors and graphic designers to create editorial illustrations, they must also be capable designers. The editorial illustration in this project will be used as the main graphic in the opening pages of an article. The first step is to sketch out possible design ideas for the illustration. The cerebellum is visible from a straight lateral view, but since it is tucked under the cerebrum, rotating the entire brain gives the reader a better view and also provides a dynamic element to the composition. See the initial sketch in

Figure 6.2. The accompanying figure of a male head has also been rotated to match. With the position of the figure and anatomy resolved, the sketches become progressively more refined as the details are worked out.

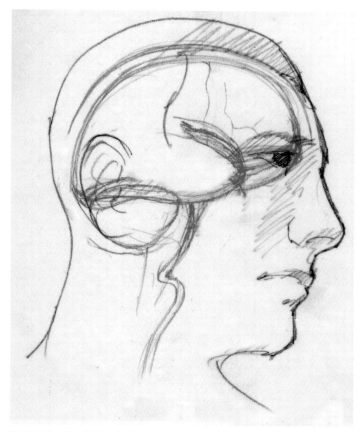

FIGURE 6.2 The initial design idea is sketched out.

The final sketch is usually a detailed drawing that can be used for final approval and will eventually be scanned as a guide for the digital painting. The final sketch indicates all the anatomical information that will be included in the final art and may also show the general lighting and color scheme. See Figure 6.3.

Often, art directors will require a color sketch that shows the general color scheme, texture, and lighting of the illustration. With Photoshop, it's very simple to quickly colorize the sketch to create a more finished look, as in Figure 6.4.

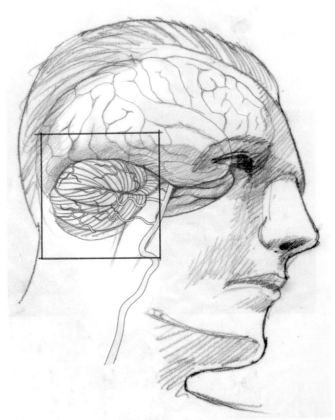

FIGURE 6.3 The details of the illustration and design are worked out with sketches. The point of view has changed so that the reader is viewing the brain from a more dramatic angle.

FREEHAND PAINTING

Once the illustration design has been approved, it's time to get started with the final art. This illustration is composed of three main elements: the anatomy of the brain and vertebral artery, the sketch of the figure, and the background. The cerebellum and its blood supply are the focus of the illustration, so all the elements must work together to draw the viewer to that area of interest.

Most illustrators working in Photoshop use selection areas and masks to control or limit the areas to be painted, as in the tutorial in Chapter 5. In this case, however, a less constrained approach will be used to create

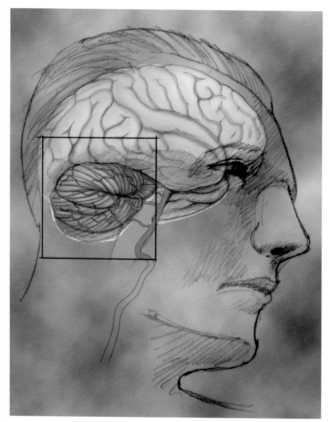

FIGURE 6.4 Quickly working out a general color and lighting scheme helps the art director to get a good idea of what the final art will look like.

the illustration. The anatomy of the cerebrum and cerebellum will be created by freely painting over the sketch without the use of selections or masks. A single layer above the sketch will be used for the painting. In traditional media, this would be similar to using regular brushes, rather than masks and an airbrush. However, there is no point in using Photoshop if we are not going to "cheat" just a little bit. Though we will not use selections or masks, we will use a handy Layer option called Lock Transparent Pixels, which will allow freehand painting but with a "safety net."

A Short Lesson in Brain Anatomy

Before getting started on the brain painting, a short lesson in the surface anatomy of the brain is in order. The human brain (and that of most other mammals) is composed primarily of the cerebrum. The cerebrum is the large, convoluted mass referred to as "gray matter" (it's not really gray)

that everyone easily recognizes as the "brain." The surface of the cerebrum is composed of folds. A gyrus (gyri plural) is the visible part of the fold in the cerebrum and a sulcus (sulci plural) is the groove created by the fold. The cerebrum is further divided into distinct areas, called lobes, by very deep sulci, called fissures. The deepest and most pronounced fissure divides the left and right hemispheres of the brain. See Figure 6.5.

Though the folds of the brain are unique to each individual, there is a general pattern to which normal gyri and sulci conform. Anyone that is trained in anatomy would easily recognize an anatomically incorrect brain, so it's important not to make up imaginary gyri and sulci. Though the cerebrum is not the focus of the illustration, it is still an important design element because it serves as a landmark, letting the reader know he is looking at the brain.

Visible directly underneath the cerebrum are the pons and the medulla oblongata, which are collectively known as the brain stem. The brain stem is included in the illustration as a landmark for the reader. The focus of the illustration is the cerebellum, which is smaller than the cerebrum and is located below the cerebrum and behind the brain stem. Like the cerebrum, the cerebellum is composed of two hemispheres, lobes, and folds. But in the cerebellum the folds, or folia, are much thinner. The folia are arranged in a distinctive pattern, albeit with some room for individual variation.

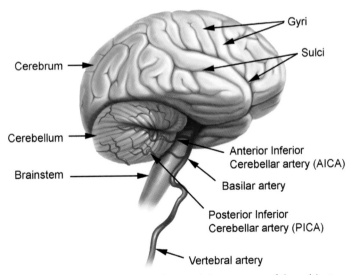

FIGURE 6.5 It is important to understand the anatomy of the subject in the illustration.

The anatomy of the brain and surrounding structures is exceptionally complex. For the sake of clarity, only those features that are necessary for orientation and understanding of the content of the article are included.

PAINTING THE CEREBRUM AND CEREBELLUM

We'll paint the brain and its anatomy first. In this section we'll just paint freehand.

ON THE CD

1. Open the stroke.psd file in the Chapter 6 folder on the accompanying CD-ROM. Note that the sketch has the brain anatomy, but the arteries have been omitted. Sometimes it is easier to isolate parts of the illustration, create them separately, and then bring it all together. Create a new layer below the sketch layer; this is where most of the painting will be done. Set the Blending mode of the sketch layer to Multiply and adjust the Layer Opacity to about 20 percent. This will allow the sketch to be used as a guide, but it will not interfere too much with the painting process.

2. In most medical illustrations, the living brain is represented with colors that range from reddish-tan to red-pink, beige, or even very light warm gray. However, the surface of the brain is more than just one color. Like skin, the brain surface is translucent, opaque, reflective, and of course, three dimensional, all of which create a large range of colors. As a starting point, we will make the base brain color pinkish tan, almost flesh color. Open the Color Picker and set the Foreground color to R252, G215, B202. Then block in the base brain color with a large, hard round brush set to 100 percent opacity. A hard edge brush is used because we want the edges of the brain to be well defined, and a soft round brush would create fuzzy edges. See Figure 6.6.

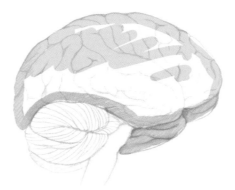

FIGURE 6.6 The illustration of the brain is started by carefully blocking in the base color.

3. Now that the base color is filled in, we'll use the Lock Transparent Pixels feature of the Layers palette to control where paint is applied. In the Layers palette make the brain layer active and press the Lock Transparent Pixels button to turn it on. The Lock Transparent Pixels

option locks down all transparent pixels so that they cannot be painted and allows color to be applied only to pixels that are non-transparent or have a fill. The Lock Transparent Pixels option creates a type of pseudo-mask without having to use selections. See Figure 6.7.

FIGURE 6.7 The Lock Transparent Pixels option helps to control where paint is applied.

4. The lighting in the illustration comes from a strong light in the upper-right corner and weaker fill light from the lower center, so keep that in mind while applying the shadows and, later on, the highlights. The dark color is just a darker version of the brain base color. There is no exact color formula here, because as the painting progresses, the color values will build up and blend into each other. You can try R180, G100, B80 as a starting point for the dark color. Switch to a soft round brush, about 25 pixels in size and 40 percent opacity. Start by carefully tracing the sulci (the lines in the brain) and then gradually fade the brush strokes toward the center of the gyri, as in Figure 6.8.

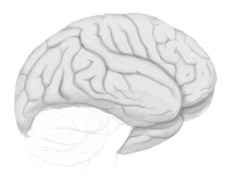

FIGURE 6.8 Start by tracing the sulci with a dark brush.

5. The light or highlight color is, you guessed it, a lighter version of the base brain color; R250, G230, B230 is a good approximation. Sharper highlights are almost pure white. As explained earlier, the surface of the brain is a complex arrangement of folds, but generally speaking, the folds are not perfectly round. In fact, they tend to be somewhat flattened, because they are pressed up against the skull (though the brain never comes in direct contact with the skull). So the light color has to be applied in broad swatches to indicate the flattened character-istic. Use a large soft round brush with a brush opacity of about 20 per-cent. See Figure 6.9. Since no masks or selection areas are being used during the painting process, use the Eraser tool to clean up any acci-dental over spray. The Eraser can be used at 100 percent opacity to to-tally remove pixels or at a lower opacity to make more subtle changes.

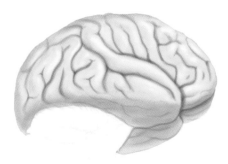

FIGURE 6.9 Begin painting the highlights, keeping in mind that the folds of the brain are somewhat flattened.

6. To give the brain tissue depth or translucence, add a blue-purple cast to the areas that curve away from the light source and toward the shadow areas. The blue color is approximately R160, G135, B200. You can experiment with this color effect: use a soft round brush in Darken mode set to about 35 percent opacity and build up the dark, cool values gradually. See Figure 6.10. The Darken mode will paint over pixels that are lighter than the brush color leaving darker pixels untouched. This effectively and gradually darkens the area but does not obliterate it.

7. Next, begin to darken the underside of the brain by slowly building up dark, cool values, as in Figure 6.11. The form of the brain will be communicated more clearly if the underside is not completely dark. Rather, show it as if there were reflected light illuminating it.

FIGURE 6.10 Use a purple-blue color to give the surface color depth.

FIGURE 6.11 Begin defining the underside of the brain.

8. Continue to define the shape of the folds by building up the color values gradually. To make the sulci appear deeper, use a small brush with a dark color with the Brush mode set to Darken and apply dark strokes in the middle of the sulci.

9. To quickly switch brush colors while painting with the Brush tool, sample the surrounding colors with the Eyedropper tool by pressing the Alt key (Option). If the sampled color is not quite right, try sampling another area or make quick adjustments with the Color Picker. The lateral sulcus, which separates the frontal lobe from the temporal lobe, is particular deep and therefore more pronounced. Build up the dark values in the lateral sulcus to make it look deeper and wider. Emphasize the folds by applying sharper and brighter highlights along the rim or edges of the gyri, as seen in Figure 6.12.

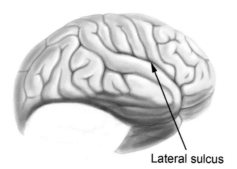

Lateral sulcus

FIGURE 6.12 The lateral sulcus is deeper and wider than other sulci. Build up highlights to emphasize the shape of the folds or gyri.

10. Some artists like the smooth look that the Photoshop brushes create, but in this illustration, loose directional brush strokes will give the illustration a more painterly appearance. Use the Eyedropper tool to sample the highlight color (or make the Foreground color white). Select a soft round brush, adjust its size to about 5 pixels, and set its opacity to about 50 percent. You may want to set the Brush mode to Lighten if the brush blocks out details when you paint. Once you have the brush ready, apply loose directional brush strokes back into the highlight areas, as in Figure 6.13. This effect works best when using a digitizing tablet, but with some practice, it can also be done with a mouse.

FIGURE 6.13 Loose brush strokes help break up the slick brush strokes that Photoshop creates.

Try breaking up the smoothness of the rest of the illustration using this same technique. When using the stock Photoshop brushes, the painting process is additive, meaning that the brush strokes add color to the illustration. As you apply the loose brush strokes, try sampling the surrounding colors and lay down more brush strokes to build up the layers of texture and color.

11. Continue to define the shape of each fold and also the overall shape of the cerebrum. Where needed, the colors can be blended by using the Blur tool, or by painting with a brush set to very low Opacity, such as 20 percent. The sulci that are facing the viewer directly are wider and have more definition, because from a direct point of view, the viewer could look into them. Notice also that the sulci that are facing away from the viewer are narrower and less defined, because the viewer can't see into them. Carefully reproducing this effect caused by perspective will create a convincing three-dimensional brain. See Figure 6.14.

FIGURE 6.14 Reproducing the effects of perspective on the brain will create a convincing three-dimensional illustration.

12. The part of the brain where the central sulcus lies is tipped away from the viewer. Therefore, even though the central sulcus is very deep, it is not as pronounced as the lateral sulcus. The longitudinal fissure visible along the underside divides the left and right hemispheres of the brain, so it is very deep, but from the angle that the brain is viewed, it should only look somewhat deeper than the surrounding sulci, as seen in Figure 6.15.

13. Once the details of the cerebrum are in place, move on to painting the cerebellum. The colors will be similar to those used in the cerebrum, and in essence, the same painting techniques will be repeated. Turn off the Lock Transparent Pixels, sample the base brain color, and block in the cerebellum with a hard round brush, as in Figure 6.16.

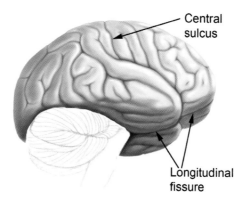

Central
sulcus

Longitudinal
fissure

FIGURE 6.15 The central sulcus is more
pronounced than the surrounding sulci. The
longitudinal fissure is seen along the underside.

FIGURE 6.16 The cerebellum is started the
same way as the cerebrum, by blocking in
the base color.

14. Once the base color is blocked in, turn on the Lock Transparent Pixels
option again, start laying in the dark colors along the grooves created
by the folia, and define the overall round shape of the cerebellum. See
Figure 6.17.

15. Notice in Figure 6.18 that because the cerebrum is tucked under the
brain, it is partly in shadow. The contrast between the areas in shadow
and the bright areas in the light will work to draw attention to the
cerebrum. Use soft round brushes of varying sizes and opacity to build
up and blend the highlight, middle, and shadow values as before.

16. Seen from the side, the cerebellum has a pronounced depression
called the horizontal fissure. As with the deep fissures in the cere-
brum, gradually build up the darker values so that the fissure appears
wider and deeper than the surrounding folia. See Figure 6.19. As the
horizontal fissure extends around to the front, it deepens even more,

FIGURE 6.17 Start defining the folia of the cerebellum.

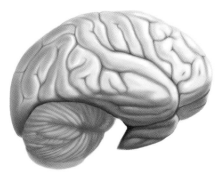

FIGURE 6.18 Because the cerebellum is tucked under the cerebrum, part of it is in shadow.

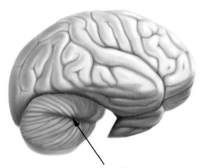

Horizontal fissure

FIGURE 6.19 The horizontal fissure in the cerebellum is deep and curves around to the front.

so darken it accordingly. Continue to use light and dark tones to define the overall shape of the cerebellum, remembering that part of the cerebellum is in shadow.

17. Although the brain stem is visible in this view, it is not the main focus, so very little detail is needed when painting it. Use a darker version of the base brain color to block in the brain stem, as in Figure 6.20. Remember to turn off the Lock Transparent Pixels option to block in the brain stem, and when you're finished, turn it back on.

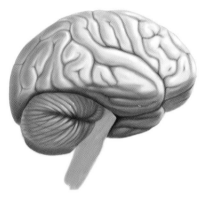

FIGURE 6.20 Block in the base color of the brain stem.

18. The brain stem is essentially cylindrical, so defining its shape using darker and lighter versions of the base color is relatively straightforward. Note that the brain stem is mostly in shadow. The brighter highlights appear only around the level of the cerebellum. See Figure 6.21. Also note that the anterior part of the cerebellum is in front of the brain stem (as seen by the reader), so the cerebellum should cast some shadow on the brain stem.

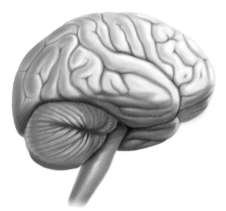

FIGURE 6.21 The shape of the brain stem is cylindrical. The brain stem is painted loosely, as it is not a focal point of the illustration.

19. To help draw the viewer's eye to the cerebellum, overemphasize the highlights in the folia as the cerebellum emerges from the shadow of the cerebrum. Smooth and blend the colors of the folia so that the surface of the cerebellum looks continuous. Remember to keep the overall shape of the cerebellum round. It is easy to concentrate on small details, only to step back and see a very flat looking cerebellum. Add reflected light to the posterior edge of the cerebellum to emphasize its round shape.

Each part of the brain has been painted one at a time, which may cause problems in the overall lighting. In other words, the different parts may not look as if they go together. Stand back and take a look at the entire brain—cerebrum, cerebellum, and brain stem—and consider the entire picture, as you see in Figure 6.22. If anything looks disjointed or doesn't seem to fit with the overall lighting scheme, correct it. Corrections can be safely accomplished by creating a layer above the illustration and experimenting; that way the original art is not ruined. When the revisions or corrections are done, simply merge the layers. One other common technique to detect problems is to flip the image horizontally (Edit:Transform:Flip Horizontal). Once flipped, any problems with highlights, shadows, perspective, and shape become obvious.

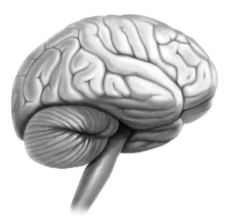

FIGURE 6.22 The finished brain, so far. Adjustments can still be made as the entire illustration progresses.

Sometimes asking another artist to review your work is the best thing you can do to find and correct problems. The process of correcting and revising the illustration is never quite done. So as we continue, there may be things that we improve along the way. Because the illustration was created with Photoshop, it is very easy to adjust color values, contrast brightness, and make revisions.

PAINTING THE BLOOD VESSELS

The last bit of anatomy to add to the illustration is the blood vessels. The cerebellum is covered with arterial and venous blood vessels, but faithfully reproducing each blood vessel would be counterproductive to the story the illustration is telling. Even painting just the arterial blood vessels would create overwhelming clutter. To give the reader the impression of many blood vessels, about half dozen branches of the Posterior Inferior Cerebellar artery (PICA) and the Anterior Inferior Cerebellar artery (AICA) will be painted. The anatomy has already been worked out in the sketches, so it's just a matter of tracing the blood vessels and painting them.

Painting the blood vessels freehand could present some problems even with a digitizing tablet. The blood vessels make many turns and are very small in some places. Since Photoshop CS has excellent vector tools that are almost identical to Illustrator, the quick and effective solution is to use Photoshop's layers, vector tools, and brushes to paint the blood vessels.

1. The stroke.psd file you have been working with has the sketch for the blood vessels—it's just been hidden this whole time. To see the blood vessels (Figure 6.23) click on the Layer Visibility icon (the eye picture in the layer). The blood vessels don't have to line up perfectly yet; minor corrections can be made in later steps.

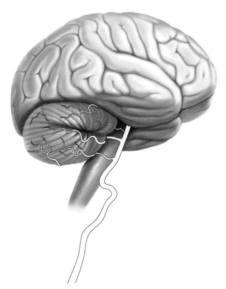

FIGURE 6.23 Make the layer with the blood vessels visible.

2. With the blood vessels in place, the layers that contain the brain anatomy and textures can be dimmed or turned off to keep them from interfering with the painting process. Next, use the Pen tool to produce an accurate outline of all blood vessels. This is a very important step, as the final quality of the blood vessels depends on tracing them accurately with the Pen tool. See Figure 6.24. Before tracing, the Pen tool should be set to Paths instead of Shape Layers, so that empty paths are created instead of filled vector shapes. (It is important to practice with the Pen tool, because it is a very useful tool, however, if you want to get started painting, the paths for the blood vessels are already in the Paths palette of the stroke.psd file.)

FIGURE 6.24 Use the Pen tool to outline the blood vessels. The only way to become proficient with the Pen tool is to practice.

3. Once the vessels are completely outlined, the Paths palette will display a new, unnamed work path. Double-click on the new work path and name it. The new path will be used as a selection mask to facilitate the painting process of the blood vessels. To make the selection from the new path, press Ctrl (Command) and click once on the blood vessels path in the Paths palette. Notice that Photoshop creates a new selection. See Figure 6.25.

4. For the next step, it is important that the blood vessels layer is active in the Layers palette, so click once on the layer to activate it. The blood vessels are an important focal point of the illustration, so they will be prominently rendered in bright red. Coincidentally, red is a common color used in medical illustrations to indicate arterial blood vessels. However, the blood vessels will be painted by using a dark base color and then lighter colors will be built up gradually. The initial base color

FIGURE 6.25 Create a selection from the new path.

of the arteries is a maroon red, so make the Foreground color R160, G15, B15. Press Shift+F5 and choose the Foreground color to fill the selection. See Figure 6.26.

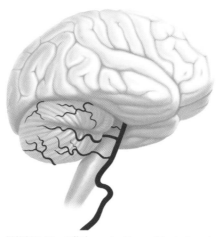

FIGURE 6.26 Fill the selection with dark red.

5. As the vertebral artery makes its way to the brain through the top two vertebrae (namely the atlas and the axis), it makes several near 90-degree turns. Though the vertebrae are not part of the illustration, the tell-tale turns of the vertebral artery are indicated by its shape and with shadows and highlights. Gradually build up the lighter red (almost pure red) and highlights by using a small soft round brush

with the opacity set to about 50 percent. Likewise, the dark areas are built up using a similar brush but with a darker color, as in Figure 6.27. The Lighten and Darken modes of the brush can be used to control the effect each stroke has on the underlying pixels; i.e., the location and amount of color that is applied.

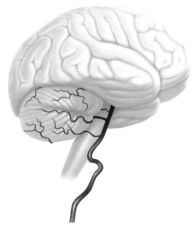

FIGURE 6.27 The three-dimensional shape of the vertebral artery is gradually defined using highlights and shadows.

6. The small arteries branching off the vertebral and basilar artery are painted using the same method as the larger vertebral artery. The only difference to note is that the arteries on the cerebellum generally follow the spherical contour of the cerebellum, so the highlights and shadows on these arteries are not only based on their shape but also the shape of the cerebellum. Since these arteries are much smaller, zoom in on the cerebellum so you may paint accurately.

7. At this point, the arteries are nearly finished. If there is a noticeable alignment mistake, use the Move tool to nudge the arteries into place. But if the alignment mistake is small, the best thing to do is use a very small brush to fill in any gaps, or use the Eraser tool to remove any offending pixels.

8. To add interest and dimension to the illustration, the arteries will have a drop shadow. The Drop Shadow Layer Style will not work in this case, because the level of control of the Drop Shadow Layer Style is not sufficient for our purposes. So in this case, the shadows will be painted. Create a new layer below the blood vessels layer and make the new layer active. The color for the shadow is selected by sampling a dark region of the main artery. The shadow is applied with a soft round brush, set to a low opacity. Based on the general lighting, the

shadow is cast to the left of the main artery and below the branches, as see in Figure 6.28. Because of the general structure of smaller arterial blood vessels, they often twist and turn as they make their way. Sometimes these turns make them lift off the surface they are following. So in this illustration there are several places where the shadows of the arteries on the cerebellum indicate that they are actually off the surface of the cerebellum.

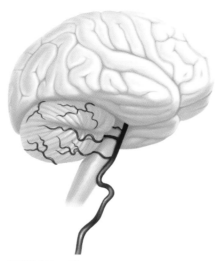

FIGURE 6.28. The arteries' drop shadow is painted in a separate layer.

Step back once more and take a look at the entire illustration; it should look something like Figure 6.29. Make any corrections or changes that you deem necessary. For example, the posterior edge of the cerebellum looks a little square. It could be rounded out a bit to give it a more natural look. With Photoshop, making corrections like this is very easy; in this case, a new layer was created and the changes were tried out on the new layer.

Compositing the Painting of the Brain with the Figure Drawing

The next element to be added to the illustration is the hand drawing of the figure. The figure drawing is created using traditional drawing pencils (as opposed to writing pencils) and bright white drawing paper. The bright white paper makes it easier to scan the image with minimal gray or yellow cast from the paper grain. Alternatively, the figure could have been created with Photoshop, Painter, or even Illustrator and with some effort made to appear hand drawn. See Figure 6.30.

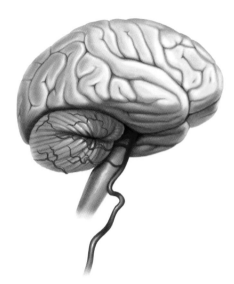

FIGURE 6.29 The completed brain and arteries.

FIGURE 6.30 The figure drawing will complement the illustration of the brain.

The figure drawing is purposely drawn in a very loose style, and with little detail, as it plays two roles in the illustration. First, it helps to orient the viewer, and second, it provides a complementary design element to the more detailed color painting of brain. It is very important to carefully match the general lighting in the figure drawing to that used in the brain illustration; otherwise, the two will not look like they go together. The figure drawing is developed using various photographic references; trial and error aid in determining how much detail is needed. Though most of the figure will be hidden to allow the brain to be the focal point, the entire head of the figure is drawn, offering more options as to what parts will eventually be hidden.

Different brands of scanners have varying settings for scanning grayscale images, but overall, the desired result is an image in which the background color is consistent and as close to white (R255, G255, B255) as possible. No matter how carefully one scans the drawing, some pencil strokes will be lost, but it is important to retain as much of the pencil detail as possible. To minimize detail loss, scan drawings or line art at double the final output resolution. For example, if the final print resolution is 300 ppi, scan at 600 ppi. Scanners are not perfect, and most have hot spots or dark spots, which can cause uneven scans. It is best to get to know your scanner very well and try different settings to get the best scan possible. Photoshop can compensate for a mediocre scan, but it's always best to start with the best scan you can get.

ON THE CD

1. Open the file figure.psd in the Chapter 6 folder in the accompanying CD-ROM. Then cut and paste or drag and drop the figure drawing into the stroke.psd file. First, move the figure drawing's layer above the brain and blood vessel layers and set its blending mode to Multiply. This will leave only the pencil lines and remove the white paper. See Figure 6.31.
2. Position the figure drawing using the Move, Scale, and Rotate tools so that it is in place over the brain. Remember to take into account the thickness of the skull, skin, and hair. Center the brain, as seen in Figure 6.32.

CREATING THE BACKGROUND TEXTURE

In the next few steps, we'll create a background texture for the entire illustration. The background will serve as a design compliment but will also help to focus attention on the cerebellum by placing very bright colors underneath the cerebellum. The steps below are just a general guideline for creating an interesting texture for the illustration; you can experiment with the steps to create your own texture.

FIGURE 6.31 The figure drawing is placed in the illustration.

FIGURE 6.32 The Move, Scale, and Rotate tools are used to position the figure drawing and brain.

1. Create a new layer below the figure drawing, brain, and blood vessel layers. Fill the new layer with dark blue, R45, G60, B102. See Figure 6.33.

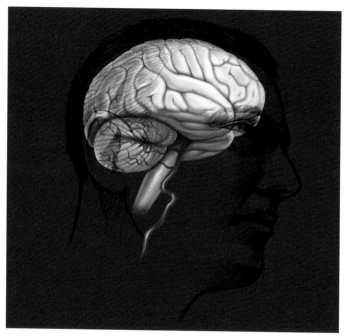

FIGURE 6.33 Create a new layer and fill it with blue.

2. Turn off all layers except the layer filled with dark blue. Since you just filled the background with dark blue, the Foreground color is probably still dark blue, which is what we need for the next step. Make the Background color white. From the Filter menu choose Render and from the submenu select Clouds. You will get a pattern similar to Figure 6.34.

3. Next, enlarge the texture about 400 percent, so that the texture looks like Figure 6.35. The goal is to try to get one of the "clouds" around the center of the texture. To keep the file manageable press Ctrl+A to select all and from the Image menu choose Crop. The reason for cropping is that when you enlarged the texture 400 percent, the part of the texture outside of the document edges is still there, and that makes the file very large.

4. Select a large soft round brush and adjust its opacity to about 30 percent. Make sure the Foreground color is still dark blue. Now make the blue areas in the texture larger and darker by painting over some of the clouds, as seen in Figure 6.36.

FIGURE 6.34 The initial results of the Clouds filter.

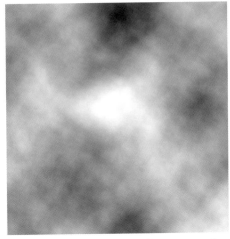

FIGURE 6.35 Enlarge the clouds texture until you can see just one "cloud" in the center.

5. To make the color of the texture more interesting, we'll blend in some cool and warm colors. With a soft round brush, paint subtle blue-green (R105, G150, B180) areas, as in Figure 6.37.

FIGURE 6.36 The blue areas are made darker and larger.

FIGURE 6.37 Blend in some subtle cool greens.

6. Finally, add subtle magenta (R174, G113, B196) into the clouds, as in Figure 6.38.

As mentioned earlier, the idea of the texture is to create an interesting background for the illustration and to help focus attention on the cerebellum. Your texture does not have to look exactly like the one in the

FIGURE 6.38 And blend in some warm magenta.

figures. Chances are that with a little practice, you can come up with your own textures. You can even apply some of the other Photoshop filters to change the look of the texture you just created.

FINISHING UP

With the brain anatomy, the figure drawing, and the texture complete, all the elements of the illustration are finished. Now, we'll edit the design and layout to make the illustration work together. The first thing we'll do is hide part of the figure drawing with a Layer mask so the brain anatomy shows up clearly.

1. Turn all layers on so that you can see the brain, the blood vessels, the figure drawing, and the background. Select that layer that contains the figure drawing. From the Layer menu choose Add Layer Mask and from the submenu select Reveal All. Notice that a small white square appears next to the layer thumbnail; this is the Layer Mask thumbnail. See Figure 6.39.
2. To hide part of the figure drawing, select a black soft round brush. Click once on the Layer Mask thumbnail, then paint over the back of the head in the figure drawing. Notice that the part of the head you are painting over becomes hidden. See Figure 6.40. If you switch the Foreground color to white and paint over the same area, the head will be revealed.
3. Now we'll add some highlights to the figure drawing so that the face is defined. Create a new layer below the figure drawing. Make the Foreground color white and, with a soft round brush set to a very low opacity, add subtle highlights to the figure, as in Figure 6.41. At this point, the figure drawing is complete.

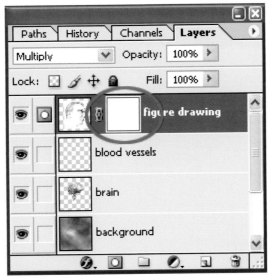

FIGURE 6.39 Add a Layer mask to the figure drawing's layer.

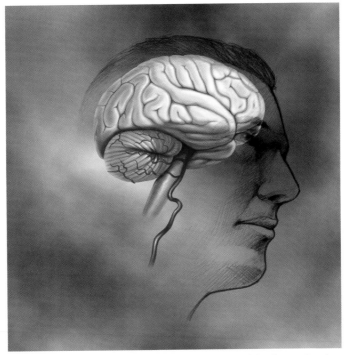

FIGURE 6.40 The Layer mask is used to hide part of the figure drawing.

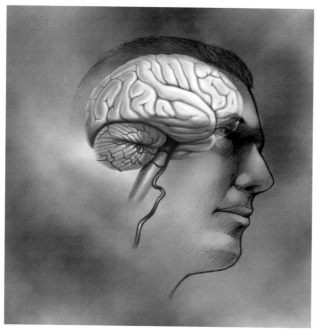

FIGURE 6.41 Adding subtle highlights to the figure drawing makes the face more visible.

4. Next, select the blood vessels layer and merge it with the brain layer below by making the blood vessel layer active and choosing Merge Down from the Layer palette menu. See Figure 6.42.

5. In the following steps, we'll finalize the design by using Layer masks to make the cerebellum the focus of the illustration. Make a copy of the new brain layer by right-clicking (Option + click) on the brain layer and choosing Duplicate layer from the pop-up menu. Make sure the brain copy layer is active or selected, and from the Image menu, choose Adjustments and then select Desaturate. This will make the brain grayscale. See Figure 6.43.

6. Create yet another layer above all other layers and make a rectangular selection with the Rectangular Marquee that encloses the cerebellum. Make the Foreground color white and from the Edit menu, choose Stroke. Set the Stroke Width to about 8 pixels and click OK. See Figure 6.44.

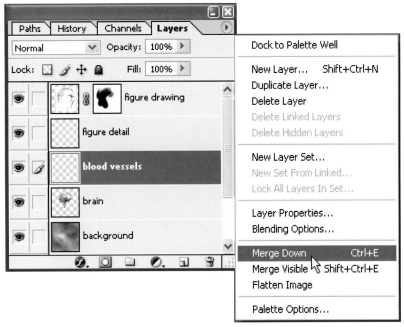

FIGURE 6.42 Merge the blood vessels layer with the brain layer below.

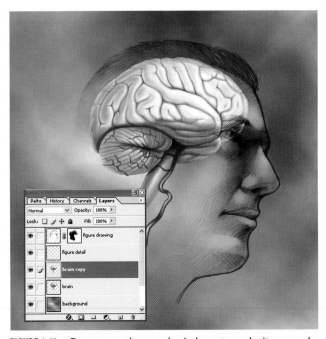

FIGURE 6.43 Desaturate the new brain layer to make it grayscale.

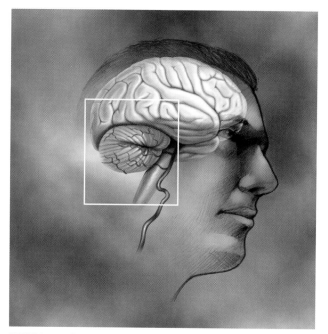

FIGURE 6.44 Create a new layer and make a white box around the cerebullum.

7. With the Magic Wand, click once inside the box to create a selection. Next, invert the selection by choosing Inverse from the Select menu. Then select the grayscale brain layer and make a new Layer mask (Layer:Add Layer Mask:Reveal All). Once the Layer Mask thumbnail appears, fill the selection with black. This will mask part of the grayscale brain, revealing the color brain below, as seen in Figure 6.45.
8. Finally, fade the grayscale brain similar to Figure 6.46 with the Layer mask.

Using a little bit of design sense and Photoshop Layer masks, we can easily make the cerebellum the focal point of the illustration. The illustration is now complete, but try experimenting with different background textures, lighting, or now that you know how to use Layer masks, try creating variations on the basic design idea. See Figure 6.47.

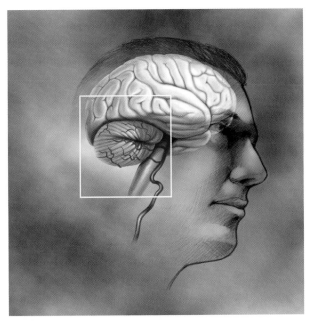

FIGURE 6.45 Create a Layer mask in the grayscale brain layer so that part of the color brain below becomes visible.

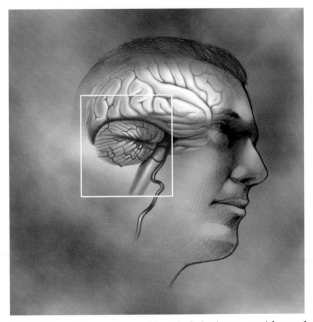

FIGURE 6.46 With a soft round brush, fade the top and front of the grayscale brain.

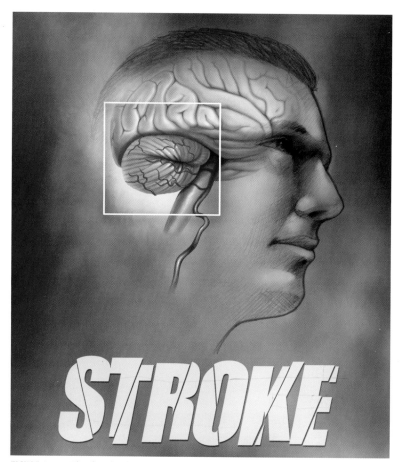

FIGURE 6.47 The finished art, with a few embellishments.

INTERVIEW WITH EDWARD BELL, ART DIRECTOR FOR *SCIENTIFIC AMERICAN* MAGAZINE

What qualifications or experience do you look for in a medical artist?

As with all the scientific illustrators I now work with, the first thing I looked for was excellent artistic ability. It may seem obvious, but a medical artist is an artist who specializes in a subject matter. No matter how well the person knows the subject matter, if it is not depicted in an exciting and informing way, then my interest in that person will diminish. The person must be a good artist. I can always provide the artist with additional data and information pertinent to the piece that is being illustrated, but the ability to illustrate well should be brought by the artist. Having said that, it is still

important that the artist know well his or her subject. This is especially help-ful when illustrating complex subject matter. There have been times when a well-informed illustrator has found an error or two in an author's sketches and pointed them out. A well-informed medical artist can help to make a project proceed very smoothly.

How do you find medical artists?

My two methods for finding medical illustrators are by receiving self-promotion pieces and through the *Medical Illustration Source Book*.

Any tips for new medical artists looking to get commissions from Scientific American?

There are a lot of very talented medical artists competing for assignments. Getting noticed or standing out becomes more and more difficult. When I receive self-promotion pieces, the first question I ask myself is "Could this have appeared in *Scientific American*?" This will eliminate many pieces im-mediately. The trick is to not eliminate yourself. What this means is that the artist should be very familiar with the need of the publication or company that he or she is attempting to attract. If you never see black-and-white medical illustrations in the book, don't send me black-and-white illustra-tions. In addition, I also have a preference for viewing/printed pieces of dig-ital on screen pieces.

How do you decide to use digital art vs. traditional paintings? What are the ad-vantages and disadvantages of each?

It is extremely rare that we would ask an artist to use a specific medium. However, with the current state of medical illustration, almost all of our med-ical illustrators are working digitally. This is also true for most of the other sci-entific disciplines. The main advantage of the digital medium is the ability to make many and complex corrections relatively easily. This advantage cannot be overstated. Because clients (art directors, ad agencies, editors, etc.) know this, many rounds of corrections have become the norm. In addition, the "sketch" stage of an illustration has evolved under the digital medium. The word "sketch" has its origins in traditional media, and with that media, a sketch has a very "preliminary" look. In digital media, a well-developed sketch may be almost identical to the finished piece. This gives editors and scientists a better feel for how the finished piece will ultimately look.

What is your production workflow for illustrations like?

Almost all of our articles are expertly authored (written by scientists). Each article is assigned to an editor. After reading the original manuscript and

reviewing suggested illustrations by the author, the editor will meet with an art director to develop possible illustrations for the article. The editor will also give the art director an overview of the text of the article. Armed with this information, the art director will decide on an artist and then meet with the artist or communicate by e-mail for the purpose of developing a round of sketches that must pass author, editor, and art director approval. The number of rounds of sketches will vary on the complexity of the illustrations. The development time, from the initial meeting with the artist through the completion of the project, may run from three to five weeks.

Is there a process to check for accuracy in the illustrations within the Scientific American *staff?*

Fact checking at *Scientific American* is handled by the copy department. However, all stages of illustration development are passed through several people including the art director, editor, executive editor, managing editor, copy chief, author, as well as assistant art directors and copy assistants.

Do medical artists have contact with the expert authors of the articles they are illustrating?

Sometimes. If the content of the illustration is extremely complex, it is sometimes best to let the artist talk directly to the expert author. They will have a level of understanding that the art director and editor may not. Under normal circumstances, however, the art director will act as intermediary between the artist and the author.

How much latitude does the illustrator have in the design of the final art?

We give the illustrators great latitude in the design of the final art. This is where having an illustrator with very good artistic abilities pays dividends. We may instruct the illustrator to work in a predefined size or shape (i.e., a full page, one-third of a page, a full spread, etc.). Prior to the initial sketch, however, the illustrator may lay out or design the illustration in any way he or she sees fit. After that stage, the design will be more collaborative between the artist and art director.

What copyrights do you normally negotiate with the medical artist?

The same as with all of our artists: the artist grants us the right to use the illustration (one time) in our magazine and in all our foreign language magazines. We also buy rights to reprint the illustration in any *Scientific American* branded product, including our Web site. The artist retains the original copyright to the illustration. Our usage is exclusive for 60 days.

How much stock illustration do you use?

Almost none.

What are some of the rates paid for different types of illustrations (spot illustrations, editorial illustrations, cover art, etc.)?

We tend not to pay rates, but rather by the complexity or difficulty of the illustration.

CONCLUSION

In this chapter, we have seen that medical illustrators do more than just create serious medical art. When producing editorial illustrations they are also called upon to use their creativity to design interesting, attention-grabbing, conceptual illustrations that sum up the point of an article. We have also learned that Photoshop is a versatile tool that allows artists to easily create digital paintings and even mix traditional drawings with digital art. In the next chapter, we will delve into the world of real-time 3D for the Web.

CHAPTER

7

MEDICAL-LEGAL ILLUSTRATION

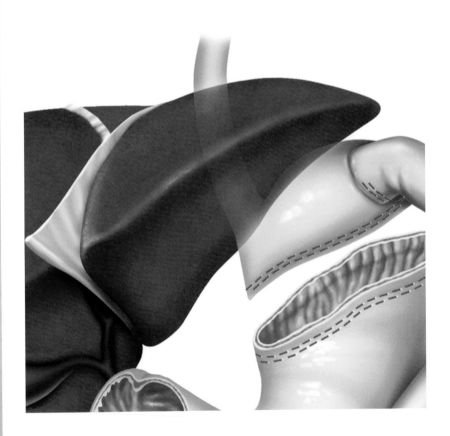

Introduction to Medical-Legal Illustration

Medical-legal illustration is a recent but increasingly in-demand specialization. It is no secret that we live in a litigious society, and the demand for medical-legal illustration is directly related to the explosive increase in the number of medical malpractice and personal injury cases. Persuasive and educational, medical-legal exhibits have become an established and essential tool to communicate the facts of a meritorious case.

You may have seen legal exhibits before on the news or on television channels such as Court TV—maybe even medical-legal exhibits. In courtroom scenes, lawyers are often seen explaining to the jury the contents of oversized graphics on easels. Generally, those graphics are prepared legal exhibits. In no other place is the adage "a picture is worth a thousand words" more applicable than in medical-legal illustration. Medical court cases involve exceedingly complex medical and scientific concepts that a lawyer arguing his case must make sure the jury and judge understand. The problem is not so much the lawyer's ability to argue his case but the short amount of time in which he has to do it. As such, well-designed and researched medical-legal exhibits can, in many cases, make all the difference in having a jury clearly understand the merits of a case.

When preparing for trial or mediation, lawyers gather a team of skilled experts on which they rely to build their case. When the subject of the litigation is medical in nature, medical artists are often part of the team of experts. Medical artists who focus on medical-legal illustration have specialized knowledge and skills, such as being able to read and understand stacks of medical and legal records to design the exhibit, or even a general understanding of legal terms and concepts, which helps them produce accurate and persuasive exhibits that are admissible as evidence in courtrooms.

The first challenge that the medical artist faces in producing medical-legal exhibits is interpreting the clinical facts of a case in order to design an exhibit that a jury with an average high school science education can clearly understand. Prior to listening to the facts of the case, jurors have probably never heard of the terms or concepts that they will be required to understand to render a verdict. Additionally, the exhibit must not only be understood by the lay jury but must assist the arguing lawyer and any experts giving testimony. The medical artist must draw on his training in science and medicine, as well as his skills as a communicator, to produce an exhibit that is concise yet contains all the technical facts of the case.

The medical artist must produce exhibits that focus attention and are aesthetically pleasing. Here, the medical artist applies his artistic and layout skills to create an exhibit that effectively blends typography, color, layout, design, and content to focus the jury's attention. Because humans are visual beings, it is important to create an exhibit that makes a good

first impression. Exhibits that look good, are well designed, and are neatly mounted make a positive impact on the jury.

Finally, the medical artist must work with legal experts to produce an exhibit that is admissible as evidence in court. A discussion on the rules of evidence is beyond the scope of this book, but the general idea is simple: if an exhibit is unfairly prejudiced, confusing, or misleading, opposing counsel may object to it. If the objection is sustained, the exhibit is deemed inadmissible and thrown out. Since the rules of evidence vary from state to state, can be complicated, and are often revised, it is the responsibility of the lawyers—not the medical artist—to make sure that the content or design of an exhibit follows the rules of evidence.

In the recent past, medical-legal illustrations were usually one-of-a-kind illustrations produced by hand with traditional art tools, such as an airbrush, pencils, markers, etc. Today, however, medical-legal illustrations are almost exclusively produced digitally. Whether the art is created from scratch in Photoshop (or a similar program) or traditionally produced art is digitized, you can be sure a computer had some part in producing the exhibit.

In the growing field of medical-legal illustration, medical artists are called upon to work on many different types of cases. Sometimes a medical artist will work to defend a physician, and sometimes he will work on behalf of the patient. At other times, the medical artist will work to illustrate the injuries a plaintiff has suffered in an accident, an assault, or from neglect. In any case, the medical artist must create comprehensive exhibits that are easy to understand, focus attention, and are admissible in a courtroom.

TUTORIAL | **EXHIBIT FOR FAILED ROUX-EN-Y GASTRIC BYPASS**

PROJECT OVERVIEW

The illustration in this project will be painted with Photoshop, much like we did in the surgical illustration chapter. However, the large size of the exhibit poses some challenges. Creating a high-resolution, full color, 30 x 40-inch document would require a tremendous amount of computer horsepower, but as we'll see, there are some simple workarounds to manage large files.

Medical artists can be called upon to develop exhibits for either the defendant or the plaintiff. Each side in a medical malpractice case will probably have a medical artist working for them. In this case, an exhibit will be prepared for the plaintiff of a medical malpractice suit in which the stapling of a laparoscopic gastric bypass failed in two places shortly after the gastric bypass surgery, putting the life of the patient in danger. A

second surgeon had to perform emergency surgery to repair the holes created by the failed staples.

Whether the plaintiff's case is meritorious or not is up to a jury to decide. The job of the medical artist is to work with the legal team, educate himself on the clinical aspects of the case, and design exhibits that will clearly illustrate the facts of the case.

RESEARCH

Research for a medical-legal exhibit is similar to the research carried out for other types of medical illustration. For example, when creating illustrations for courtroom display, the medical artist will work from medical records such as operative reports, emergency room reports, and discharge reports. This exhibit is specifically based on what the second surgeon saw as he entered the abdomen of the plaintiff, as recorded in his postoperative report and legal deposition. Often large law firms have specially trained legal nurses on staff who work with the medical artist to interpret the medical information. Working with medical experts makes the job of the medical artists much easier.

DESIGNING THE EXHIBIT

Once the legal team has decided what they want to include in the exhibit, the medical artist will begin to design and lay out the information. The main focus of this exhibit is the failed staples that caused injury and eventually required a second emergency surgery; therefore, the majority of the exhibit will be dedicated to focusing attention on the failed staples. Since there are no photographic or radiographic records of what the second surgeon saw as he entered the plaintiff's peritoneal cavity, the anatomy is reconstructed using anatomical atlases and the information in the medical and legal records. However, since there are different types of gastric bypass techniques, the medical artist must also determine which gastric bypass technique was used and accurately depict that technique in the exhibit.

The exhibit will contain two illustrations. The main illustration will show the reflected liver, gall bladder, common bile duct, esophagus, the stomach pouch, the distal stomach, the Roux-en-Y bypass, the failed stapling, and the pancreas. The components of the main illustration are critical to help the lawyers explain to the jury exactly what happened. For comparison and clarity, the inset will show the staple lines as they would have appeared had they not failed. See Figure 7.1.

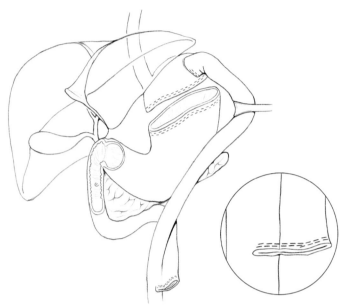

FIGURE 7.1 The initial sketch for the main illustration of the exhibit.

CREATING LARGE ILLUSTRATIONS

The painting process of this illustration is very similar to those in previous chapters. However, the large size of the illustration presents some challenges. Large, high-resolution digital files can require a lot of computer horsepower. If the entire exhibit were to be created at the full 30 x 40 inches at 300 ppi, the file would be over 300 megabytes (MB) for just one layer. We know by now that Photoshop illustrations almost always require many layers, so it is easy to see how a file this size can quickly get out of hand requiring numerous gigabytes (GB) of memory and disk space.

The best approach to creating large exhibits is to paint each part of the exhibit in its own separate Photoshop file, and then combine the flattened files in another program. In this case, the main illustration and the inset will be painted separately and then positioned in a 30 x 40-inch Adobe Illustrator CS file. Since Adobe Illustrator is a vector program, a 30 x 40-inch document is only a few hundred kilobytes (KB), about the size of a large JPEG on a Web page. Even though Photoshop CS has much improved type tools, Adobe Illustrator still has better type tools and is a better layout program.

PAINTING THE ROUX-EN-Y GASTRIC BYPASS ILLUSTRATION

The painting process for this exhibit is similar to previous projects in this book. However, in this project we will be building a custom Photoshop brush and customizing stock brushes to paint parts of the illustration.

Photoshop CS's new paint engine allows precise control over brushes so that painterly or more natural brush strokes are possible.

The main illustration of the exhibit will be a large illustration, but it should still be manageable in newer computers. In an actual production setting, the size of the main illustration would be about 20 inches square at 300 ppi. 300 ppi is the standard resolution for artwork that will be printed, but if you can get away with 200 ppi or even 150 ppi with your printers or plotters and still have the illustration look good from a distance, you may want to work in lower resolutions to help make the painting process go faster. The tutorial illustration will be 8 x 10 inches.

The initial steps in preparing to paint for this project are similar to the steps in the surgical illustration chapter. To recap, open the Photoshop document bypass_sketch.psd from the CD-ROM, convert the background layer that contains the sketch in to an editable layer, increase contrast to remove gray areas, and change the Layer mode to Multiply to get rid of the white pixels, leaving only the black pixels. See Figure 7.2. Next, each anatomical element is outlined using the Pen tool to create paths, which will then be used to make selections, as in Figure 7.3. (If you prefer to dive right in and start painting, the file gastric_bypass.psd in the Chapter 7 folder in the accompanying CD-ROM contains the prepared guide sketch, the background layer, and the paths needed to create selections.)

ON THE CD

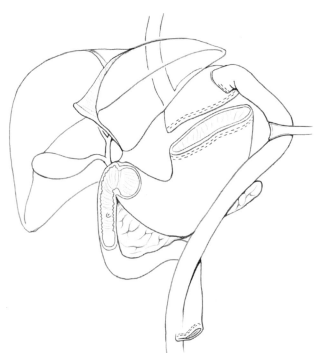

FIGURE 7.2 The sketch is prepared for painting.

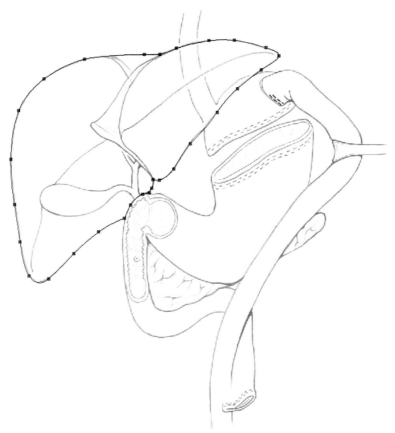

FIGURE 7.3 Paths are created for each element in the illustration. The paths will be used to make selections.

PAINTING THE LIVER AND GALL BLADDER

The first part of the illustration to be painted will be the liver. Note that the liver is a large organ made up of left and right lobes, divided by the falciform and round ligaments. The liver is often illustrated as perfectly smooth, but in this illustration, we'll try to approximate the tiny pores and bumps characteristic of a parenchymal organ. When light hits the surface of the liver, the pores and bumps become evident, especially around highlights. The living liver is a bright, reddish-brown color, but it is often illustrated in a wide range of colors, from red-brown to dark brown, red-purple, and so on. As we have learned, the surface characteristics of living organs are a complex composite of texture, color, and lighting, and the liver is no exception. Re-creating the surface properties of the liver with stock brushes would be very time consuming, so for this project, a custom Photoshop brush will be created to facilitate the process.

However, before creating the custom brush and painting the liver texture, the base color, dark colors, and highlights should be painted, as seen in Figure 7.4. The base color, dark colors, and highlights are painted in separate layers. The base liver color is roughly R140, G70, B46, which is a reddish brown. The dark shadow and highlight colors that define the basic shape of the liver are variations of the base color. The distinctive shape of the liver is created by the space that it occupies in the upper abdomen. The liver is nestled beneath the diaphragm, directly below the right lung and the heart. From below, the liver is shaped by the stomach and intestines. The gall bladder normally creates an indentation into the liver and that should be clearly indicated as the painting progresses.

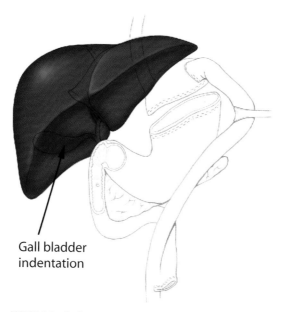

Gall bladder
indentation

FIGURE 7.4 Before creating a custom brush to paint the liver surface texture, the general shape of the liver is defined with a base color, shadows, and highlights. Note the beginning of an indentation in the underside of the liver where the gall bladder fits.

Creating a Custom Brush

Photoshop can create a custom brush from any part of a digital photograph, scanned image, or digital painting. However, in this case, a stock soft round brush will be used to paint the pattern that will become the new custom brush. Creating custom brushes requires quite a bit of experimentation and patience.

1. To begin the custom brush, create a 72 ppi, 2" x 2" Photoshop document with a white background. Brushes can be sampled from a color digital source or painted with brushes loaded with a color, but the Photoshop CS brush engine will convert the color information into a grayscale. To create the custom brush pattern paint a "random" series of black circles with a soft round brush. The circles should vary in size and have some overlap. This custom brush pattern was designed after a period of trial and error where different patterns were tried. There is no magic "liver" brush; it is possible that you could come up with a better brush to paint the liver texture. See Figure 7.5. (The completed liver texture brush preset is included in the accompanying CD-ROM in the Chapter 7 folder. The file is named liver_texture.abr. However, to learn to create custom brushes go through the brief steps below.)

ON THE CD

FIGURE 7.5 The pattern for the custom brush is created by painting a pattern with a stock brush.

2. Once the brush pattern is designed, open the Edit menu and choose Define Brush Preset as in Figure 7.6 and name the new brush Liver Texture. Photoshop will automatically store the image as a new brush in the Brush Preset Picker.

FIGURE 7.6 Name the new brush, click OK, and Photoshop will store it in the Brush Preset Picker.

3. The new brush will be customized further with the options in the Brush Preset palette. The first option we will adjust is Shape Dynamics. To turn on Shape Dynamics, check the box next to the Shape Dynamics label and click once in the Shape Dynamics row to display the Shape Dynamics settings. See Figure 7.7. If you are using a digitizing tablet like a Wacom Intuos™ tablet, set the Size Jitter Control menu to Pen Pressure and leave the Size Jitter value at zero. Leaving the Size Jitter at zero will keep the texture uniform. Next, set the Angle Jitter to 45 percent and the menu to Pen Pressure. The Angle Jitter will rotate the brush tip based on the pressure of the pen, giving the brush strokes randomness and preventing moiré patterns from appearing.

FIGURE 7.7 The Shape Dynamics options control the variation in the brush stroke.

4. In the Scattering settings adjust Scatter to about 60 percent and choose Pen Pressure from the Control menu. The Scatter value will also add randomness to the brush stroke. In the Texture settings choose the Wrinkles texture (the Wrinkles texture is a default Photoshop texture) and set the scale to about 40 percent. The texture adds a more organic feel to the brush stroke. See Figure 7.8.

5. In Other Dynamics, adjust the Opacity Jitter to about 20 percent and set the menu to Pen Pressure, as in Figure 7.9. Turning on Other Dynamics and setting it to Pen Pressure will allow you to vary the opacity of the brush stroke as you paint.

Now the brush is ready to be used to paint the liver texture. New brush presets appear at the end of the brush list. Like any new tool, it will

FIGURE 7.8 Scattering specifies the number of times and position a brush tip pattern appears in the brush stroke. The Texture setting combines a texture with the brush pattern.

FIGURE 7.9 The Other Dynamics setting creates a brush stroke that varies in opacity.

take some practice to get the desired result. In the case of this illustration, the new custom brush is being used primarily to create the texture of the liver surface and to help define the shape of the liver.

Painting the Liver Texture with a Custom Brush

To keep things under control, the liver texture will be painted in a new separate layer. So far, the liver has three layers: a base color layer, a dark layer, and a light or highlights layer. Create and position the new texture layer so that it is below the shadow layer but above the highlight layer (you can experiment with different layer positions to get different results).

1. Select the Liver Texture brush (if it is not already selected), make the Foreground color dark reddish-brown, set the brush Opacity to about 50 percent, and click on the Airbrush icon to set the brush to Airbrush mode. To create a rich texture, the Liver Texture brush is used to gradually build up layers of color. See Figure 7.10.

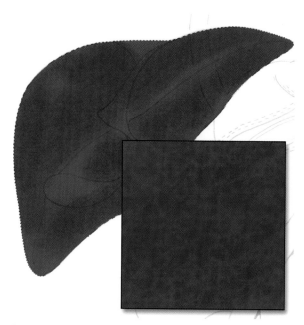

FIGURE 7.10 The initial layer of the liver texture.

2. The texture is slowly built up with varying strokes; some strokes are very dense (based on pen pressure) and some are not. This variation will create light and dark areas in the texture that follow the shape of the liver. Load the brush with a lighter color by sampling a light color in the illustration (hold the Alt/Option key to toggle to the Eyedropper tool) and begin painting with the lighter color; see Figure 7.11. The lighter color is applied to help define the shape of the liver, getting lighter towards the highlights.

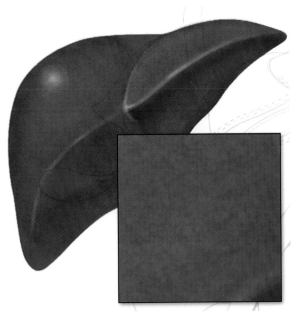

FIGURE 7.11 Layers of texture brush strokes are used to build up a rich texture.

3. Finally, use the Liver Texture brush loaded with a very light version of the base color to begin painting the highlights, as in Figure 7.12.

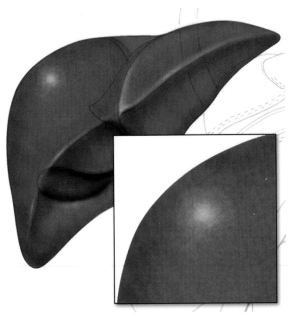

FIGURE 7.12 Subtle highlights are painted with the custom texture brush.

4. To complete the liver, the falciform and round ligaments will be painted (Figure 7.13). In normal anatomy, the ligaments keep the liver in place and are attached to the peritoneal wall; however, because this is a dissected view, we are looking at the cut edge of the ligaments. Ligaments, like tendons, are usually painted in cool translucent blues and grays, and since ligaments are fibrous tissues, they are often painted with a grain or striations. Create a new layer for the ligaments and position the new layer above the liver layers. If you created a path for the falciform ligament, make a selection. If you didn't create a path for the ligaments, you can use the Polygonal Lasso tool to trace the ligaments using the sketch as a guide and create a selection that way. Once the selection is complete, fill it with a blue-gray base color. To fill the selection, make the Foreground color blue-gray and press Shift +F5, choose Foreground, and click OK.

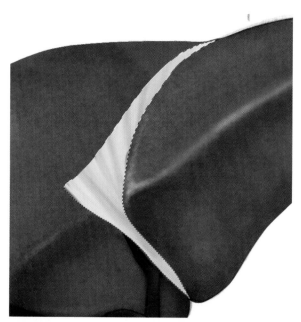

FIGURE 7.13 The falciform and round ligaments begin to take shape.

5. With a soft round brush set to a low opacity and loaded with a warm beige color, begin to create folds in the falciform ligament and to define the round ligament. To add a bit of variation, switch to a warm pink color and set the opacity of the brush to about 15 percent and add some warm tones to the ligaments. Use the Smudge tool to add subtle striations that run along the folds. Leave the default settings for the

Smudge tool but adjust its brush size to about 20 pixels. Near the top of the liver, the Smudge tool is used to blend the liver color into the ligament to break up the hard edge (Figure 7.14). Finally, the cut edge of the ligaments is indicated by a thin, almost white, brush stroke.

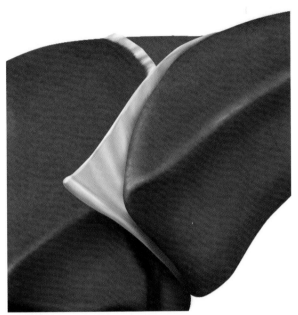

FIGURE 7.14 The Smudge tool is used to create subtle striations in the ligaments and to blend the ligament into the liver.

Painting the Gall Bladder

The gall bladder is depicted with little detail, as it is not the main focus of the illustration. Typically, the gall bladder is illustrated in some variation of green, from olive green to gray-green to dark green, because it is the organ that collects bile from the liver, and bile is green. As always, there is some room for variation in the anatomy, and in this case, the gall bladder, the cystic duct, common hepatic duct, and the common bile duct are drawn in a straightforward manner, avoiding the twists and turns that are sometimes associated with the ducts.

1. Create a new layer for the gall bladder and make a selection from the path created earlier and fill it with a dark green color; R50, G80, B60 would be a good starting point. See Figure 7.15.

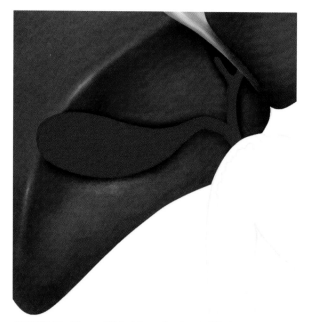

FIGURE 7.15 The gall bladder selection is filled with dark green.

2. Because the gall bladder and the ducts are basically cylindrical in shape, they are easy to paint, and you can do so in one layer. With the selection still active, use a large, soft round brush loaded with a darker version of the base green color and paint the shadows. Finally, to complete the gall bladder's round shape, add the highlights and the reflected light underneath. See Figure 7.16. If you don't like the smoothness of the stock brushes try applying a filter, like Sponge, to the gall bladder.

Painting the Stomach and Gastric Bypass

The primary focus of the exhibit is the anatomy of the stomach and the Roux-en-Y bypass. The stomach and bypass will draw attention to the failed staple lines and to the possible route taken by bile, pancreatic enzymes, and food as they spilled into the peritoneal cavity. Gastric organs such as the stomach and the intestines are almost always painted in variations of flesh colors. In this illustration, details like blood vessels, fat, and connective tissues have been omitted from the stomach surface to allow the viewer to focus on the disrupted staple lines.

When empty, the stomach is collapsed like an empty bag, but painting a collapsed stomach makes it uninteresting, difficult to see detail, and sometimes unrecognizable as a stomach. So the stomach is almost always painted as though it was inflated with some invisible gas. Though not completely accurate, this approach creates a clearer illustration. However, to

FIGURE 7.16 The shadows begin to define the shape of the gall bladder and the ducts. The highlights are painted to complete the gall bladder.

prevent the stomach from looking like a balloon, the surface is not painted as though it were taught, but has some variations or waviness indicated by shadows and highlights.

The stomach is simple in structure. Some notable characteristics for this illustration include the lesser curvature, which is the inner curve, the greater curvature, which is the larger outer curve, and the pylorus. The pylorus is located at the distal end of the stomach at the junction where the stomach empties into the first section of the small intestine called the duodenum. The pylorus is a sphincter that is usually illustrated as an abrupt narrowing in the passageway between the stomach and the duodenum.

The short sections of small intestine that illustrate the bypass are painted in similar surface colors and characteristics as the stomach. It is important to note that even in these short sections of intestine, there are telltale flexures or permanent bends in the intestine. In this illustration the Duodenojejunal flexure is clearly seen directly below the stomach, as the duodenum becomes the jejunum and changes direction. Typically, the flexures of the intestines are illustrated by a change in lighting that indicates the change in direction and also by folds and creases in the surface of the intestine created by the turn in the intestine.

Painting the stomach and bypass is straightforward; three layers— one for the base color, one for the dark and shadow colors, and one for the highlight colors—are used to compose the surface. As we have learned in

previous chapters, the multiple layer technique provides better control over the painting process. However, if you are feeling a bit adventurous, the stomach and bypass can be painted in one layer. The mucosa of the stomach, the cut-away of the pylorus and duodenum, and the staples are all painted in separate layers.

1. Make a selection for the esophagus, stomach, and duodenum and fill it with the base color of the stomach, R250, G190, B150. Figure 7.17.

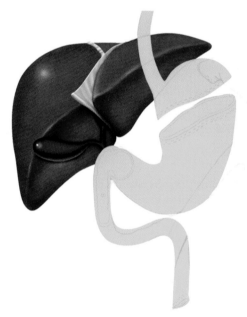

FIGURE 7.17 The base color of the stomach is applied first.

2. Next, the shadow colors that define the round shape of the stomach are laid down in their own layer with a large soft round brush set to a low opacity and Airbrush mode. If you are using a digitizing tablet, open the Brush Preset palette, check Shape Dynamics and Other Dynamics, and set their drop-down menus to Pen Pressure. This will give you better control over the brush stroke. As you paint, the shadow colors begin to create the unevenness of the stomach surface to prevent the stomach from looking stiff. The pyloric sphincter, located at the distal end of the stomach, is indicated by a depressed area as it connects to the duodenum. See Figure 7.18.

3. Set the Foreground color to white and gradually build up the large areas of lighter color with a soft round brush set to a low opacity. The smaller highlights are painted intermittently to prevent the stomach from looking like an inflated balloon. The very small, sharp highlights that make the stomach look wet are almost pure white and are painted

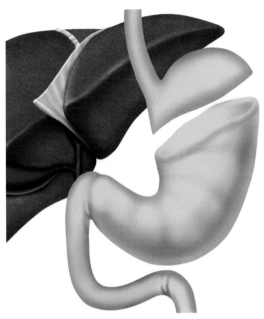

FIGURE 7.18 The shadows and dark areas of the stomach are painted gradually.

with a hard round brush set to varying opacities. See Figure 7.19. The highlights complete the three-dimensional shape of stomach.

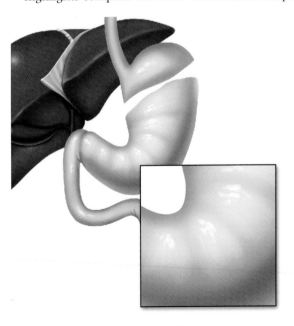

FIGURE 7.19 The highlights finish off the esophagus, stomach, and duodenum.

4. When the staple line at the top of the distal stomach failed, the lining, or mucosa (the inside), of the stomach was revealed. This is one of the main focal points of the exhibit, so it will be painted with detail. When the stomach is empty, the mucosa is composed of folds called rugae. To paint the mucosa, create a new layer and position it above the stomach layers. As usual, a selection must be created to safely mask off the area in which the painting will be done. Once the selection is created, fill it with a dark red, as in Figure 7.20.

FIGURE 7.20 The opening created by the failed staples is started by filling a selection with a dark red color.

5. The rugae are folds composed of many peaks and valleys, so a hard round brush set to a low opacity is used to paint the different levels. The brush strokes are loose and gradually build up to the three-dimensional shape of the rugae. The rugae that are in direct lighting have sharper highlights than those in shadows. See Figure 7.21.

6. To give the edge of the mucosa a more folded and uneven look, use the Eraser tool to create a rough or uneven look along the cut edge, as seen in Figure 7.22.

7. The cut edge of the stomach is painted with a light version of the base color. With the Eyedropper, sample a color close to the highlights but that is not white. Select a medium-hardness brush (a brush that is not soft or hard) and paint the stomach cut edge in a new layer below the layer that contains the rugae. See Figure 7.23.

8. The stomach is not simply a collection bag for food; it has muscles that help to mechanically digest and move food downstream through the

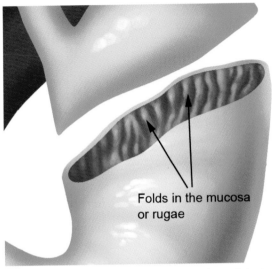

Folds in the mucosa
or rugae

FIGURE 7.21 The rugae have a random and rough look
that is best approximated with loose brush strokes
with a hard round brush.

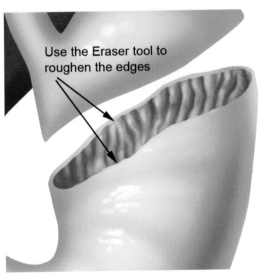

Use the Eraser tool to
roughen the edges

FIGURE 7.22 The edge of the mucosa is given an
uneven look with the Eraser tool.

gastrointestinal tract. When the stomach is dissected, the muscularis, or muscles, is revealed. Though there are three layers of muscles, a single ring of muscles will be painted inside the cut edge to represent the muscularis. Select any round brush and open the Brush Presets

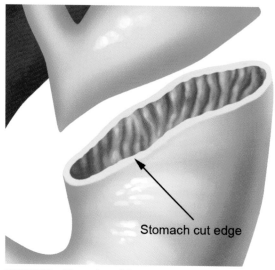

Stomach cut edge

FIGURE 7.23 The color of the stomach cut edge is sampled from the highlights and applied with a medium hardness brush.

palette. Check Color Dynamics, set the Foreground/Background Jitter to about 40 percent, and set the Control to Pen Pressure. The Foreground/Background Jitter will mix the Foreground and Background colors as you paint creating a nice texture. In the Brush Tip Shape settings, adjust the Hardness to about 50 percent and Spacing to about 37 percent, then make sure Spacing is checked. Set the brush Opacity to 100 percent and, as a final adjustment before painting, set the Foreground color to a dark reddish brown and the Background color to a lighter reddish brown. See Figure 7.24.

9. Using short overlapping strokes, paint the muscularis, as seen in Figure 7.25. The custom brush settings will create a random pattern of lights and darks along the brush stroke, simulating a cut muscle edge. If the Spacing is increased, the result is more distinct areas of light and dark (less overlap) making the individual bundles of muscle fibers more noticeable.

The cut edge around the pylorus and the duodenum and the opening at the distal end of the jejunum bypass are created in the exact same way as the cut edge around the top of the distal stomach. Notable differences include: the folds in the mucosa of the duodenum are more circular, and the greater duodenal papilla is shown in the duodenum. See Figure 7.26.

The bypass, which is made by rerouting a section of the jejunum, is painted much the same way as the stomach; note that the bypass is being retracted to give the viewer an unobstructed view of the disrupted staple

FIGURE 7.24 To paint the muscle layer in the cut edge of the stomach, a stock brush is customized to make the task easier.

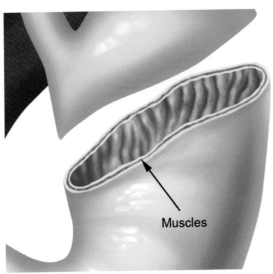

Muscles

FIGURE 7.25 The muscle layer is painted with the customized stock brush.

line. See Figure 7.27. The retractor is very simple and painted in just one layer. A Bevel and Emboss Layer Style is applied to quickly give the retractor thickness without having to paint it. The final step in painting the stomach and bypass is to create the staple sutures.

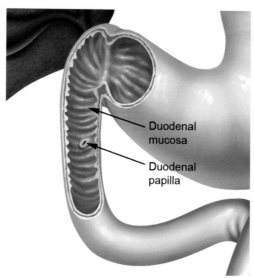

Duodenal
mucosa

Duodenal
papilla

FIGURE 7.26 The technique used to paint the cut
edge at the top of the stomach is repeated to paint
the cut edge of the pylorus and the duodenum
and the distal end of the jejunum bypass.

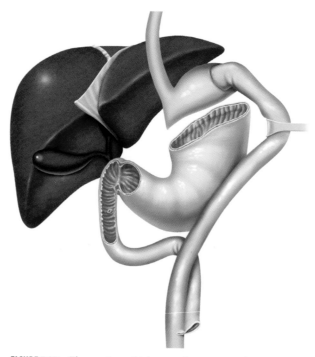

FIGURE 7.27 The section of jejunum that creates the bypass is
painted in the same way as the stomach.

10. Figure 7.28 shows that the staples start as a small rectangular selection created with the Rectangular marquee tool. The staples are made out of metal, so the initial fill color is in the blue-gray range. To give the staples some dimension, use a small brush to create a dark underside and a lighter top. You could also use the Bevel and Emboss Layer Style to quickly give the staple depth. On the right side of the staple, paint a small patch of highlight color to simulate the indentation created by the staple. Now that there is one staple created, it is just a matter of duplicating the single staple until the staple lines are created.

FIGURE 7.28 A single staple is created; it will be used to build the rows of staples.

11. Use the Transform tools Move, Rotate and Scale to position the staples. The staples that are farther away from the viewer are a bit smaller. Based on the sketch, there are two rows of staples along the bottom of the stomach pouch, the top of the distal stomach, the proximal end of the bypass, and the distal end of the bypass, as in Figure 7.29.

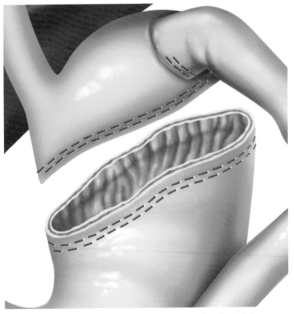

FIGURE 7.29 The Transform tools are used to build the rows of staples.

At this point the liver, gall bladder, stomach, and the bypass with the staples should be complete as seen in Figure 7.30. Next, the pancreas will be added.

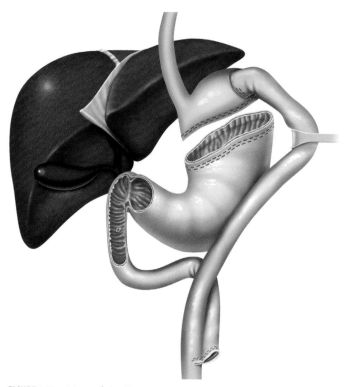

FIGURE 7.30 Most of the illustration is now complete.

Painting the Pancreas

The pancreas is a lobular organ made up of a head section, body, and tail. The pancreas sits behind the stomach, with the head of the pancreas tucked into the loop formed by the descending and transverse duodenum. Through the greater duodenal papilla flow digestive enzymes secreted by the pancreas. In this illustration, a single papilla is illustrated; sometimes there are two distinct papillae in the duodenum. The pancreas is illustrated in different manners and in a range of colors, from almost yellow to beige to tan/pink. In this illustration, to distinguish it from the stomach, we'll use a range of yellows.

1. At this point, we determine whether to use multiple layers or a single layer to paint this part of the illustration. Since the pancreas is fairly

simple, we'll use two layers. The first layer will hold the base color, which is a raw sienna, as seen in Figure 7.31.

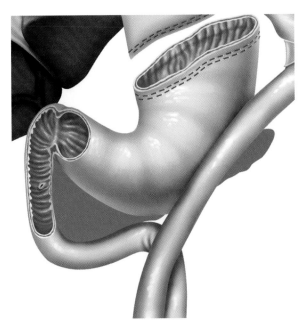

FIGURE 7.31 The beginning of the pancreas.

2. The lobes of the pancreas are painted using a hard round brush, but before painting, the brush is customized in a similar fashion to the brush used to paint the muscularis of the stomach. The three-dimensional shape of the pancreas is gradually defined by successive, short brush strokes, starting with dark mustard yellow brush strokes and ending with lighter brush strokes. To help define the individual lobes, the Eraser tool is used to remove some of the color between the lobes to reveal the raw sienna below. As a final step, the shadow cast by the stomach onto the pancreas is painted. See Figure 7.32.
3. Since the pancreas rests on top the transverse duodenum a new layer is created to paint the bit of the pancreas, as in Figure 7.33.

FINISHING UP

In this illustration, the liver is reflected, or lifted upwards, to reveal the stomach, but because the stomach normally lies behind and underneath the liver, the esophagus and the fundus of the stomach should not be

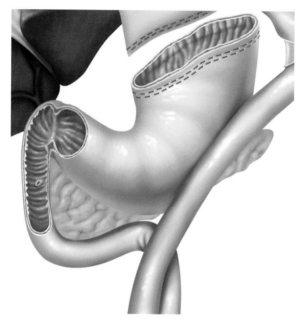

FIGURE 7.32 The lobes of the pancreas are painted with a customized stock brush.

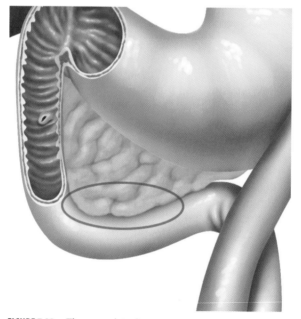

FIGURE 7.33 The completed pancreas.

shown in front of the left lobe of the liver. However, hiding part of the stomach fundus, which makes up the stomach pouch, is not a good idea because as much of the stomach as possible should be visible in the exhibit. To solve this problem, the esophagus and the fundus will be ghosted as though they can be seen through the liver. Ghosting is a common illustration technique that allows the viewer to see information that would normally be hidden, but at the same time, allows accurate placement of the structures that are ghosted.

A Layer Mask will be used to create the ghosting effect, but since the stomach is painted in several layers, the layers have to be flattened first. However, never flatten layers in an original painting unless you are absolutely sure that you will not need the information in those layers. Once layers are flattened, you will loose the ability to edit the contents of the layer separately from other layers. If you definitely need to merge layers to continue, as in this case, the best solution is to create a copy of the Photoshop file and work with the copy, leaving the unique layers intact in the original file. The quickest way to make a copy of a Photoshop file is to use the Duplicate Image command from the Edit menu.

1. To flatten the stomach layers only, select the base color layer for the stomach and then link all of the stomach layers. From the Layers palette fly-out menu, choose Merge Linked. See Figure 7.34.

FIGURE 7.34 The stomach layers are flattened in a copy of the original Photoshop file using the Merge Linked command.

2. Next, click once on the Add Layer Mask icon at the bottom of the Layer palette. See Figure 7.35. This creates a Layer Mask in the stomach layer.

FIGURE 7.35 Add a Layer Mask to the new stomach layer.

3. With a large black soft round brush set to 50 percent opacity, paint over the esophagus and the fundus. Gradually, the esophagus and the fundus fade, and the liver underneath becomes visible. Leave just enough of the esophagus and the fundus so that they are visible. See Figure 7.36. Use the Layer Mask technique to fade the distal end of the bypass.

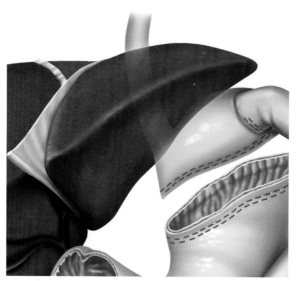

FIGURE 7.36 In the Layer Mask, gradually hide the esophagus and fundus, leaving them barely visible.

Now that the painting is complete, it is time to prepare the painting for import into the layout program. If the illustration will be imported into Adobe Illustrator for layout, there are no further steps, because Illustrator will import native Photoshop files. However, if the illustration is being imported into another layout program such as QuarkXPress, Freehand, or Canvas, it is best to save a copy of the Photoshop file as a TIFF file. TIFF files

can be imported into just about any program. Once the main illustration is imported into the layout program, the other illustrations that make up the exhibit are imported and labeled. See Figure 7.37.

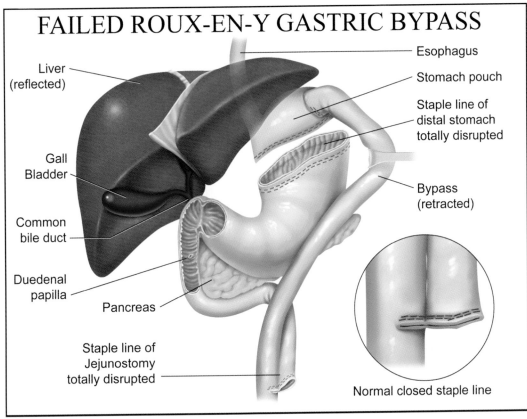

FAILED ROUX-EN-Y GASTRIC BYPASS

- Esophagus
- Liver (reflected)
- Stomach pouch
- Staple line of distal stomach totally disrupted
- Gall Bladder
- Bypass (retracted)
- Common bile duct
- Duedenal papilla
- Pancreas
- Staple line of Jejunostomy totally disrupted
- Normal closed staple line

FIGURE 7.37 The completed exhibit.

INTERVIEW WITH MICHAEL PHIFER OF PHIFER LAW

How does a lawyer decide what information to include in a medical-legal exhibit?

The information included in an exhibit is that which will be most helpful to the jury in understanding the nature of the injuries suffered or how those injuries occurred.

What are some of the general rules that a lawyer must keep in mind to make sure that opposing counsel does not object to an exhibit? In other words, what makes an exhibit admissible in court?

It has to be a fair and accurate depiction of the subject matter, and it must be helpful to the jury's understanding of the case. An expert should testify that the exhibit is a fair and accurate depiction of the subject matter and should also state that it would be helpful in explaining to the jury the facts of the case.

Although this may seem obvious, specifically what expectations does a lawyer have of an exhibit? In other words, how does it help in court?

Visual evidence is very powerful in this age of electronic communications and television. The exhibit needs to be professionally prepared, since jurors are comparing it to the images they see on computers and television. It must also be able to visually communicate its message with little reliance upon words.

Lawyers want medical exhibits to look professional, illustrate clearly, and explain and support the key points of their message to jurors. For example, exhibits must explain the nature of injuries, and in the case of malpractice cases, exhibits should include timelines for medical treatment with key delays in treatment and critical errors highlighted. Exhibits of surgical procedures should explain how and when negligence may have occurred. It is important for an exhibit to be professional and clearly explain the key points of the lawyers, because an exhibit may remain on display in the courtroom for hours or even days, silently conveying its message to the jury.

What do you look for in a medical artist or medical-legal illustration company that will produce exhibits for your case?

The ability to create cost-effective, professional quality exhibits on short notice with minimum supervision by the attorney.

What three characteristics should a good medical-legal exhibit have? What three characteristics would a poor medical-legal exhibit have?

TOP THREE GOOD CHARACTERISTICS:
1. Persuasive
2. Imaginative
3. Accurate

TOP THREE POOR CHARACTERISTICS:
1. Not clear
2. Slow turnaround
3. Sloppy

Are exhibits that use 3D illustration or animation common?

Animations and 3D illustrations are used but due to their expense with modeling, setup, and labor costs, they are typically used only in the most serious cases. I typically see 3D modeling and animation in automotive product liability litigation (accident sequencing).

How do you think that medical-legal exhibits have changed in the last 10 years?

With the advent of computers, turnaround and quality have improved and costs have gone down.

What do you think are some pros and cons of stock illustration as opposed to case-specific or custom exhibits?

Stock exhibits are usually cheaper but may not fit the facts of your case. However, not every case needs or requires custom exhibits. After all, there are only so many ways to depict a broken ankle.

CONCLUSION

Medical artists that create legal exhibits use their knowledge in medicine and science, as well as their skills as communicators, to meet the challenge of producing exhibits that focus attention, are easy to understand yet comprehensive, and are admissible in courtrooms. As we have seen in this chapter, today that challenge is met with a computer and with programs like Photoshop with which one can produce digital paintings.

VETERINARY ILLUSTRATION

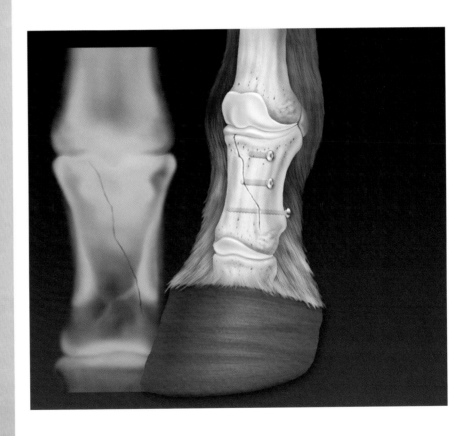

INTRODUCTION TO VETERINARY ILLUSTRATION

The principles that apply to the production of standard medical illustration—research, accuracy, aesthetics, content, and appropriate design for audience—also apply to veterinary illustration. However, veterinary illustration is a unique specialty that requires knowledge beyond human anatomy and physiology, because the veterinary illustrator must understand the anatomical systems of different animal species. Veterinary illustration has a long history dating back hundreds of years, but in the United States, as with human medical illustration, professional veterinary illustration can be traced back to Max Brödel's veterinary textbooks.

Obviously, the subject matter of veterinary illustration is nonhuman animals, especially domestic animals, such as dogs, cats, pigs, domestic birds, goats, cattle, horses, and so on. See Figure 8.1. Veterinary illustration is of great importance because it disseminates clinical, research, and healthcare information to veterinarians, animal caretakers, ranchers, farmers, and even pet owners. Veterinary illustration appears in a wide range of publications, including academic books and journals such as *Veterinary Medicine*, where it is usually divided into small and large animal care, and in lay magazines, like *Cat Fancy* and *Dog Fancy*.

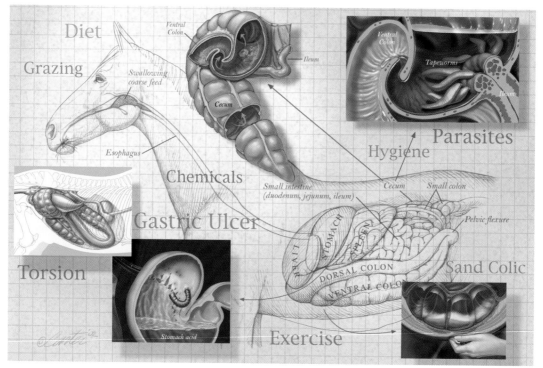

FIGURE 8.1 The subject of veterinary medical illustration is typically domesticated animals. "Causes of Equine Colic" by Kip Carter. Scanned drawings painted in Photoshop. © 2004 Reprinted with permission from Kip Carter.

Sometimes the line between veterinary illustration and natural science illustration is not always distinct, because the veterinary illustrator is often called upon to create illustrations of animals that are not quite domesticated (or recently domesticated), such as lizards, snakes, ferrets, and exotic birds, or of animals that are wild, such as apes, big cats, whales, and birds, as seen in Figure 8.2. One variable that may help to distinguish veterinary illustration from natural science illustration is that veterinary illustration almost always depicts clinical topics like therapies for injury and disease, and anatomy and physiology, whereas natural science illustrations deal more with general ecology, biology, and zoology.

FIGURE 8.2 Sometimes the line between veterinary illustration and natural science illustration is blurry. "Dendrobates azureus" by Chris Akers. Photoshop. © 2004 Reprinted with permission from Chris Akers.

TUTORIAL **FRACTURE OF THE FIRST PHALANX IN AN EQUINE**

PROJECT OVERVIEW

The veterinary illustration in this chapter will be created for an article on fractures of the first phalanx (pastern) in horses and will be published in a horse magazine as opposed to an academic veterinary journal. The purpose of this illustration is to clearly depict the location, pathology, and repair of a spiral fracture of the pastern of the foreleg. The illustration will be designed for a lay audience and will be created as an editorial illustration, which will allow room for a more interesting design.

RESEARCH

Fracture of the pastern is a common injury in performance and athletic horses, and can occur from activities such as racing, roping, cutting, and jumping, but can also happen from stable or pasture accidents. See Figure 8.3. Hairline fissures, spiral fractures, and even severe comminution are typically the result of rotational stress and compression forces from sudden turns, slides, and landing from jumps. Treatments for different types of fractures range from rest to casts to internal immobilization with lag screws. This illustration will depict the latter: immobilization of the fracture with lag screws to allow the fracture to heal.

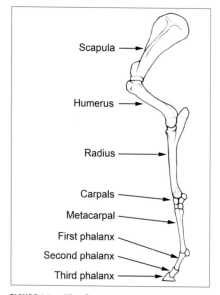

FIGURE 8.3 The first phalanx or pastern in a horse makes up part of the digit or finger.

The anatomy of domesticated animals is as well documented as that of humans, and there are many resources available for the artist. The reference book used in this project was *Atlas of Equine Surgery*. Other reference materials included x-ray films of various types of fractures. In most projects, a medical artist works with an expert who will provide much of the clinical and technical information for the content of the illustration. However, even though an expert is readily available, the artist will still need to become familiar with the anatomy and physiology of the animal being illustrated—in this case, a horse—and thoroughly understand the therapy being illustrated—in this case, immobilizing a fracture with lag screws.

DESIGNING THE ILLUSTRATION

To accomplish the goal of the illustration, an x-ray that shows a spiral fracture and a color drawing of the lag screws immobilizing the fracture will be used to clearly show the location of the spiral fracture and how it is repaired. However, just placing the x-ray next to the drawing is not very interesting and is more typical of an illustration for an academic publication, so the job of the artist is to work out a design that not only conveys all the clinical information but is also interesting and aesthetically pleasing. In this design, the x-ray will be used as a large background element. Overlapping the x-ray will be a full color drawing of a horse's foreleg from the metacarpal down to the hoof. This will orient the viewer. Finally, ghosted through the foreleg will be the metacarpal pastern, or first phalanx and the second phalanx. The pastern will show the fracture and the lag screws in place. See Figure 8.4.

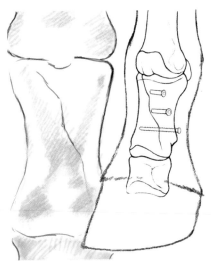

FIGURE 8.4 A sketch of the illustration's design and layout.

PAINTING THE FORELEG

The first element that will be painted is the foreleg, as seen in the sketch. The foreleg is composed of the skin covered with fur and the hoof. The hoof and the fur will be painted with custom brushes that will tremendously facilitate the process of painting the texture of the hoof and the hundreds of hairs in the fur.

Painting the Hoof

ON THE CD

To get started, open the horse-fx.psd file found in the Chapter 8 folder in the accompanying CD-ROM. The horse-fx.psd file already has the guide sketch, the blue background, and paths for creating selections. Also, load the horse-fx.abr brush preset. To load the *.abr file, copy it from the Chapter 8 folder in the accompanying CD-ROM and place it in the Photoshop Brushes folder. The horse-fx.abr brush preset contains two similar custom brushes that will be used to paint the hoof texture and the fur. You can study the brushes' presets to see how they work.

To make the brush appear in the Brush Preset Picker so you can use it, either restart Photoshop or select the Brush tool, open the Brush Preset Picker, and click once on the small arrow pointing to the right. From the pop-up menu choose Load Brushes and select the horse-fx preset. New brush presets usually appear at the bottom of the brush list.

The hoof of a horse is actually its fingernail (or claw), which is made out of keratin—the same material that human fingernails are made of. It may be painful for us to think that a 1,200 pound horse walks around on the nail of one finger, but the foot of a horse is uniquely adapted to a life of running in open grasslands. Though the hoof of a horse is a complex structure, we will only be painting its outer surface. If you look closely at your fingernails you will see a texture of ridges created by the nail bed as it produces the nail. Similarly, a horse's hoof has a texture of ridges.

1. Horse hooves come in all shapes, sizes, and colors. The base color for the hoof in this illustration will be raw sienna, because it will compliment the blue background and the bone colors. Since this is an editorial illustration, the goal is to make the illustration look interesting in addition to telling its story. First, create a new layer and name it hoof, then Ctrl + click (Command+Click) once on the Hoof path in the Paths palette to make a selection. Click once on the Foreground color to open the Color Picker and enter R150, G80, B30 in the RGB values to select raw sienna; click OK. Then fill the selection with the new color by pressing Shift + F5 (or Edit:Fill), select Foreground color, and click OK, as in Figure 8.5.

 Remember that you can hide the "marching ants" of the selection without turning off the selection itself by toggling Ctrl + H (Command + H). Temporarily hiding the "marching ants" helps to see the area you are working in without interference.

FIGURE 8.5 Create a selection from the hoof path in the Paths palette and fill it with raw sienna.

2. Next, select a soft round brush, make its color a darker version of the raw sienna, and set the brush opacity to about 15 percent. Gradually build up the general shape of the hoof, as in Figure 8.6.

FIGURE 8.6 The general shape of the hoof is defined with a dark soft round brush.

3. To paint the hoof texture, select the Brush tool, open the Brush Preset Picker, and select the Hoof brush preset (you installed the Hoof brush earlier). Once again, load the brush with a darker version of raw sienna or dark brown and adjust the brush opacity to about 30 percent. Gradually build up horizontal ridges by following the round contour of the hoof, as in Figure 8.7.

FIGURE 8.7 The beginning of the hoof texture.

4. When you are done with the first set of texture ridges, switch to light brown and, with the Hoof brush, apply short brush strokes that follow the ridges you painted in the previous step. Concentrate the strokes in the middle to create a highlight. See Figure 8.8.

FIGURE 8.8 The highlights are applied with the same brush.

5. Continue to define the shape and texture of the hoof by building up the texture of ridges and the general shape of the hoof. See Figure 8.9.

FIGURE 8.9 The completed hoof.

Painting Short Fur

From a distance, it is difficult to make out the individual hairs in a horse's coat, but close up, they are readily visible. In the next few steps, we will walk though a simple process to paint short fur with Photoshop. At first, it may seem that painting hundreds of individual hairs would be a daunting task, but as we have seen in previous chapters, one of Photoshop's best features is its new Brush Engine, which allows complex textures to be readily painted.

However, the best "tool" in painting believable fur is not Photoshop or custom brushes, it is being observant and studying the patterns and colors that make up fur in different animals. All hair and fur grows in distinct patterns; getting this pattern correct from the start is very important. To make the job easier, be sure to have several reference photos of horse fur available as you paint so you can check your work. More important, painting fur should be a fun exercise where you get to experiment and be creative. Try not to get caught up in making each hair perfect; relax and let Photoshop do most of the work for you. The goal here is not to paint each hair but to paint a patch of fur that is believable.

1. As you did when you started the hoof, create a selection from the leg path in the Paths palette and fill the selection with dark brown. See Figure 8.10.
2. Next, select the Brush tool and, in the Brush Preset Picker, choose the Fur brush preset. Load the brush with very dark brown and apply a layer of brush strokes that follow the downward pattern of the fur on a horse's leg, as in Figure 8.11.

FIGURE 8.10 Make a selection from the leg path and fill it with dark brown.

FIGURE 8.11 Select the Fur brush preset, load it with dark brown, and paint the first layer of fur. Note that the natural pattern of fur growth is followed by the brush strokes.

3. The fur color pattern that we'll paint on the foreleg is often referred to as a "sock" or "stockings" because the fur near the hoof is lighter in color than the rest of the leg, giving the appearance that the horse is wearing socks.

 Load the Fur brush with a light beige color and lower the brush's opacity to about 20 percent. Concentrate the beige color towards the hoof and, as you work your way up the leg, blend in the brush strokes with the base color painted in the previous step. Apply short brush strokes to gradually build up layers that simulate clumps of fur. Make some areas darker than others to help create the illusion of depth. If needed, select the Eraser tool and choose the Fur brush

preset as the Eraser's brush tip. By choosing the Fur brush preset for the Eraser, you can remove color using the same pattern you were painting with. Set the Eraser's opacity to about 15 percent and create subtle dark areas by removing color.

Because fur is generally made up of more than one color (take a look at your cat's or dog's fur), load the brush with light brown and mix it in with the base beige color then, as you paint, begin to sample the new colors with the Alt modifier key (Option) and mix those colors in. Try adjusting the brush opacity every few strokes to strengthen the sense of depth. The brush strokes should always follow the general pattern of fur growth, with a little variation here and there to keep things from appearing stiff. See Figure 8.12.

FIGURE 8.12 Gradually build up the fur by applying layers of brush strokes with similar shades of colors and different brush opacities.

4. Continue to build up the clumps of fur, gradually mixing colors until the fur looks similar to Figure 8.13. Notice that bright highlights have been worked into the fur near the front of the leg and that the fur is not one consistent color but a blend of many colors.

5. To give the edges of the leg a "furry" look, select the Smudge tool and pull out wisps of fur. Leave the Smudge tool's setting as default but adjust the brush size to about 15 pixels. Start the smudge stroke in the fur color and move towards the outside of the leg. See Figure 8.14.

The completed leg should like Figure 8.14. The goal here was to paint fur without having to paint each individual hair. By using a Photoshop custom brush that does the majority of the work, we are free to concentrate on the larger characteristics of fur—such as color, texture, and lighting—making the whole process easier and more fun. In this illustration, the furry leg and hoof are not the main focus of the illustration, they are there to orient the viewer as to what part of the horse they are looking at. In fact, when the illustration is complete, most of the fur will be hidden by the

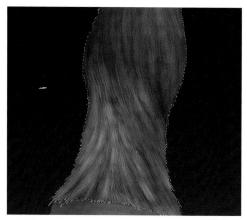

FIGURE 8.13 As a finishing touch, apply highlights and accentuate the dark shadows created by the clumps of fur and by the general shape of the leg.

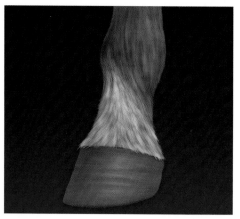

FIGURE 8.14 Use the Smudge tool to create wisps that give the outline of the leg a furry look.

bones we'll paint in the next steps. Consequently, the fur and hoof are painted with just enough detail to make them realistic and believable. However, you can see that with a little effort and a custom brush, there really is no limit to how much detail you can create when painting fur. The previous steps on painting fur should give you enough of a foundation so that you can experiment with your own furry projects.

PAINTING BONES AND A FRACTURE

The focus of this illustration is the repair of a spiral fracture in the first phalanx or pastern of a horse's foreleg. As such, the main elements in the illustration will depict a three-quarter view of the pastern with lag screws

immobilizing the fracture so that it can heal. The three-quarter view is used because it gives the viewer a better sense of depth and dimension than a front or side view.

Bones are a common subject in medical illustrations and are illustrated in a broad range of styles. Living bone is enclosed in a dense, white, fibrous covering called the periosteum. However, in most medical illustrations bones are usually illustrated without the periosteum, allowing an unobstructed view of the surface of the bone.

The bones of the skeletal system form a living framework for the bodies of all vertebrates, including humans. Bones are an easily recognized and understood part of vertebrate anatomy by a lay audience, because even the smallest bone is clearly visible and their role as the framework and protection of the body is obvious. The skeletal system as a whole or in part is one of the most commonly illustrated subjects in medical illustration, because bones form natural landmarks that can be used to orient an illustration.

It may be hard to believe, but bones are living tissue that is constantly repaired and replaced. When illustrating bone, it is important to remember that many of its surface characteristics are directly related to the fact that the bone is alive. For example, foramina are perforations where blood vessels and nerves penetrate the bone. Some large foramina are common in most vertebrates, such as the mental foramen of the mandible or the foramen magnum of the skull, however, smaller foramina are generally scattered through all bones. Many of the ridges or rough areas on the surface of bone are caused by ligaments and tendons as they firmly attach to the bone, and even blood vessels can leave impressions on the bone surface.

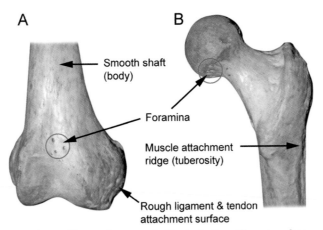

A

B

Smooth shaft
(body)

Foramina

Muscle attachment
ridge (tuberosity)

Rough ligament & tendon
attachment surface

FIGURE 8.15 These photographs illustrate the different surface characteristic of bone. Both photographs are of a right human femur. a) shows the front distal of the knee, b) shows the back of the hip. (Photography by Mike de la Flor.)

See Figure 8.15. So even though bones may resemble a hard inanimate object, in reality they are just as alive as any other part of the living organism.

The next few steps will show you one way to illustrate bone tissue using Photoshop. It helps to have reference photographs handy so that you can see the different bone textures. In this tutorial, the Lock Transparent Pixels option in the Layers palette will be introduced. The Lock Transparent Pixels locks the transparent pixels in a layer so that they cannot be changed. If you recall from Chapter 6 where we first used Lock Transparent Pixels, this feature allows you to control where paint is applied without having to use selections.

1. To begin, hide the layer that contains the illustration of the furry leg and make the Sketch layer visible. It may help to hide the blue background at this stage and reveal the white background layer. Next, create two new layers in the Layer palette, one for the bone color and one for the cartilage color. Select a small hard round brush (about 20 pixels), make the Foreground color tan-yellow (R255, G233, B185), and carefully trace or outline the bones using the sketch as a guide. Once the outline is complete, use a larger brush to completely fill in the rest of the bone color. See Figure 8.16.

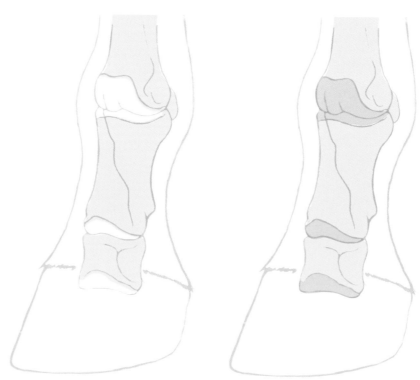

FIGURE 8.16 The bone base color painted in its own layer.

FIGURE 8.17 The cartilage base color is also painted in its own layer.

2. Repeat the same painting process for the cartilage except, instead of a tan color, use a blue-gray color (R195, G185, B215), as in Figure 8.17.

3. Now that both layers (bone and cartilage) have solid pixels and transparent pixels, select each layer and turn on the Lock Transparent Pixels option in the Layers palette. See Figure 8.18. Turning on Lock Transparent Pixels makes it so that any painting will be applied only in pixels that already have a color, or that are nontransparent. The Lock Transparent Pixels option effectively creates a type of pseudo-mask that does not require a selection.

4. Next, begin the gradual process of building up lights and darks to create the three-dimensional shape of the bones. The light in this illustration is coming from upper left. Keep in mind that most bones are not perfectly smooth, and often a single bone will have different types of surface textures. The shaft of the pastern has a few ridges on the front created by attachment points or grooves caused by blood vessels. Select a soft round brush set to a low opacity and make the Foreground color dark brown (R125, G75, B30). Gradually define the general shape of the bone, as in Figure 8.19.

FIGURE 8.18 Select each layer that has solid and transparent pixels and turn on the Lock Transparent Pixels option to control where paint is applied.

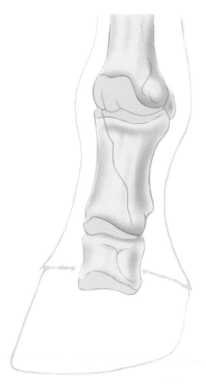

FIGURE 8.19 The general shape of the bone is defined with a soft round brush.

5. To break up the smooth application of color created by the soft round brush, select the Eraser tool and choose the Chalk brush preset as the Eraser's brush tip. Adjust the Eraser opacity to about 20 percent and randomly "erase" the chalk texture into the smooth color. See Figure 8.20.

6. The distal and proximal ends of the pastern have a distinctly rough surface where ligament and tendon attachments occur. To create the rough surfaces, use the Chalk brush preset (the same one you used with the Eraser tool). Set the brush opacity low and make the Foreground color dark brown (R125, G75, B30). Apply short, single strokes, as though you were stamping the chalk pattern instead of "painting" by dragging the brush. See Figure 8.21. To prevent recognizable patterns from appearing, open the Brush Presets palette, increase the Size Jitter in Shape Dynamics option, and set the menu to Pen Pressure. Of course, this option works only with a digitizing tablet. To add interest to the bone surface, break up any noticeable patterns, and to add texture, use a large spatter brush set to a low opacity to spray subtle stippling around the ends of the bones.

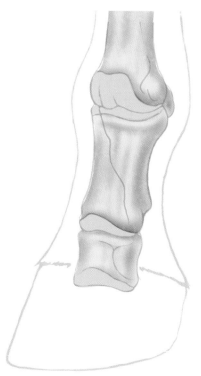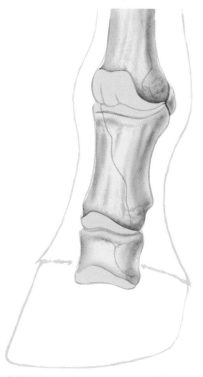

FIGURE 8.20 To break up the smooth color application, use the Eraser tool with the Chalk brush preset to "erase" in a texture.

FIGURE 8.21 The rough ends of the bone are painted with a Chalk preset, then a Spatter brush is used to add texture.

7. Foramina, which are small pits or perforations mentioned earlier, are another important bone characteristic. In the case of long bones like the pastern, foramina tend to be clustered near the ends of the bones. Each individual foramen is easily painted by using a small round hard brush set to almost full opacity. Most foramina are not perfectly round and tend to follow the grain in the bone, so try to make the larger foramina oval. The large foramina form distinct holes or pits in the bone surface that require shading. See Figure 8.22.

8. Bone is usually not illustrated as shiny, so there are no bright specular highlights. So to paint the lighter or highlight areas, use a soft round brush, make the Foreground color white, and set the brush to a low opacity, then gradually build up the lighter areas. Remember that the light source is generally coming from the upper left. Use the Chalk brush once again to add highlights to the rough surfaces. Each larger foramen should have a small highlight delineating its edge. See Figure 8.23.

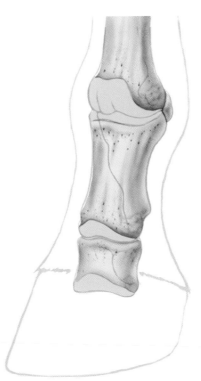 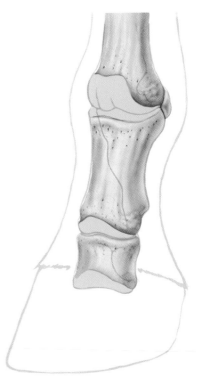

FIGURE 8.22 Foramina are yet another characteristic of bone that needs to be painted.

FIGURE 8.23 Highlights and the lighter areas of the bone surface are painted to complete the three-dimensional look.

9. The entire purpose for painting the pastern was to show the partial spiral fracture, which is actually the simplest part of the painting. Select a very small hard round brush (about 15 pixels), set it to medium opacity, and make the Foreground color a dark maroon red, then trace the fracture line from the sketch. See Figure 8.24. The fracture line is neither uniform nor linear, instead it varies in thickness and is rough, indicated by layering additional brush strokes. Once the initial fracture line is painted, make the Foreground color a darker red and randomly paint in darker spots along the fracture to indicate variations in depth. To make the fracture line appear three dimensional, paint subtle highlights along the edges.

The bone illustration should be similar to Figure 8.25. However, bones have a wide range of textures and are illustrated in a variety of styles, so there is some room for artistic license, especially in an editorial illustration. Next, the cartilage will be finished to complete the bone illustration.

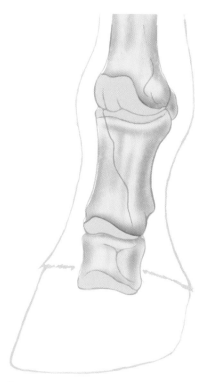

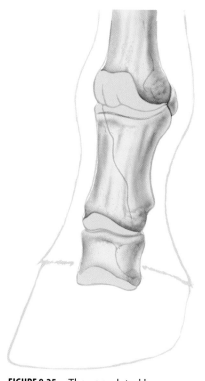

FIGURE 8.24 The fracture is actually the easiest part of the illustration to paint.

FIGURE 8.25 The completed bone.

Painting Cartilage

As we have learned, living tissues are not composed of a single color, and cartilage is no exception. Cartilage is typically represented as a shiny, light colored surface. Additionally, cartilage has a translucent quality that makes it appear to glisten. Color for cartilage can range from white to light blue to warm gray, but in this illustration, the articular cartilage that forms a cushion between the bones will be painted in the blue-purple range with some license to create an interesting contrast to the bone textures.

In step three of the bone tutorial, the basic cartilage shape was painted in its own layer. In the next steps, the three-dimensional shape of the cartilage will be finished with the addition of shadows and highlights. Before proceeding, make sure that the Lock Transparent Pixels option toggle is on in the cartilage layer.

1. Make the Foreground color blue-purple (R165, G195, B155), choose a soft round brush, and adjust its opacity to about 20 percent, then begin to apply darker areas as seen in Figure 8.26.

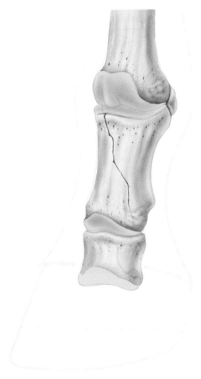

FIGURE 8.26 Start shading by laying down the darker colors.

2. Next, switch to red-purple (R225, G185, B187) and paint subtle gradations from the blue-purple to the base color of the cartilage. See Figure 8.27.
3. Now make the Foreground color white and, with a small soft round brush, add soft highlights around the upper edges and subtle reflected light along the bottom edges of the cartilage. Finally, use a small hard round brush to paint bright highlights, as in Figure 8.28.
4. We are going to revisit the bone layer for a moment. To accent the three-dimensional shape of the bone, add a subtle blue cast (R190, G170, B240) to the right side of the bone with a large soft round brush set to a low opacity, as seen in Figure 8.29.

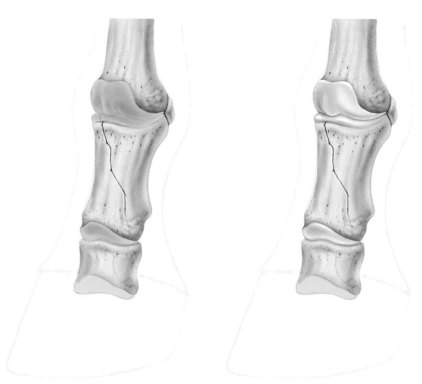

FIGURE 8.27 The red-purple color gives the cartilage a broader range of colors.

FIGURE 8.28 The highlights and reflected light complete the cartilage.

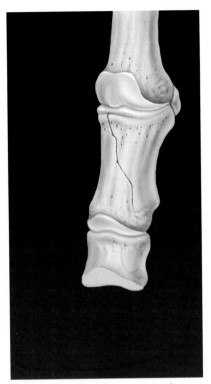

FIGURE 8.29 A subtle blue cast of reflected light is painted on the right side to give the bone more interest and dimension. (The blue background is visible to see the cast light).

Creating the Lag Screws

The lag screws are an important element, though rather than being created directly in Photoshop, they were created in Adobe Illustrator CS, imported into Photoshop, and moved into position. (The lag screws are available in the file screws.psd, found in the Chapter 8 folder in the accompanying CD-ROM.) Illustrator has much better path tools than Photoshop, which were needed to create the outlines of the screws. Though it would have been possible to paint the screws in Photoshop, in an actual production situation, the tool that does the fastest job is always used.

ON THE CD

The heads and threads of the screws were imported into Photoshop into separate layers. The layer that has the screw heads is placed above the bone layer so they appear clearly. The layer that has the threads is placed above the bone layer also, but the Layer Opacity is reduced to about 80 percent to make the threads appear to be ghosted, as if they

were inside the bone. The screw heads have a subtle Drop Shadow Layer Style applied. See Figure 8.30.

At this point, we have completed the horse leg and the skeleton, so the illustration should look something like Figure 8.31. Later in the chapter, we'll make the bones appear as though they are ghosted through the leg. Next, we will use Photoshop to paint an x-ray.

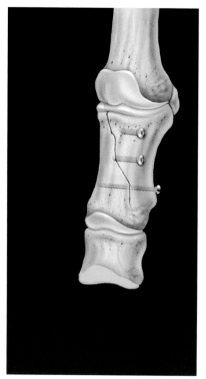

FIGURE 8.30 The lag screws are created in Illustrator and imported into Photoshop.

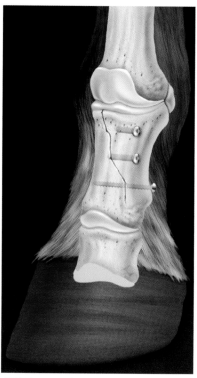

FIGURE 8.31 The completed leg and skeleton.

PAINTING AN X-RAY

It may seem odd that a medical artist would "paint" a radiograph (x-ray) instead of just using the real thing, but sometimes there is good reason. For example, confidentiality or copyrights can make an x-ray unavailable for reproduction. Problems can also occur with the actual reproduction of an x-ray, making it useless for print in a publication. Sometimes an x-ray showing the desired pathology is not available and has to be created, because medical records like x-rays are not stored indefinitely. Finally, in the case of editorial illustrations, sometimes it is easier to paint an x-ray that fits the general design of the illustration than to try to locate an actual x-ray that would work with the design. Note that "creating" an x-ray for publication in

an academic journal, book, or presentation in a medical-legal case is absolutely never done.

To most people, an x-ray appears to be ghostly images that every now and then coalesce into recognizable structures like a knee or shoulder or skull. However, to the trained eye, an x-ray contains a wealth of information about an injury or disease. The image on an x-ray is formed because the tissues in the body have different densities and therefore absorb different amounts of radiation. For example, dense tissue, like bone, absorbs more radiation and appears lighter on the x-ray than less dense tissues like a lung, which appear darker on an x-ray. See Figure 8.32. Infections like tuberculosis or diseases like breast cancer increase the density of tissue, so the disease is detected as a lighter area on the x-ray. Fractures generally appear dark on an x-ray, because they are areas of lower density within the normally dense bone.

The x-ray that we will paint in the following tutorial is of an AP view (anterior-posterior), which means that the x-ray was shot from the front of the leg. By now, we should know that having good reference materials

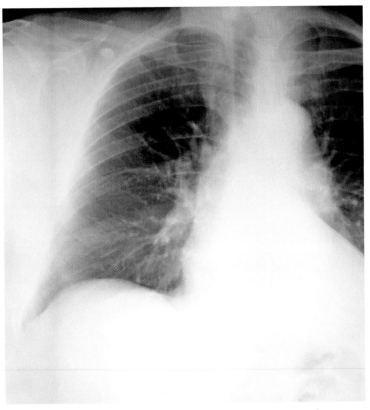

FIGURE 8.32 Radiographs, or x-rays, are created by the amount of radiation that is absorbed by the different tissues in the body.

readily available as you work is absolutely necessary to create images that look real or are at least believable. In this case, the reference materials include several x-rays of pastern fractures.

To begin, hide the layers that contain the leg and the skeleton, leaving just the blue background. Just above the blue background, create a new layer and fill it with black, because it is easier to paint the x-ray on a solid black background. The Paths palette already contains the paths necessary for the selections that we'll use in the next few steps.

There are several methods for creating a selection from a path, for example, Ctrl + clicking on the path or clicking on the Load Path as Selection button in the Path palette. However, in this tutorial, it is important to create the selections using the Make Selection command from the fly-out menu in the Path palette, because the Make Selection command allows you to create a selection with a feather radius to soften or blur the edges of the selection.

1. The entire x-ray will be painted on just one layer, so above the black layer, create a new layer and name it x-ray.
2. In the Paths palette, click once on the first phalanx path and, from the fly-out menu, choose Make Selection. Set the Feather Radius to 10 pixels, check Antialias, and click OK. See Figure 8.33. Creating a

FIGURE 8.33 Make a selection from the first phalanx path with the Make Selection command.

Feather Radius with the Make Selection command will keep any brush strokes that get close to the edge blurry, like an x-ray.

3. Back in the Layers palette, the areas of dense bone, which show up the brightest on an x-ray, will be painted first. The entire x-ray is painted with white; the amount of white is controlled by adjusting the brush opacity. The brighter areas are gradually built up with successive strokes. Select a soft round brush and set the opacity of the brush to about 40 percent, then start roughing the bright areas of the bone, as in Figure 8.34. In the case of the pastern, the densest bone is at proximal and distal ends, showing up bright white on film.

FIGURE 8.34 The distal and proximal ends of the pastern are very dense and show up almost bright white on film. (The selection's marching ants have been hidden with Ctrl+ H.)

4. The next areas of dense bone are created by thick medial and lateral ridges on the palmar side of the pastern where ligaments attach, as seen in Figure 8.35. Even though the ridges are on the palmar side of the pastern, they show up clearly on film, because the x-rays pass through the less dense bone in front and are absorbed by the denser bone behind.

5. Now that the general areas of dense bone are painted, it's time to lower the brush opacity to about 20 percent and fill in the lighter shapes of less dense bone. Painting the less dense bone can begin by simply extending the range of the dense bone and fading it into the black background, as seen in Figure 8.36.

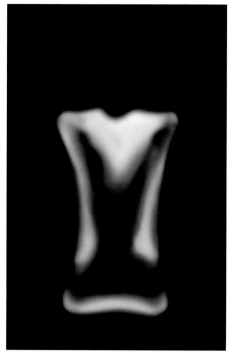

FIGURE 8.35 Thick ridges where ligaments attach also show up bright white on film.

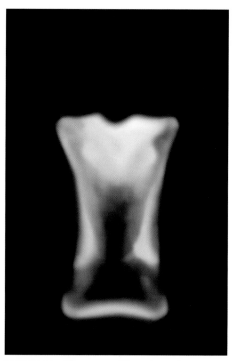

FIGURE 8.36 The areas of less dense bone can start out by subtly extending the dense bone.

6. Because of differences in anatomy and variables in the x-ray procedure such as exposure time, film type, and angle, there is room for variation as to where and how bright the less dense areas appear. This is where having good references to see the general pattern that the pastern creates on film comes in very handy. Remember that the pastern is three dimensional so create a sense of depth in the variations between dense and less dense bone. Also, don't make the bone perfectly symmetrical as that is an easy giveaway to a painted x-ray. See Figure 8.37.

7. Note that in most x-rays the edges of the bone are not distinct, instead, they tend to blend or blur into the background nonuniformly, following the unique variations in bone density. In Figure 8.38 you can see that there is bone beyond the ligament attachment ridges but it's barely visible.

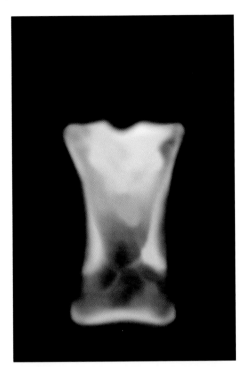

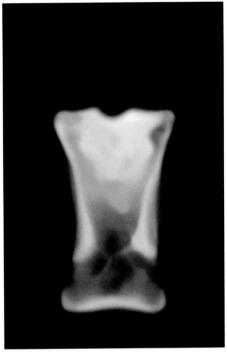

FIGURE 8.37 Create variations in the patterns of dense and less dense bone and remember to not make the image symmetrical.

FIGURE 8.38 The edges of the bone are sometimes not distinct and can blur into the background.

8. Finally, the reason we are creating the x-ray in the first place is to show the partial spiral fracture that is the focus of the article. As we have already learned, fractures in an x-ray show up as dark lines. To paint the fracture, select a very small, medium hardness brush, set to about 60 percent opacity, and make the Foreground color black. It may take a few tries before you get it to look right, so be patient. Fractures are generally not straight lines but tend to meander a bit as the bone breaks at its weakest points, as in Figure 8.39. It is important that you try to make the fracture on the x-ray similar to the one you painted earlier in the drawing.

9. To complete the x-ray, use the techniques in the previous steps to paint the distal end of the metacarpal and the proximal end of the middle or second phalanx, as see in Figure 8.40.

Once the x-ray is done, the Photoshop file should contain a blue background, the furry leg and hoof, the bones, cartilage, screws, and the x-ray. However, we are not done yet, in the next few steps we'll use a little Photoshop magic to make the illustration work together.

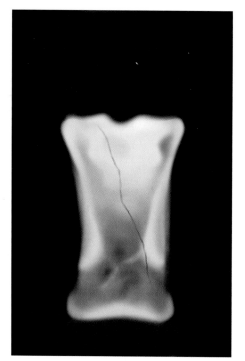

FIGURE 8.39 The fracture on the x-ray is painted with a small, medium hardness brush set to a low opacity.

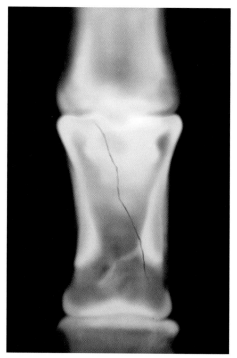

FIGURE 8.40 Finish the x-ray by completing the other two bones.

FINISHING UP

Though all the elements of the illustration are complete, the illustration itself is not quite done. First, we'll use Layer Masks to create the illusion that we are looking through the leg at the bones inside. Then we'll work with the x-ray so that it remains visible but becomes a background element and does not compete with the leg and bone illustration. Finally, labels will be added to help the viewer identify what he is looking at.

1. Hide the layer that contains the x-ray and make sure that the layers that contain the blue background, the leg and hoof, the bones, cartilage, and the screws are visible, as seen in Figure 8.41. The layer that contains the leg and hoof should be below all the bone layers.
2. Make a copy of the layer that contains the leg and hoof. To make a copy of the layer, simply right-click on the layer and choose Duplicate Layer from the pop-up menu. Move the new layer (which contains a new copy of the leg) above all the bone layers.
3. Next, create a Layer Mask in the new leg layer by clicking once on the Add Layer Mask button at the bottom of the Layers palette, as in Figure 8.42.

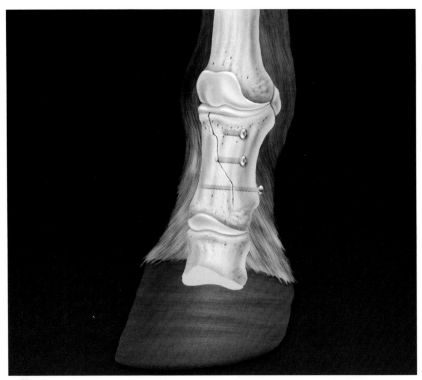

FIGURE 8.41 Make the layers that contain the leg and hoof, bones, cartilage, and screws visible and hide all others.

FIGURE 8.42 Make a Layer Mask in the new leg layer by clicking once on the Add Layer Mask button at the bottom of the Layer palette.

4. Click once on the Layer Mask thumbnail in the new leg layer, select a large soft round brush, and make sure that the Foreground color is black. With the brush, begin to gradually reveal the bones underneath. See Figure 8.43. The mask reveals almost all the bones except that the bottom bone, or second phalanx, is blended into the fur as well as some of the edges of the metacarpal.
5. To complete the illusion, select the original leg layer (the one below the bone layer) and adjust the Layer Opacity to 50 percent. This creates a "halo" of darker fur around the bones, as seen in Figure 8.44. At this point, the leg and bones illustration is complete.

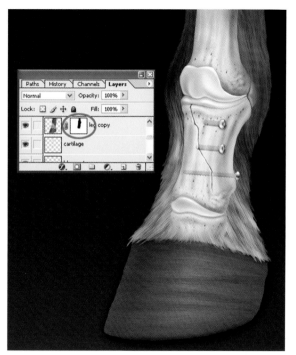

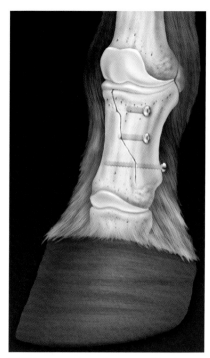

FIGURE 8.43 Paint in the Layer Mask thumbnail with a large soft round brush to reveal the bones below.

FIGURE 8.44 Select the original leg layer and set its Layer Opacity to 50 percent. The leg and bones illustration is done.

6. Reveal the hidden x-ray layer and make sure it is below all the other layers except the blue background. Delete the layer filled with black that was created in the x-ray part of the tutorial. See Figure 8.45.

7. The x-ray is very bright and competes with the bones, so to fix that problem, adjust its Layer Opacity to about 80 percent. Reducing the Layer Opacity keeps the x-ray visible, but it no longer competes with the rest of the illustration, as seen in Figure 8.46.

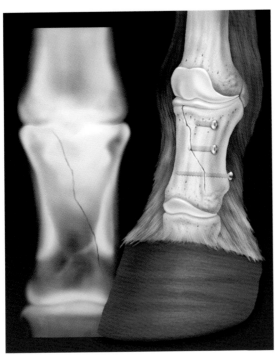

FIGURE 8.45 Reveal the x-ray layer.

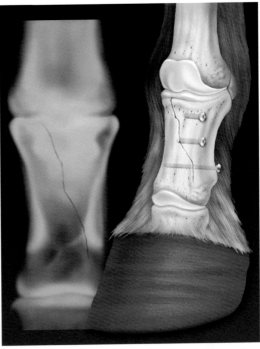

FIGURE 8.46 Reduce the Layer Opacity of the x-ray layer.

8. To make the x-ray a background element, enlarge it so that it bleeds off the edges of the illustration and move it so that the leg illustration overlaps the x-ray. See Figure 8.47. To enlarge the x-ray, use the Transform tool from the Edit menu or press Ctrl + T (Command + T). You can Shift + drag the corner control handles of the Transform box or enter the Height and Width percentages in the Options bar.

9. Finally, use the Type tool to add labels to the illustration, as in Figure 8.48. The leader lines or arrows were created with the Line tool with the Arrowhead option turned on.

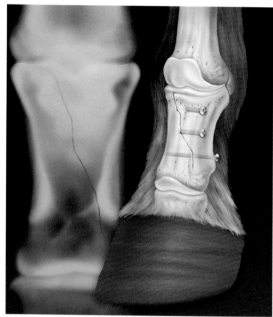

FIGURE 8.47 Use the Transform tool to make the x-ray bleed off the edges and to move it behind the hoof.

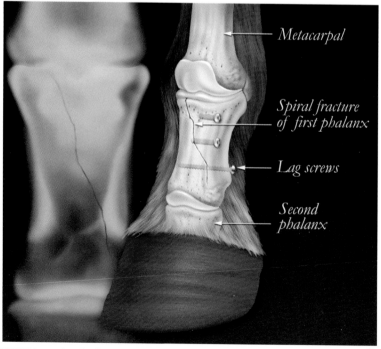

Metacarpal

Spiral fracture of first phalanx

Lag screws

Second phalanx

FIGURE 8.48 Leader lines and labels complete the illustration.

CONCLUSION

Veterinary illustration is one of the more interesting and unique special-izations in medical illustration, because it involves such a wide range of subject matter. The veterinary illustrator has to not only understand the anatomy and physiology of many animal species but also the diseases and therapies specific to different animals, as seen in Figure 8.49. As we have seen with Photoshop, painting complex textures like fur can be easily ac-complished with custom brushes, and with a little practice, we can even create x-rays.

FIGURE 8.49 Anatomy of the great white shark. Photoshop. © 2004 Reprinted with permission from Kip Carter.

9

MEDICAL ILLUSTRATION
FOR THE WEB

INTRODUCTION TO MEDICAL ILLUSTRATION FOR THE WEB

The Internet—specifically the World Wide Web (Web)—has fundamentally changed the way we communicate, learn, and do business. What we now know as the Web began as a worldwide network designed by scientists to facilitate the exchange of information across different types of devices and operating systems. Because of its scientific origins, the Web contained medical information very early in its history, but due to technological limits at the time, it probably did not contain many medical illustrations. In the early '90s, the Web rapidly transformed into a conventional publishing medium, and the majority of its users shifted from the scientific community to a worldwide audience.

When the bulk of the information on the Web started to be authored by graphics designers, writers, and artists (not by scientists), the limitations of HyperText Markup Language (HTML), the language of the Web, became abundantly clear. The original designers of HTML focused on document structure, with little capacity to incorporate visual or multimedia elements into HTML documents. What may seem like an oversight on the part of the Web originators was really a response to the state of network technology 20 years ago, when a 14.4 bps modem was considered state-of-the-art. There would have been no point 20 years ago in designing a transfer protocol that could transmit large multimedia files if the infrastructure to support it did not exist. However, in the last five years, networks, computers, and software have quickly developed in response to consumer demand, and today we enjoy very fast and affordable Internet connections, such as DSL, ISDN, and cable, commonly known as broadband. Companies like Microsoft, Apple, Netscape, Adobe, Macromedia, Anark, and many others are developing technologies that make rich and interactive multimedia experiences over the Web possible.

While today we can view movies, listen to music, play games, or shop on the Web, the initial purpose of the Web was education, the same goal of medical illustration; as such, the Web has always been a potential venue for medical illustrations. But as we have seen, it has taken Web technologies many years to mature to the point where that potential could be fully realized. Though posting low-resolution medical illustrations on the Web has been possible for some time, it is only in recent years that medical artists have been able to produce high-end content for the Web, such as 2D/3D animations, video, interactive applications, and as we will see later in this chapter, real-time 3D applications. These cutting-edge technologies have spawned a new breed of medical artist whose primary focus is developing medical multimedia content.

TUTORIAL MODELING AN ARTIFICIAL HEART FOR REAL-TIME 3D

PROJECT OVERVIEW

The goal of this project is to create a real-time 3D, Web-based presentation that will describe how the artificial heart works once it is implanted into the patient. In the first part of this project, we will model part of the artificial heart using discreet's 3ds max 6. See Figure 9.1. In the second part of the project, we will use Anark Studio 2.5 to create an interactive real-time 3D presentation that can be delivered on the Web or on a CD-ROM. You may be asking yourself what is real-time 3D? Well, if you have ever played a video game on PlayStation, Nintendo, or X-Box then you have experienced real-time 3D.

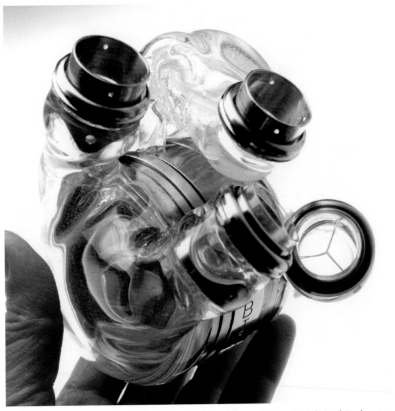

FIGURE 9.1 The AbioCor artificial heart is the subject of the tutorials in this chapter.

BOX MODELING

Box modeling is a polygonal modeling method that allows the artist to interact directly with the surface of the model; in other words, the artist sculpts the model by creating extrusions and bevels, moving edges, and pushing and pulling on vertices. An important advantage of box modeling is that the 3D model generally starts out as a low-resolution (few polygons) model that can be easily managed during the modeling process. Once the basic modeling is complete, the low-resolution model can be converted into a higher-resolution model (many polygons) as needed. For example, for film animation or illustration, the final resolution of the model can be increased significantly with either the MeshSmooth tool or the Mesh-Smooth modifier, or if the model is for real-time 3D, as in our case, we will only slightly increase the resolution to smooth out the model.

MODELING FOR REAL-TIME 3D

Before any modeling project is started, it is important to determine the final medium in which the model you are creating will be used. Since we know that our model will be used in a real-time application, it is important to keep the polygonal as low as possible. This does not mean we will end up with a boxy looking model but we will have to be efficient in our placement of polygons. Real-time applications animate 3D geometry, textures, and lighting as you are watching (hence, the term *real time*), which puts a great load on the computer's processor. The more polygons a model has, the more computing power is needed to make the animation calculations; if a critical point is reached where the computer cannot handle the processing load, the animation will no longer be in real time, frames will be dropped, and the animation will appear choppy. We will try to head off animation problems with our real-time 3D application (which we will develop in the second part of this chapter) by being smart about the number of polygons we use to model our objects now.

GETTING STARTED

In the following tutorial, we will model the right ventricle of the artificial heart using the box modeling technique. The goal of the first part of this tutorial is to introduce you to the basic polygonal modeling tools found in 3ds max 6. We will start out with a primitive shape and gradually model it into the right ventricle of the artificial heart and then smooth the model using the MeshSmooth tool. In this tutorial, we will be modeling only the right ventricle; the left ventricle and other components are already modeled for you. Take a look at Figure 9.2 to get familiar with the parts of the right ventricle we will be referring to in the tutorial.

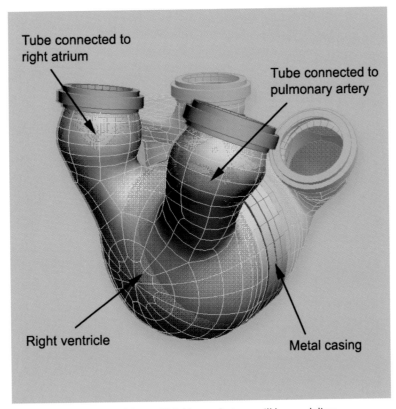

FIGURE 9.2 The parts of the artificial heart that we will be modeling.

ON THE CD

The Chapter 9 folder in the companion CD-ROM has incremental 3ds max files that have the heart model at milestones in modeling. Some of the files will be referenced in the steps, so if you get stuck just open the model and study how it was modeled. Remember to save your work often and get in the habit of saving incremental files of your own work by pressing the (+) plus sign in the Save As dialog box.

Keyboard shortcuts or hotkeys are important, because they save considerable time during the workflow. 3ds max ships with a handy hotkey reference map, but in this tutorial the hotkeys will be shown in parentheses the first time a tool is introduced.

Box Modeling the Right Ventricle

Following are the steps on how to box model the right ventricle:

1. Launch 3ds max or reset it if you already have it open. To reset 3ds max, go to the File menu and select Reset. Resetting assures that we have a clean slate on which to start. To model the heart, we will use

Viewport background images to help guide the modeling process. All the background images you will need are in the Chapter 9 folder in the companion CD-ROM. To get started, right-click once on the Front viewport to make it active, then in the Viewport controls, found in the lower right corner of the user interface, click on the Min/Max toggle. Now the Front viewport is the only one displayed. See Figure 9.3

FIGURE 9.3 Use the Min/Max toggle to make the front viewport the main viewport.

2. From the Views menu choose Viewport Background, (alternatively press Alt+B). The Viewport Background dialog box appears. Click on the Files button in the Background Source tab and browse to the front.jpg file in the CD-ROM. In the Aspect Ratio tab, select Match Bitmap and then check Lock Zoom/Pan to turn it on, and click OK. See Figure 9.4. These options will help keep the background image locked and steady as you model and move around the scene.

3. The Front Viewport should now have a line drawing of the front of the artificial heart, as seen in Figure 9.5a. One final detail before we start modeling: press G to hide the viewport grid. The grid can be very helpful when modeling but sometimes it makes seeing the background image difficult. If you prefer to work with the grid, press G again to reveal it. Finally, select the Zoom tool from the Viewport

FIGURE 9.4 Use the Viewport Background dialog box to set the background image for the front viewport.

controls and zoom in on the line drawing as much as possible. If your mouse has a mouse wheel, you should be able to zoom in and out by scrolling the wheel.

FIGURE 9.5 a) The guide drawing in the background of the front viewport. b) Press G to temporarily hide the viewport grid.

4. To begin modeling, click once on the Create panel and then click on the Shapes button. From the Object Type rollout, select the NGon. In the scene, click in the middle of the circle that makes up the right ventricle and drag out to the edges. 3ds max will draw a multisided circular shape. In the Parameters rollout, make the Radius 105 and the Sides 10. Use the Select and Move tool (W) to center the NGon. Your NGon should look like Figure 9.6.

FIGURE 9.6 A 10-sided NGon shape starts out the modeling process.

5. Before moving on to the next modeling step, reset the viewports by clicking on the Min/Max toggle to see all four viewports. Right-click on the Left viewport and display the left.jpg line drawing (follow the earlier steps for displaying a background image in a viewport). In the Left viewport, move the NGon so that it is flush with the inner edge of the right ventricle. See Figure 9.7.

6. Now we will convert the NGon into an Editable Poly (Poly is short for polygon) so that we can begin shaping it into the right ventricle. Select the NGon in the Modifier stack, right-click on the NGon name, and from the Convert to: list choose Editable Poly, as in Figure 9.8. 3ds max will convert the NGon into a polygon object, and the list in the Modifier stack should now show an Editable Poly object. The first input field in the Modify panel is the name of the object; at this point,

FIGURE 9.7 Display the left.jpg line drawing in the Left viewport.

FIGURE 9.8 Convert the NGon into an Editable Poly.

it should be named NGon01. Type Right ventricle over the old name so now we have our first recognizable object.

7. In these next steps we will use the Bevel Polygon tool to rough in the round shape of the right ventricle. To apply the Bevel Polygon tool we have to expand the Editable Poly object so that we can see its fundamental elements, known as sub-objects. Click once on the small plus sign next to the Editable Poly. You should now see a list that looks like Figure 9.9.

8. Select the Polygon sub-object in the Modifier stack. To select the polygon, either click on it or press 4. If you scroll down the Modify panel, you will see the Edit Polygons rollout. Choose the Bevel Polygons command from the Edit Polygons rollout by clicking on the small square next to the Bevel button. This will bring up the Bevel Polygons dialog box. For the Height enter 20 and for the Outline Amount enter 0; click OK. This will add some thickness. See Figure 9.10.

FIGURE 9.9 Click on the plus sign next to the Editable Poly to reveal the sub-objects that make up the object.

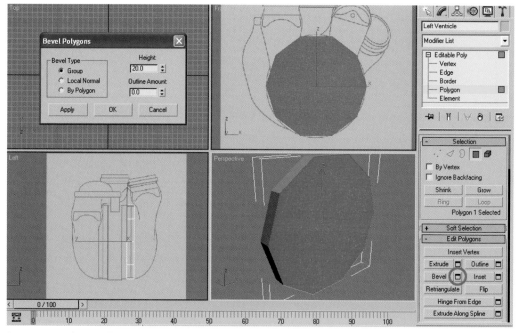

FIGURE 9.10 The Bevel Polygons dialog box allows you to extrude and bevel.

9. Next, we are going to perform the Bevel Polygons command three more times; each time we will add a little more thickness but will also reduce the Outline Amount so that the final object will resemble a

rough hemisphere or dome. Open the Bevel Polygons dialog box again, enter 10 for the Height and for the Outline Amount –3, and click OK; note the new extrusion. Apply the Bevel Polygons command again with the values Height 40 and Outline Amount –35. One last time, with the values Height 10 and Outline Amount –35. Your right ventricle should look like Figure 9.11. See the file heart2.max to study the model to this point.

If your viewports do not look like the figures, you can easily change the display mode to match. In the upper-left corner of the Perspective viewport right-click on the label Perspective. From the pop-up menu choose Smooth + Highlights. The other viewports are set to Wireframe. You may also notice that the right ventricle has a default color (which may be different from the one in the figures); this is a temporary color that helps to differentiate it from other objects in the scene.

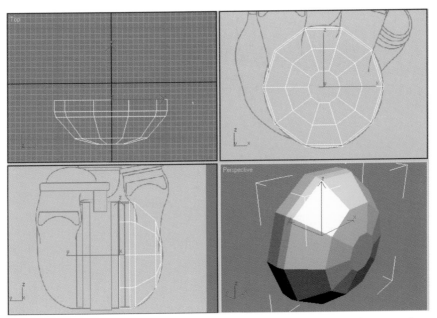

FIGURE 9.11 After several applications of the Bevel Polygons tool the result is a rough hemisphere.

10. The right ventricle object has very few polygons on purpose, because the low polygon count makes it easy to model the basic shape. Later, we will let 3ds max do all the work of smoothing out the shape. Now we are going to begin to shape the tube that connects the heart to the recipient's right atrium. In the Modifier stack, select the Edge sub-object.

Right-click the Perspective viewport to activate it, right-click once again on the Perspective label in the upper-left corner of the viewport, and from the pop-up menu choose Edge; this will display the edges of the polygons. Choose the Select and Move tool (W) and Ctrl click on the three edges shown in Figure 9.12 to select them. The selected edges will turn red when selected.

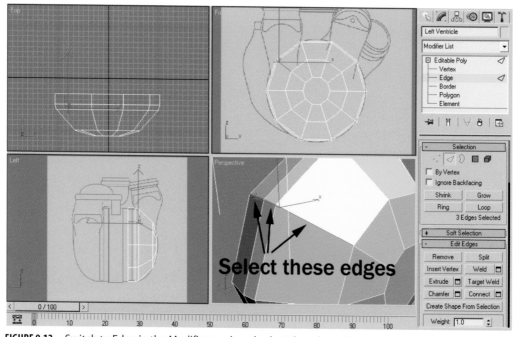

FIGURE 9.12 Switch to Edge in the Modifier stack and select the edges shown.

11. Move the edges to the left in the front viewport so they line up with the outline of the tube in the left side in the background line drawing, as seen in Figure 9.13.
12. With the edges in place, we will use the Hinge From Edge tool to begin extruding the tube that connects to the right atrium. In the Modifier stack, select the Polygon sub-object once more and in the Edit Polygons rollout, click on the Hinge From Edge button. In the Perspective viewport, click once on the edge shown in Figure 9.14 and drag. The Hinge From Edge tool will extrude the selected polygon but only from the opposing edge that you clicked.
13. We will use Hinge From Edge once more to level out the extrusion. This time, click on the inner edge and drag. The extrusion should look like Figure 9.15. If for some reason your extrusions do not look

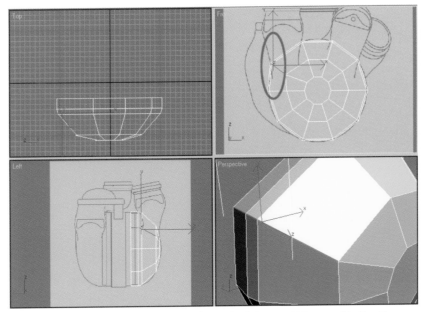

FIGURE 9.13 Once the edges are selected, use the Select and Move tool to line them up with the line drawing in the background.

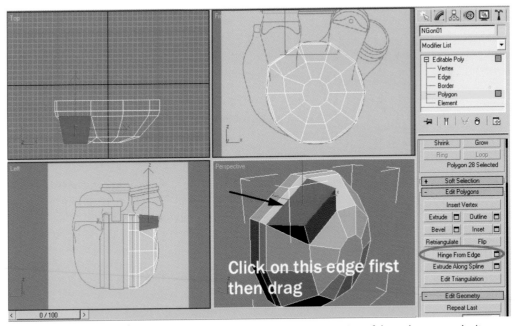

FIGURE 9.14 The Hinge From Edge command is used to begin the extrusion of the pulmonary vein. It may take a couple of tries to get it to work right.

exactly like the ones in the figure that is all right, just keep going; later we will move the vertices created by the extrusions to get things to look better.

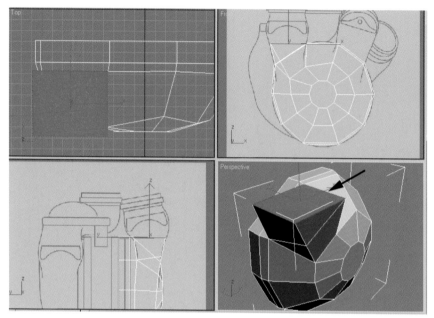

FIGURE 9.15 Use Hinge From Edge once more to level out the extrusion. (Arrow indicates edge to click before dragging.)

14. Now that we have the basic extrusion, we have to clean up the extruded faces so that they line up with the line drawing in the background. In step 11, we moved the edges to line up with the background image, but here we will switch to the Vertex sub-object (1) in the Modifier stack. Notice that the individual vertices are now visible as blue dots. With the Select and Move tool, position the vertices created by the extrusion, as in Figure 9.16. There really is no shortcut to the process of aligning and moving individual vertices when modeling; luckily, we have a very low polygon count so moving the few vertices into position should not take long. When moving vertices, pay attention to all the viewports to make sure you have the correct vertex selected and that you are moving in the right direction. It is easy to get confused when working in 3D space with 2D monitors. So don't rush.

15. So far we have the beginning of the tube that connects to the recipient's right atrium; next we will keep extruding the top polygon until the tube is complete. To do this, we will use the Bevel Polygon tool once more, except this time we will use it interactively in the scene,

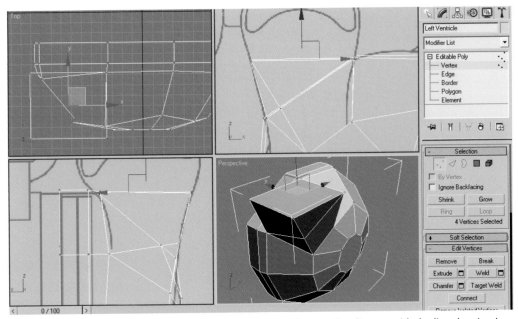

FIGURE 9.16 Position the new vertices created by the extrusions so they line up with the line drawing in the background.

bypassing the dialog box. Before we continue, make sure you pay close attention to the outline of the tube in the line drawing. Switch to the Polygon element, select the top polygon, and in the Edit Geometry rollout press the Bevel button, not the small square as before. See Figure 9.17.

FIGURE 9.17 Select the Bevel button—not the small black square next to it.

16. Notice that the cursor changes to a beveled shape. In the Perspective viewport, click and hold once on the top polygon and drag to set the height of the extrusion. When you are satisfied with the extrusion, release the mouse button, now drag to set the size of the outline amount; when the outline amount is correct, press the mouse button once more. See Figure 9.18a. Repeat the process two more times until the extrusion looks like Figure 9.18b and then c.

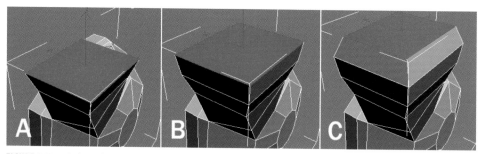

FIGURE 9.18 Select the top polygon in the tube and use the Bevel Polygon tool to extrude the vein up. Panels A, B, and C show the sequence of extrusions and bevels.

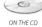

ON THE CD

17. Now we'll do a little clean up once again so that the outlines of the extrusion match the line drawing. In the Modifier stack, switch to the Vertex sub-object once more. Now with the Select and Move tool, move the vertices of the newly extruded polygons until the outlines match the line drawing. See Figure 9.19. In the Chapter 9 folder of the accompanying CD-ROM, you will find the model to this step in the file heart3.max. If you get stuck modeling, the best thing to do is to study the completed file. Remember to save your work.

18. At this point, we should have the body of the ventricle and the tube that connects to the recipient's right atrium complete. Admittedly, the model is very rough in that it has few polygons, but for now, that is just what we want. Remember that later in the tutorial we will refine the model so that it is smooth. Now we will switch to modeling the tube that connects to the recipient's pulmonary artery. In the Perspective viewport, rotate the view so that you can see the other side of the ventricle. To rotate the view (not the model), press the Arc Rotate SubObject button in the Viewport controls. A yellow circle appears in the Perspective viewport, and the cursor turns into ovals with arrows; click and drag inside the yellow circle to rotate. If you have a mouse with scroll wheel or a middle button, press it, hold the Alt key, and drag; the view should rotate. See Figure 9.20.

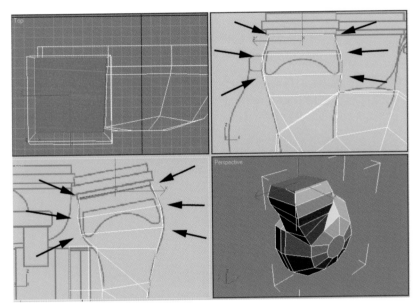

FIGURE 9.19 The process of cleaning up the extrusions by pushing and pulling on vertices so that they match the line art in the background is usually necessary after every extrusion. (Arrows indicate vertices to be moved to match the background.)

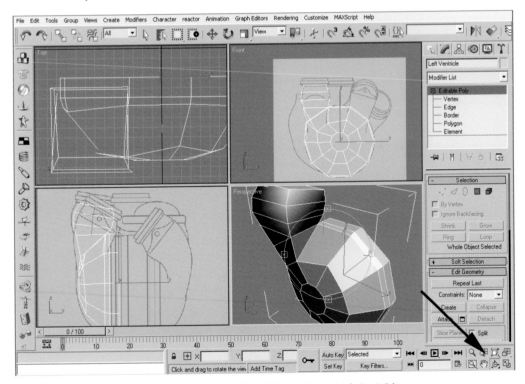

FIGURE 9.20 Rotate the view so that the other side of the right ventricle is visible.

19. Before going any further, switch the Left viewport that is currently showing the left side (left.jpg) of the artificial heart to the Right viewport. To switch viewports, right-click on the Left label in the upper-left corner; from the pop-up menu, choose Views; and from the submenu select Right. One you have switched the viewports, change the background image to right.jpg. See Figure 9.21.

FIGURE 9.21 Switch the Left viewport to the Right viewport and swap the background images.

20. The tube that connects to the recipient's pulmonary artery is modeled using the exact same techniques we used in modeling the first tube. To begin, select the polygon shown in Figure 9.22a. Select the

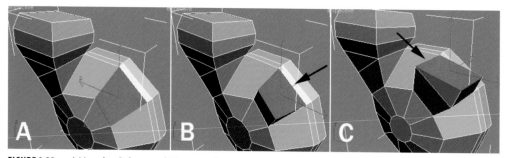

FIGURE 9.22 a) Use the Select and Move tool to select the polygon shown. b) Use the Hinge From Edge tool to extrude the polygon from the edge indicated. c) Repeat the Hinge From Edge tool from the other edge indicated.

Hinge From Edge tool and click on the edge shown in Figure 9.22b and drag. Then click and drag on the inner edge and drag once more until your model looks like Figure 9.22c.

21. Continue with the Bevel Polygons tool to finish the extrusions. Then switch to the Vertex sub-object and move the vertices to line up with the Front and Right background images. See Figure 9.23. The file heart4.max in the Chapter 9 folder of the companion CD-ROM has the completed right ventricle.

ON THE CD

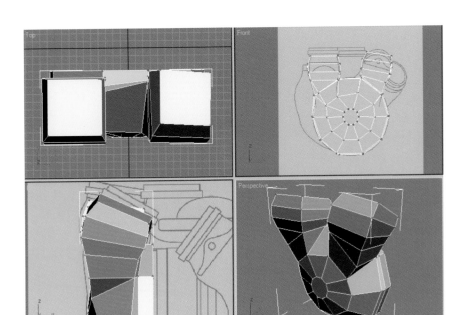

FIGURE 9.23 The completed ventricle, pulmonary vein, and aorta.

At this point the modeling of the right ventricle is just about complete. You may be thinking to yourself that the model does not look anything like the picture in Figure 9.1 or the background images. Remember that we are starting out simple and later in the modeling process we will use the MeshSmooth tool to let 3ds max smooth out the model. Next we will model the metal casings with the Line tool and Lathe modifier.

Modeling the Metal Casing with the Line Tool and Lathe Modifier

Following are the steps on modeling the metal casing with the Line tool and Lathe modifier:

1. Switch the Right viewport to Left viewport and use the Min/Max toggle to hide the other three viewports. Change the background image in the

Left viewport back to the left.jpg. Next we will temporarily hide the right ventricle so that we can model the casing without any distractions. To hide the right ventricle, select it in Modifier stack or click on it in the scene. Once it is selected, right-click anywhere in the scene in any of the viewports. You should see a set of pop-up menus; these are called the Quad menus. The Quad menus are context-sensitive pop-up menus that allow quick access to common tools and commands. In this case, select the Hide Selection option from the Display menu. This will hide the right ventricle. See Figure 9.24.

FIGURE 9.24 Use the Quad menu to choose the Hide Selection command to temporarily hide the right ventricle.

2. Next use the Zoom tool (Alt+Z) to zoom in the area shown in Figure 9.25. In the Create panel click on the Shapes icon and choose the Line tool. The task at hand is to trace the profile of half of the casing using the Line tool. If you have experience with vector tools or splines in programs such as Adobe Illustrator, Freehand, or Flash, drawing with the Line tool should be very familiar. Once the Line tool is selected, click once to place the first vertex then hold the Shift key and drag to the next position and click once again to place the second vertex. As in most graphics programs, holding the Shift key constrains the drag direction; in this case, it is constrained to the Y and Z axes. The line will have six vertices; once you get to the final vertex, click to place it

FIGURE 9.25 The casing is started by drawing a line with the Line tool.

and then right-click to terminate the Line tool. See Figure 9.25. Next we will complete the first half of the casing with the Lathe tool.

3. Make all viewports visible and select the newly created line. Focus on the Modify panel; right above the Line object in the Modifier stack is the Modifier List. Click once on the down arrow button to display the list of modifiers available. There are many modifiers in the list, which may make it a bit difficult to locate the modifier you want; however, the modifiers are listed alphabetically, so that helps. But there is a quicker way to find the modifier you want: in this case, press the letter L while the Modifier List is open. The list will scroll to the Ls and will probably select the Lathe tool right away since it is first on the L list. See Figure 9.26. Click once on Lathe, and the Lathe modifier is instantly added to the Modifier stack.

4. Take a look at the viewports; you should see a 3D shape that probably looks like Figure 9.27. By adding the Lathe modifier to the line object in the Modifier stack, you are telling 3ds max to lathe the 2D shape of the line to create a 3D object. If the result of the Lathe does not look like Figure 9.27, click on the X axis button in the Direction section of the Parameters rollout. For now, set the Segments to 16. See Figure 9.27. In the next step, we will adjust the Lathe so that it looks like the casing.

FIGURE 9.26 Select the Lathe modifier from the Modifiers List to add it to the Modifier stack.

FIGURE 9.27 The result of the Lathe modifier.

5. This next step may be a little challenging, so follow closely. In the Modifier stack, click once on the (+) plus sign next to the Lathe modifier; you should see the Axis sub-object. The Axis is the center around which the line was lathed. The casing does not look correct because the Axis is too close to the line. To correct this, we will reposition the Axis to expand the lathe effect. You can reposition the Axis in the Left, Front, or Perspective viewports. Click once on the Axis sub-object in the Modifier stack; notice that the Select and Move tool becomes active. Right-click in the Left viewport and click once on the green arrow and drag down (the green arrow is the Y axis in the View coordinate system). Keep dragging until the Axis is near the center of the ventricles. You should now have half of the casing similar to Figure 9.28. You can keep adjusting the Axis until the casing matches the background images.

FIGURE 9.28 Moving the Axis of the Lathe modifier down expands the lathe and creates the casing.

Smoothing the Right Ventricle and the Casing

Ever since we started the modeling process, we have been working with a very low-resolution version of the right ventricle, but in the next few steps, we will use the MeshSmooth tool to smooth out the right ventricle so that it looks round. We will also add segments to the casing and smooth it out.

1. Unhide the right ventricle by choosing Unhide All from the Quad menu. You should see the right ventricle and the casing together as in Figure 9.29. In this next step, select the right ventricle, expand the sub-object list, and select the Polygon sub-object. To make selecting sub-objects faster, you can simply select the Editable Poly and without expanding the list, press 4 (remember that 4 is the hotkey for selecting the Polygon sub-object). Now select each polygon at the ends of the tubes we modeled and delete them by pressing Delete after selecting them. See Figure 9.30.

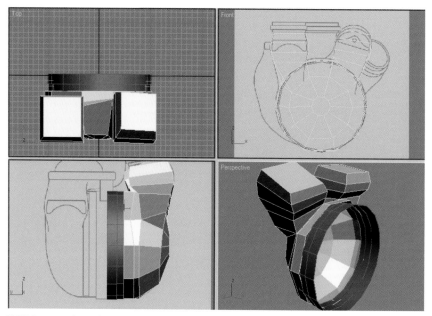

FIGURE 9.29 The right ventricle is revealed using the Quad menus.

2. Next we will smooth out the right ventricle so that it looks more like Figure 9.31. Make sure the right ventricle is selected and that none of its sub-objects are selected, just the Editable Poly. Look for the Edit Geometry rollout and click once on the MeshSmooth button. Voila! The right ventricle is smoothed because 3ds max subdivides the polygons. However we are not done yet: locate the Subdivision Surface rollout and check Use NURMS Subdivision, Smooth Result, and Isoline Display. In the Display section of the Subdivision Surface rollout enter 1 for Iterations and either 1 or .5 for the Smoothness. See Figure 9.31. Increasing the Iterations value will continue to smooth the model more, but for our purposes, it is not necessary.

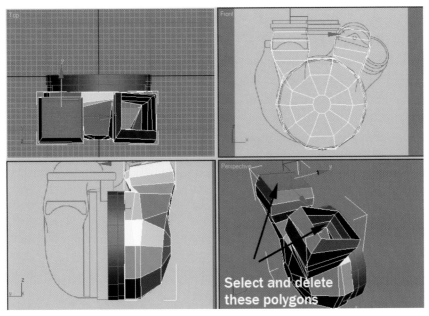

FIGURE 9.30 Select and delete the top polygons of each tube.

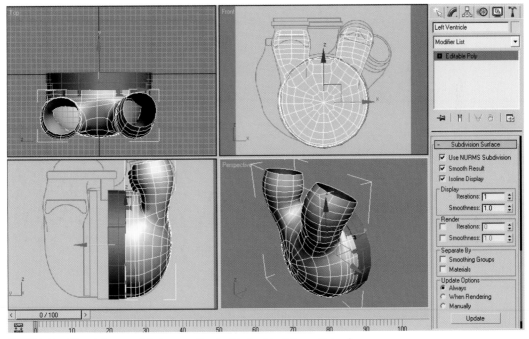

FIGURE 9.31 The right ventricle is smoothed with the MeshSmooth tool.

3. You may have noticed that the right ventricle and the casing intersect in some places, as seen in Figure 9.32. To fix this problem select the casing and use the Select and Move tool to center the casing within the ventricle. Next, in the Parameters rollout, increase the Segment count to 20 to smooth the casing. These two steps should take care of most, if not all, of the intersections so that the right ventricle and the casing fit nicely. However, if there are still areas where the two objects intersect, try scaling down the casing by about 1 percent or select the vertices of the right ventricle that intersect the casing and move them until the they don't intersect the casing anymore. See Figure 9.33.

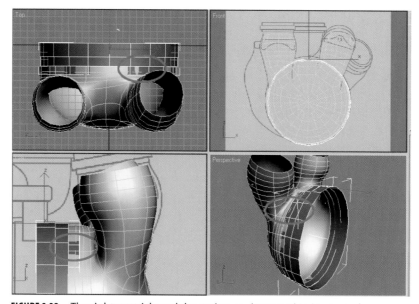

FIGURE 9.32 The right ventricle and the casing are intersecting in some places.

So far, we have used the box modeling technique to model the right ventricle and we used the Lathe modifier in conjunction with the Line tool to model half of the metal casing. As you can see, box modeling techniques like extrude, bevel, and moving polygons, edges, and vertices can be used to model just about any object. And the Lathe tool can be used to quickly model shapes that are lathed or swept around a central axis.

Obviously, there is more to the heart, and you can continue to model the rest of the heart using the exact same techniques we have practiced. For example, the connectors that go on top of each tube are modeled using the Lathe tool and the left ventricle is modeled using box modeling. Admittedly, the left ventricle is a little more challenging to model. However, the remaining parts of the heart are already modeled in the file heart7.max. You can merge the missing parts with your model by using the Merge command from the File menu to import the parts. Once

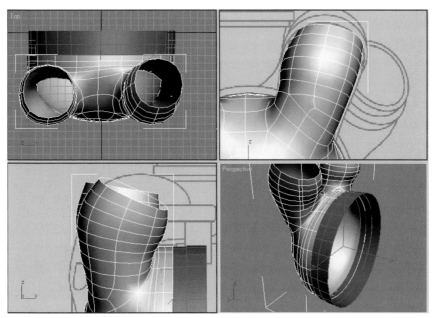

FIGURE 9.33 The intersections are cleared up by smoothing the casing and moving the offending vertices of the right ventricle.

imported, use the Select and Move tool to position the new objects. The completed and rendered artificial heart is seen in Figure 9.34.

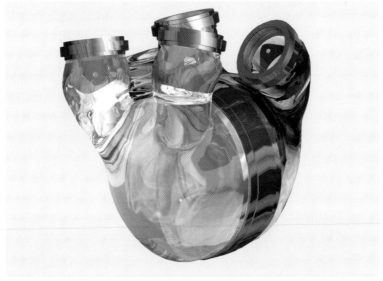

FIGURE 9.34 The completed 3D model of the artificial heart. The heart shown in the figure has been textured and rendered as a high-resolution model.

TUTORIAL | **CREATING A REAL-TIME 3D PRESENTATION FOR THE WEB WITH ANARK STUDIO**

As the Web has matured, it has become possible to deliver rich, multimedia, 3D presentations to Web users around the world. In the second half of this chapter, we will create a real-time 3D presentation that will educate users on how the artificial heart works and what its different components do. As a final step, the presentation will be embedded in an HTML file so that viewers can access it over the Web.

ORGANIZING THE PRESENTATION

Before any project is started it is important to be organized and have a plan. For example, when creating an animated movie, animators will work from a storyboard that helps to guide the animation and keep the movie on track. When we modeled the left ventricle of the artificial heart in the previous tutorial, we used isometric views (top, bottom, left, right, front, back) of the model that helped guide the modeling process. In other words, we knew exactly how to proceed because we had a plan. It takes time to create a storyboard or isometric views, but in the long run, having a plan helps to anticipate and solve problems, make revisions, delegate work, and it makes the whole work flow faster.

We need to decide what features we want to build into the real-time 3D presentation to meet the goal of educating the user about the artificial heart. Since we are building a 3D presentation, we can move in 3D space, so our presentation will allow the user to orbit around and zoom in and out to get a better look at the heart and its components. However, just looking at the components does not tell the whole story; the next feature we want is to allow the user to access information about each component. So we will make the heart and its components clickable so that when the user clicks on the heart or its components, a window will appear that describes the function of that component. To make the experience user friendly, we will add graphics that display instructions and add sounds to the clickable areas to give the user feedback. Finally, we will set the mood of the presentation with some ambient or background music. Now that we know what we are building, let's get started.

IMPORTING THE 3D MODELS

The first task we will tackle in this tutorial is importing the 3D model that will be the focus of the presentation. In the first half of this chapter, we modeled the right ventricle and the casing of the artificial heart. Using the same modeling techniques, the rest of the heart was modeled along with its components, like an internal battery, a controller, and external driver.

Each model was carefully built so that it had just enough polygons to accurately depicted detail, while maintaining a low polygon count.

Once the objects were completed in 3ds max, the Anark .amx exporter plug-in was used to export the models from 3ds max into Anark format. The .amx exporter is probably the best way to export models from your favorite modeling program into Anark Studio. However, Anark Studio will also import .3ds files.

ON THE CD

1. Open Anark Studio. From the File menu choose Import Resource (Ctrl+R), browse to the 3D_model.amx file in the Chapter 9 folder in the companion CD-ROM. All the 3D models required for the presentation are loaded into the Library as a group labeled 3D_model. See Figure 9.35. Now from the Library, drag and drop the group 3D_model into the scene (the Anark Studio window). The model should appear in the middle of scene, albeit probably very small.

FIGURE 9.35 Use the Import Resources command from the File menu to import the 3D models into the Library.

2. Make sure that the model is selected in the scene and in the Inspector palette, enter the following values: Position X 0, Y –300, Z 0, Rotation X –90, Y 0, Z 0, Scale all values to 10, as in Figure 9.36. Now the figure is the correct size, orientation, and location.

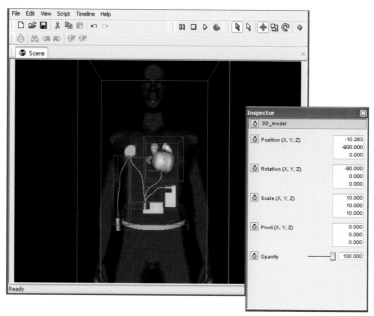

FIGURE 9.36 Use the Inspector palette to position the figure in the scene.

3. Before moving on, let's explore the timeline. Notice that the timeline contains a single layer and within that layer there is a camera, a light, and the 3D_model group (Figure 9.37). Rename the layer Heart_layer. To rename the layer just double click on the Layer label and type. Open the 3D_model group by clicking once on the small black arrowhead next to the group name. Once opened, you can see all the 3D objects and the Heart subgroup. For now, close the Heart group.

FIGURE 9.37 The timeline has a single layer that contains the entire 3D model we just imported.

INSERTING THE ORBITCAMERA BEHAVIOR

In this next task, the OrbitCamera.bvs behavior will be added to the scene to allow the user to orbit around the figure and zoom in and out to get a better look at the heart and its components.

1. In the Storage palette, open the Interactive folder, locate OrbitCamera.bvs, and drag and drop it onto the word Scene in the timeline, as in Figure 9.38. Next, we will customize the OrbitCamera object so that it works the way we want. Make sure to select the OrbitCamera object in the timeline and in the Inspector palette, set the On Event property to onMouseDown. See Figure 9.38. This will allow the user to orbit and zoom only when the left mouse button is pressed. For the Orbit-Camera behavior to work correctly, the object around which the camera will orbit must have its X and Z coordinates at 0. The Y (up and down) coordinate does not have to be at 0 but should be close.

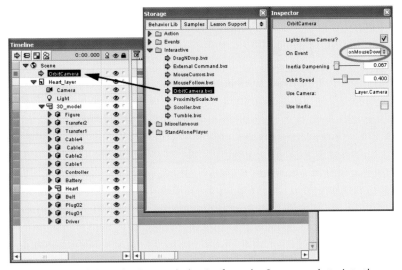

FIGURE 9.38 Add the OrbitCamera behavior from the Storage palette into the timeline.

2. OrbitCamera.bvs is not a camera, it is a scripted behavior, so we have to tell it which camera in the scene to apply the behavior to. In this case, it will be the camera in Heart_layer. In the timeline, open the Heart_layer, right-click on the Camera object, and from the pop-up menu, choose Copy Object Path. See Figure 9.39. Now, select the OrbitCamera behavior once more and in the Inspector palette, right-click in the input field next to the label Use Camera, and paste. Notice

that the path to the Camera in the Heart_layer appears in the input field. See Figure 9.40. The OrbitCamera behavior is now applied to the camera in the Heart_layer.

FIGURE 9.39 Right-click on the Camera object in the Heart_layer to copy its path.

FIGURE 9.40 Paste the copied camera path into the Use Camera: field for the OrbitCamera behavior.

3. To see how the OrbitCamera behavior works, press F12 to preview your presentation. Once the Anark Player appears on screen, click and drag to rotate around and Space drag to zoom. See Figure 9.41.

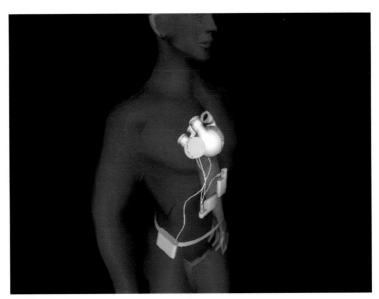

FIGURE 9.41 Press F12 to preview the presentation. You should be able to orbit around the figure and zoom in and out.

Customizing Materials

Next we will customize the materials of the internal battery and the figure to adjust their color and surface properties.

1. In the timeline, open Heart_layer and open the group 3D_model. Finally, open the object Battery and click on the checkered square. Notice that the Inspector palette now displays the materials information for the battery. See Figure 9.42. Click on the Diffuse Color color chip to display the Color Picker and choose any color you like. The diffuse color is the predominant color of an object. Once you have made your choice, the color is applied to the battery in the scene.

2. Next click on the Figure object to reveal its material properties. If you like, you can change its Diffuse Color, but in this case, check the Specular Enable checkbox and set the Specular Color to white. Enabling specularity makes the figure appear to be shiny by creating highlights on the surface. See Figure 9.43.

3. So you can see the heart and its components inside the figure, the Opacity property is set to 25; 100 opacity is completely opaque or solid. Try changing the opacity to see what happens. You can adjust the opacity to suit your taste. Another interesting effect is the Wireframe property. Right now the Wireframe property is set to Solid, but if you change it to Wireframe, the figure will be displayed as a Wireframe object, which can create some interesting effects. Try enabling

FIGURE 9.42 Open the Battery object to reveal its materials. In the Inspector palette, set its surface qualities.

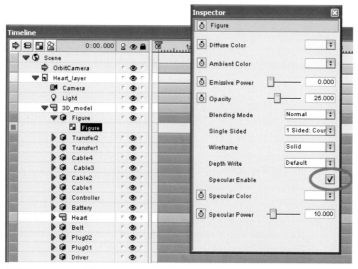

FIGURE 9.43 Enable the Specular option to give the figure a shiny appearance.

Specularity for the left and right ventricles of the heart so that they appear shiny; that is a good way to draw attention to them. Once you are done experimenting, press F12 to see the result of your work.

Importing 2D Graphics

Next we will import graphics that will display the title in the header and navigation instructions in the footer.

1. Before we import the graphics, we need to create a new layer to contain the graphics. If we do not create a new layer and we import the graphics into the Heart_layer, the graphics would rotate and zoom along with the figure and the heart, and that is not what we want. To create a new layer, simply drag the Layer object from the Library in to the timeline. See Figure 9.44. Double-click on the Layer label and rename the new layer Nav_layer (short for Navigation).

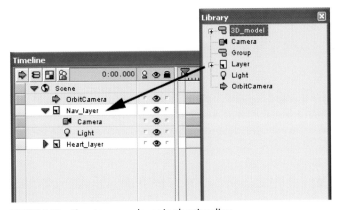

FIGURE 9.44 Create a new layer in the timeline.

ON THE CD

2. Now that we have a layer to import the header and footer into, right-click on the Library palette and from the pop-up menu, choose Import Resource. Browse to the Header.psd file in the Chapter 9 folder in the companion CD-ROM and click on Open to import. Notice that a new object labeled Header has been added to the Library. To add the graphic to the scene simply drag and drop it from the Library in to the scene, as in Figure 9.45. Once the Header graphic has been added to the scene, note that the icon in the Library changes from a graphic symbol (pink triangle) to a 3D symbol (blue cube).

3. In Anark Studio 2.5, 2D graphics are applied as textures to 3D cubes in order to be displayed in the scene. Since the cube is in 3D space we have to move the cube to position the graphic within the scene. Click on the newly placed graphic in the scene or in the timeline and in the Position property of the Inspector palette, enter: X –1.887, Y 202.351, and Z –224.000. Once the values are entered, the graphic should move into position at the top of the scene. See Figure 9.46.

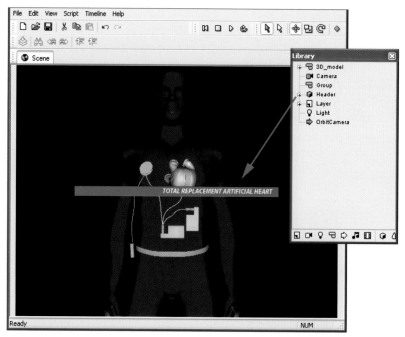

FIGURE 9.45 Once the Header.psd file is imported, drag it in to the scene.

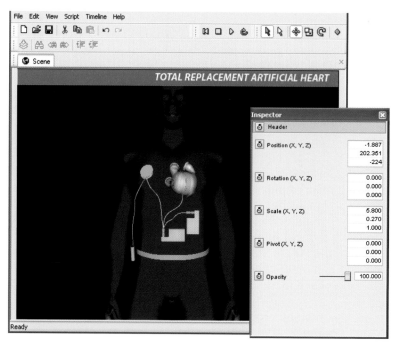

FIGURE 9.46 Position the header using the X, Y, Z values in the Inspector palette.

4. Now we are going to import the footer. However, this time we will simply drag and drop the Footer.psd file directly into the scene from the Chapter 9 folder from the companion CD-ROM. Make sure you can see the Footer.psd file in the Chapter 9 folder and the Anark Studio window at the same time. Drag the Footer.psd file from the folder into the Anark Studio window; the footer should appear in the scene. See Figure 9.47. Note that once you have added the footer to the scene a new object labeled Footer is created in the Library.

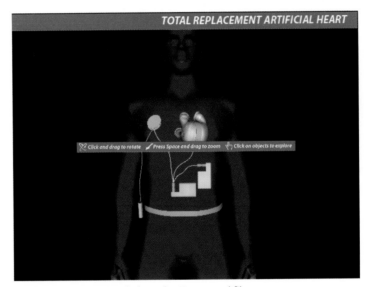

FIGURE 9.47 Import and place the Footer.psd file.

5. Click on the footer in the scene to select it and click on the Position tool in the toolbar. Now hold the right mouse button down and drag; the footer should move in the Z axis towards you. Release the right mouse button and press the left mouse button to move in the Y and X axes. When you are done, check the Inspector palette; the Position co-ordinates for the footer should be close to X 0.5, Y –205, Z –224.000. See Figure 9.48.

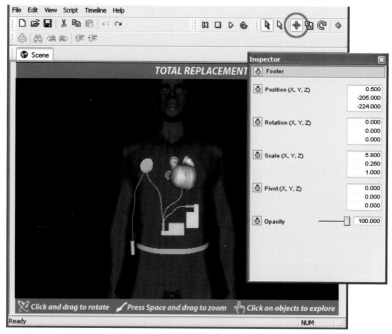

FIGURE 9.48 The X, Y, Z coordinates for the footer.

CREATING INTERACTIVITY

Up to this point, we have created a presentation in which the user can rotate and zoom in on the parts of the artificial heart. However, there is really nothing to inform the user about the heart and its components. To give the user access to more information, we will make the heart and each component a clickable area (something akin to a link or hotspots in an HTML image map) so that when the user clicks on one of the components, a window appears describing what they just clicked on. For example, if the user clicks on the heart, a window appears describing what the heart does. To keep things brief, we will make just the heart clickable and create the window that will be displayed when the heart is clicked. You can repeat the same steps to complete the interactivity for the other components.

Creating the interactivity that allows the user to get more information requires several steps. First, we will assign behaviors to the heart so that when the user clicks on the heart, a window appears. Next, we have to build the window with 2D graphics and assign behaviors to the window so that the user can close the window when he is done reading it.

1. In the timeline, open the Heart_layer layer, open the 3D_model group, and locate the Heart group. The first behavior we will assign to the Heart group is ObjectJump Time.bvs. In the Behavior Lib tab of the

Storage palette open the Events folder and then open the Timeline folder. Locate the ObjectJump Time.bvs object and drag and drop it on to the Heart group in the timeline, as seen in Figure 9.49. Later in the tutorial, we will set the properties for the ObjectJump Time.bvs behavior. Before we leave the Heart group, let's add one more behavior. Back in the Storage palette, open the Interactive folder and add the MouseCursors.bvs behavior to the Heart group. This behavior will display the standard finger cursor when the mouse is over the heart. Press F12 to see the presentation so far. The only new thing that should happen is that when you mouse over the heart, the cursor turns into the finger cursor. You should still be able to orbit around and zoom the figure, as seen in Figure 9.50.

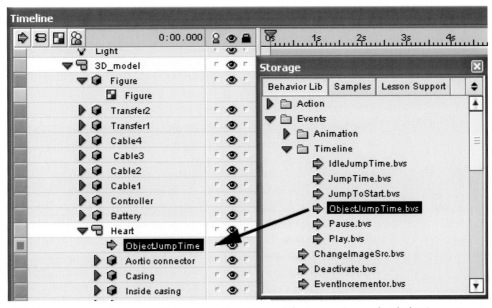

FIGURE 9.49 Drag and drop the ObjectJump Time.bvs and the MouseCursors.bvs behaviors on to the Heart group.

2. Next we need to create the window that will be displayed when the heart is clicked on. We will start by creating a new layer. Drag and drop the Layer object from the Library on to the timeline and rename it Heart_Desc (short for heart description). Inside the new layer, we will create a component that will contain the 2D graphics and behaviors for the window. If you are familiar with the Flash movie clip, you will feel right at home with the Anark Studio component. Like the Flash movie clip, the Anark Studio component has its own timeline

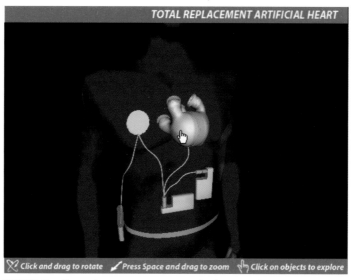

FIGURE 9.50 Now when you mouse over the heart in the preview, a finger mouse appears.

independent of the main timeline and can contain objects and behaviors, all of which can be referenced from the main timeline via a dot notation path. Open the new Heart_Desc layer and drag the Group object from the Library into the Heart_desc layer. Right-click on the group and choose Make Component from the pop-up menu. See Figure 9.51. Notice that the icon changed from a group icon (yellow stacked cubes) to the component icon (yellow circle with a black dot). If you are doing this for the first time, the steps may seem complex. For now just follow the steps; when we are done you will see how it all ties together.

3. Name the new component heart_desc. You can name the component anything you like, but to keep things organized, the component that is in the Heart_Desc layer is named heart_desc (lowercase) to make its association with the parent layer easy to remember. Double-click on the component to jump into it. Once you are in the component, click on the top most layer, and in the Inspector palette, set the following properties: Initial Play State is Pause, Play Mode is Play Once, leave the Playback Speed default, as in Figure 9.52. To add the 2D graphics that will create the window, drag and drop the files Close.psd and Heart.psd from the Chapter 9 folder in the companion CD-ROM on to the component. The graphics should appear in the scene. See Figure 9.53.

ON THE CD

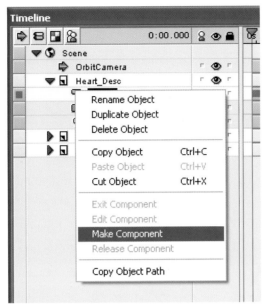

FIGURE 9.51 Create a component from the group in the Heart_Desc layer.

FIGURE 9.52 Set the basic properties for the new component.

4. One at a time, position the graphics as seen in Figure 9.54. You can use the Position tool or enter values for the Position property in the Inspector. The close button is at X 234.375, Y 176.911, Z –220, and the window is at X 204.794, Y 105.914, Z –222.

FIGURE 9.53 Drag and drop the graphics for the window in to the scene.

FIGURE 9.54 Position the graphics for the window.

5. So far we have only been adding 2D/3D objects and behaviors to the timeline but we have not really worked with timing. However, now we will adjust the timing of the Heart and Close graphics in the component timeline so that the graphics appear in the scene only during a certain period of time, namely when the heart is clicked on. In the component timeline, click on the left edge (beginning) of the Heart Time bar and drag it to 1 second. Grab the other edge and set it to 2 seconds. Do the same for the Close button. See Figure 9.55. If you scrub (move back and forth) the Play head you will see the Close and Heart graphics appear and disappear in the scene.

FIGURE 9.55 Adjust the Time bar for each graphic so that the graphic is only in the scene from 1 second to 2 seconds.

6. Now we will add the behavior to the Close button that will close the window when it is clicked. From the Storage palette, drag and drop the JumpTime.bvs behavior on to the Close object in the timeline. From the Library, drag and drop the MouseCursors.bvs behavior onto the Close object (we can reuse an instance of the MouseCursors.bvs behavior from the Library because it was used somewhere else in the presentation). Finally, click on the JumpTime behavior in the component timeline and in the Inspector palette, set the On Event property to onMouseClick, adjust the Jump to Time to 2.200 seconds, and adjust the And . . . property to Pause. See Figure 9.56. If you haven't already figured it out, the JumpTime behavior moves the Play head to 2.2 seconds in the component's timeline when the Close button is clicked. Since the Time bar for each object only spans to 2 seconds, the Play head will move to an empty spot in the component timeline and nothing will be displayed, effectively creating the illusion of closing the window.

7. Now that we can make the window disappear with just one click of the Close button, it's time to make it appear when the heart is clicked. Let's jump back in to the main timeline by clicking once on the white arrowhead, seen in Figure 9.57.

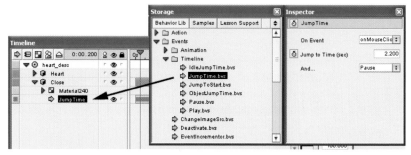

FIGURE 9.56 Add the MouseCursors and JumpTime behaviors to the Close graphic in the component timeline. Set the properties of the JumpTime behavior as seen here.

FIGURE 9.57 Press the white arrowhead to jump back in to the main timeline.

8. Locate the Heart group inside the 3D_model group in the Heart_ Layer. Click once on the ObjectJump Time behavior, and in the Inspector palette set the following properties: On Event is MouseClick, Jump to time is 1.200, and And . . . is Pause. The On object property tells the ObjectJump Time behavior where to jump to. See Figure 9.58.

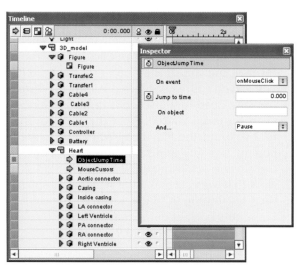

FIGURE 9.58 Set the ObjectJump Time properties for the Heart group.

9. Since we want to display the window when the heart is clicked, we need to tell the ObjectJump Time behavior in the Heart group to jump into the heart_desc component where the window resides. So open the Heart_Desc layer and right-click on the heart_desc component. From the pop-up menu, choose Copy Object Path. See Figure 9.59.

FIGURE 9.59 Copy the path of the heart_desc component.

10. Next, select the ObjectJump Time behavior in the Heart group once again and in the Inspector palette, paste the path in to the On object input field. See Figure 9.60.

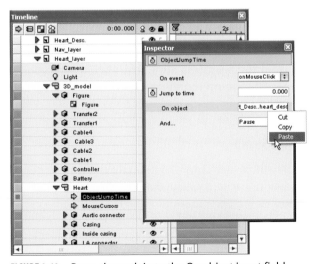

FIGURE 9.60 Paste the path in to the On object input field.

11. Press F12 to preview the presentation. You should be able to orbit and zoom around the figure, but now when you click on the heart, the heart description window should appear as in Figure 9.61; and when you click on the Close button, the window disappears.

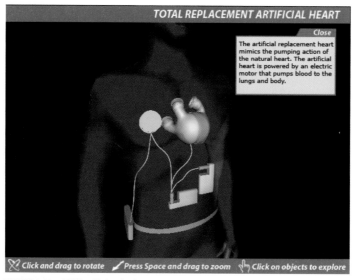

FIGURE 9.61 With all the behaviors complete, when you click on the heart, a window should appear with a description. When you click on the close button in the window, it disappears.

ON THE CD

To create the remaining clickable areas and windows for the other components, simply repeat the steps we just finished for the other objects, like the battery, controller, coils, and driver. All the graphics you need for the windows are in the Chapter 9 folder of the companion CD-ROM. The file presentation5.amw has the completed Anark Studio presentation up to this point.

ADDING SOUND

So far the presentation has visuals and interactivity, but to make the presentation a true multimedia experience, we need to add sound. Adding sound to the presentation is a very simple process that requires just a few steps. We will add a sound to the clickable areas in the presentation so that when the user clicks, he gets some feedback. For example, when the user clicks on the heart or on the close button, he will hear a sound. And

finally, we will add ambient music to the presentation that the user can turn off or on.

1. Open the file presentation5.amw from Chapter 9 folder in the companion CD-ROM or continue with the file you have been working on. We will begin by adding a new layer named Sounds. From the Samples tab of the Storage palette, open the Sounds & Music folder, open the Effects folder, and drag and drop the file boop.ogg in to the new Sounds layer. Stretch the Time bar for the boop sound so that it spans the length of the presentation, as in Figure 9.62.

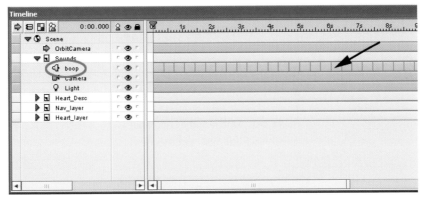

FIGURE 9.62 Create a new layer and name it Sounds, add the boop.ogg sound from the Storage palette, and stretch the Time bar for the sound so that it spans the length of the presentation.

2. Now let's set the properties of the boop sound so that it does not play automatically when the presentation loads. Click on the boop sound in the timeline, and in the Inspector palette, uncheck the Loop and Auto Start properties. See Figure 9.63.

3. Next we will add a behavior to the Heart group so that when it is clicked, it will trigger the boop sound. In the timeline, open the Heart_layer, open the 3D_model group, and then open the Heart subgroup. You see all the behaviors that we have added in previous steps. Now from the Events folder in the Storage palette, locate the SoundPlay.bvs behavior and drag it in to the Heart layer as in Figure 9.64.

4. Set the properties of the SoundPlay behavior so that On Event is onMouseClick and the target sound is the boop sound in the Sounds layer. Remember that to target the boop sound in the Sounds layer, all you have to do is open the Sounds layer, right-click on the boop sound, and from the pop-up menu, choose Copy Object Path. Then in the SoundPlay behavior, paste the path in the Target Sound input

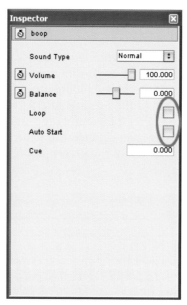

FIGURE 9.63 Uncheck the Loop and Auto Start properties of the boop sound.

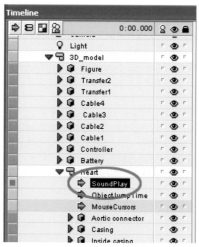

FIGURE 9.64 Add the SoundPlay.bvs behavior to the Heart group.

field. See Figure 9.65. Press the F12 key to preview the presentation. Now when you click on the heart, you should hear the boop sound. To complete the effect, add the boop sound to the Close button.

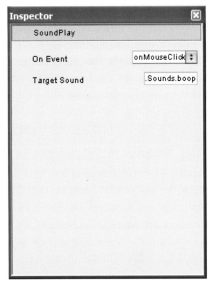

FIGURE 9.65 Set the properties of the
SoundPlay behavior so that the boop sound
is triggered when the heart is clicked.

5. Next we will add ambient music to the presentation. Ambient or
background music is often used to set a mood for the presentation.
From the Loops folder of the Samples tab in the Storage palette, drag
the ambientChoir.mp3 loop into the Sounds layer. See Figure 9.66.
Press F12 to preview; you should now hear the ambientChoir loop
playing softly in the background.

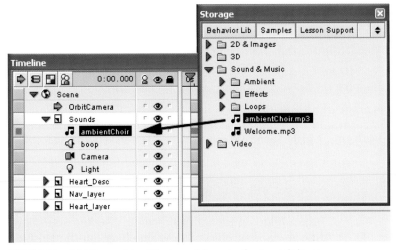

FIGURE 9.66 Add the ambientChoir.mp3 loop to the Sounds layer.

6. Even though we may like our choice of ambient music, the user may find it annoying or distracting, so always give the user the choice of turning off any music playing in the background. To do this, we will create a new button that will toggle the music on or off. First, locate the Sound.psd graphic in the Chapter 9 folder of the companion CD-ROM and add it to the Sounds layer; the button graphic should appear in the middle of the scene. Position the button so that it is in the upper-left corner of the presentation, as in Figure 9.67. If the button disappears beneath the header move the Sound layer above the Nav_Layer. Like layers in any other program there is a stacking order that you need to be aware of. The content of layers low on the stacking order that can be hidden by the contents of layers high in the stacking order.

ON THE CD

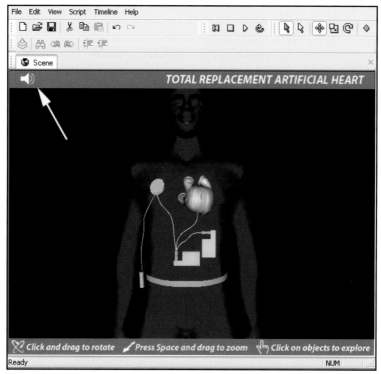

FIGURE 9.67 Add the Sound.psd graphic to begin creating the sound toggle button.

7. Now, we will add the SoundStop.bvs behavior to the Sound graphic so that the user can click on the button to turn off the music. From the Events folder in the Storage palette, drag the SoundStop.bvs behavior onto the Sound object in the timeline. Set the On Event property to onMouseClick, make the ambientChoir.mp3 file in the Sounds layer

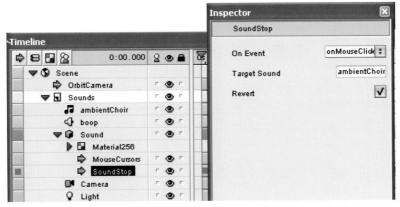

FIGURE 9.68 Add the SoundStop.bvs behavior to the Sound object in the timeline to create the on/off action of the sound button.

ON THE CD

the Target Sound, and leave Revert checked, as seen in Figure 9.68. The file presentation6.amw on the companion CD-ROM has the presentation up to this point. The Revert property will toggle the music on and off. Press F12 to preview your work.

PUBLISHING TO THE WEB

So far you have a great presentation, but at this point, only you can see it because it's only on your computer. To let the rest of the world see the presentation, you need to publish it to the Web.

1. Once you are happy with the presentation and are ready to publish it to the Web, go to the File menu and choose Export. In the Export Dialog window look for the Save as Type: menu and choose Default Browser (*.html, *.htm) and then click Save (pay attention to where you are saving the files). See Figure 9.69.

2. You should now see an HTML document and the associated Anark Player file (*.am) file. Double-click on the HTML file and your default browser will launch with the Anark Player embedded (Figure 9.70). Once the Anark Player file loads it will start playing. The HTML document created by Anark Studio is just like any other HTML document and can be edited in Dreamweaver or any HTML editor. Once you are ready, upload the HTML document and the associated Anark Player file (*.am) to your Web server. Now the world can enjoy your real-time 3D presentation!

FIGURE 9.69 To publish the presentation to the Web, choose Export from the File menu and then select Default Browser (*.html, *.htm) from the Export window.

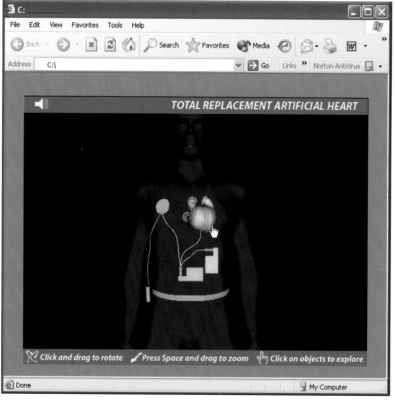

FIGURE 9.70 The Anark Player file embedded in an HTML document.

CONCLUSION

In this chapter, we have harnessed two different types of media to create an educational presentation that can be seen by anyone around the world via the Web. First, we learned to use box modeling to create complex 3D objects in 3ds max; in this case, we modeled part of the artificial heart. Then we brought the 3D models into Anark Studio and created an interactive, real-time 3D presentation. Finally, we published the presentation to the Web where it can be seen by anyone with an Internet connection, Web browser, and the free Anark Player.

The Web has come a long way from its early days when text and very small graphics were the only things that could be published. As we have seen in this chapter, creating rich, interactive multimedia that educates and entertains is not only possible but is now expected by Web surfers.

MEDICAL ILLUSTRATION FOR PATIENT EDUCATION

Introduction to Medical Illustration for Patient Education

What happens during the surgery? Will it hurt? What do I do at home after surgery? How long will it take to heal? Can I do the things I did before? When people face surgery or disease, whether their own or that of loved ones, the first thing they want is answers to many questions. Sometimes busy healthcare professionals, like doctors and nurses, unknowingly take for granted the vast clinical knowledge they possess and forget that patients may not understand the terminology and clinical science behind their condition or treatment. If a doctor were to say to you that he was going to remove the natural lens from your eye and replace it with an artificial lens, without knowledge of the procedure, you might imagine a horribly painful surgery and recovery, when in reality, the surgery for intraocular lens implantation to treat cataracts takes about 15 minutes, there is little pain or discomfort, no one (except the ophthalmologist) will know that you have an implant, and you will be back to normal in a few days. Fear of the unknown caused by a lack of information, especially about our bodies, can often lead us to imagine unrealistic and horrible scenarios, that in some cases will make us avoid the treatment altogether, which in the long run only makes things worse. Patient education materials teach us about our bodies, wellness healthcare, disease, treatments, and our options. In the hands of an experienced clinician, a patient education brochure can put our minds at ease by helping us understand the sometimes complex variables of disease and treatment.

In the recent past, almost all patient education materials were printed pamphlets, brochures, and booklets. Usually you had to go to your doctor's office to get the patient education materials. While printed materials still account for part of how patient education materials are disseminated today, at present fast and affordable Internet connections and comparatively new media such as video on the Web and interactive Flash, Macromedia Shockwave®, and real-time 3D presentations provide an effective means through which to distribute patient education information and make it readily available from home. In addition, personal computers and software like Adobe Premier™ and After Effects™ make it simple to create and distribute video for VHS, CD-ROM, and DVD.

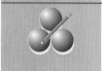

TUTORIAL **Animation of Intraocular Lens Implantation**

Project Overview

In this chapter, we will build on the modeling skills learned in previous chapters and expand your familiarity with the 3ds max interface. We will learn to import splines from Adobe Illustrator, create and edit splines

within 3ds max, and we will practice modeling with the Lathe modifier once again, but this time we will use it extensively to build complex models. We will also model with geometric primitives and additional modifiers, like Taper, Bend, and EditMesh. The Materials Editor will be introduced, and you will learn to map textures onto models and build shaders. We will add lights and cameras to the scene, then we will render still images for a Web site of intraocular lens implantation.

RESEARCH

The information for this animation was researched almost exclusively on the Web. Some medical artists may cringe at the thought of researching clinical information for an illustration or animation on the Web, but the truth is that the Web is fast becoming one of the best places to carry out research. For example, there are many Web sites published by ophthalmologists that accurately describe, in step-by-step detail, the process of intraocular lens implantation. In addition, the companies that manufacture the surgical instruments and the lens implants used in the surgery make available on their Web sites photographs and descriptions depicting how the instruments are used and how the lens is implanted by a surgeon. Finally, you can find Web sites that contain accurate information about human eye anatomy—from simple diagrams that provide the correct dimensions of the eye to actual photographs of the structures of the human eye—that are very helpful in creating 3D models.

Finding the information you need on the Web is simple thanks to search indexes such as Yahoo! and Google and search engines like Excite and Altavista. Many of the search indexes and search engines now have a feature that allows you to search for different types of media like images and video, which helps to quickly locate the images you need as reference.

Much of the clinical, medical, and scientific information on the Web is posted by physicians, researchers, and students at universities, publishing companies, biotechnology companies, and even by medical artists. However, unlike doing research in a medical library where you know the source of the information is reputable, doing research on the Web requires that you pay close attention to the source of the information posted on the Web pages. While there are many excellent and accurate sources on medical, clinical, and scientific information on the Web, unfortunately, there are also outdated and inaccurate sources.

MODELING A HUMAN EYE

In the following steps, we will model half of a human eye. Why only half? Since our medical illustrations deal with intraocular lens implantation, we need to see inside the eye, and to do this, we have to create what

is commonly known as a cut-away illustration. In other words, part of the subject, in this case the eye, is cut away to reveal the inside. To become familiar with the anatomy of the eye we will model, please take a look at Figure 10.1.

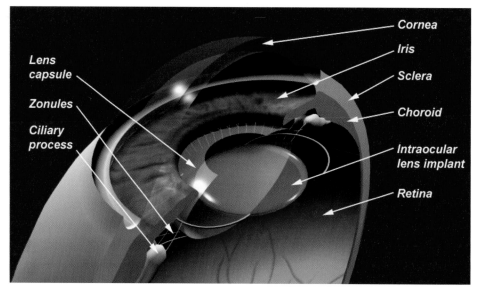

FIGURE 10.1 Parts of the eye that we will model.

In the first part of the modeling process, we will import splines that define the outline of the eye. We will also use the Line tool in 3ds max to create more splines to finish up the outlines. Once the splines are complete, we will apply the Lathe modifier to the splines to create the volume of the 3D models. To model the details like the ciliary muscles and the zonules, we will start with primitive objects and use modifiers to do the modeling for us.

Importing Splines and Modeling with the Lathe Modifier

The first step in modeling our eye model is to import splines created in Adobe Illustrator into 3ds max. Each spline outlines a particular structure of the eye such as the sclera, choroid, retina, and so on. Splines, also known as Bezier curves, are an integral part of any 3D modeling or drawing program. Splines allow us to easily model complex objects by defining their outlines, edges, or cross sections and the creating surfaces or polygons based on the shape of the splines.

Why are we importing some of the splines instead of drawing them with the Line tool in 3ds max? Well, because we can. Though 3ds max

has excellent tools to draw splines, it is sometimes easier to use a program like Adobe Illustrator to draw the splines. For example, if you are just more comfortable with Illustrator's Pen tool, you might want to create your spline in Illustrator and import it into 3ds max. Later in the tutorial we will use the Line tool in 3ds max to draw additional splines.

ON THE CD

1. Open 3ds max or reset it if you already have it open.
2. Go to the File menu and choose Import. Browse to the eye.ai file in the Chapter 10 folder in the companion CD-ROM.
3. After clicking OK in the File Import dialog box, 3ds max will display the AI Import dialog box; choose Completely replace current scene and click OK. See Figure 10.2. If there are existing objects in the scene and new objects are to be imported select the Merge objects with current scene option.

FIGURE 10.2 In the AI Import dialog box, choose Completely replace current scene.

4. Next the Shape Import dialog box will appear; choose Multiple Objects and click OK. This allows splines to be imported as separate objects as opposed to one object. The splines could be used as one object to build the model, but it is just easier to import them as separate objects. See Figure 10.3.
5. Once you click OK in the Shape Import dialog box, the splines in the eye.ai file appear in the scene, as seen in Figure 10.4. Before the splines are used to build the model, we will use the 3ds max transform tools to scale and rotate the splines into position.
6. Select the splines with the Select Object tool (Q). To select multiple objects, hold the Ctrl key and click on each spline or simply draw a marquee around all the objects. Next choose the Select and Rotate tool (E) from the toolbar, notice the rotate gizmo appears in the scene. The splines will not be rotated by clicking and dragging in the scene,

FIGURE 10.3 In the Shape Import dialog box, choose Multiple Objects.

FIGURE 10.4 The imported splines in the scene.

instead, we will enter a numerical value in the coordinate fields in the Status bar. In the X field, enter 90 and press enter. Notice in Figure 10.5 that the splines rotate 90 degrees so that they are upright instead of laying flat.

7. Next we will enlarge the splines with the Select and Uniform Scale tool (Ctrl+E). With the splines selected, click on the Select and Uniform Scale tool in the toolbar. In the Status bar click on the Absolute Transform Type-in button. It is the button to the left of the coordinate fields. Now, in the X field type a number somewhere between 500 percent or 600 percent (Figure 10.6). That is a lot, but the splines imported in to the scene are very small.

FIGURE 10.5 Click on the Select and Rotate tool in the toolbar and in the X field in the Status bar, enter 90, and press enter. The splines rotate 90 degrees.

FIGURE 10.6 Click on the Select and Uniform Scale tool in the toolbar and in the X field in the Status bar, enter 500, and press enter.

8. Press H to bring up the Select Objects dialog box. From the list, click on Shape3. Shape3 is the spline that outlines the retina. At the bottom of the Select Objects dialog box, click on Select. Notice that in the scene, the inner most spline is selected. See Figure 10.7.

FIGURE 10.7 Select Shape3 from the Select Objects dialog box to select what will become the retina.

9. Before beginning the modeling process, let's name and assign a default color to the Shape3 object. Naming the Shape3 object with a recognizable name will make selecting it in the future much easier, and assigning a default color will help differentiate it in the scene from other objects. In the Modify tab type the name Retina over the Shape3 name. Then click once on the color chip next to the name and choose an orange color (or any color you like) from the color picker that comes up; when you are done choosing a color, press OK, as in Figure 10.8.

FIGURE 10.8 Rename the Shape3 object Retina and change its color to orange.

10. Okay, now we can start modeling. Make sure that the retina is still selected, and from the Modifier List, choose the Lathe modifier. See Figure 10.9. Once the Lathe modifier is added to the Modifier stack of the Retina object, the spline is lathed in the scene. Chances are that initially the retina looks like a cup, as seen in Figure 10.10.

FIGURE 10.9 From the Modifier List, add the Lathe modifier.

FIGURE 10.10 The retina object is lathed in the scene, albeit not correctly at first.

11. The lathe problem can be corrected by moving the lathe axis so that the object expands. To do this, click once on the plus sign (+) next to the Lathe modifier in the Modifier stack to see the Axis sub-object. Click on the Axis sub-object to select it. Now, with the Select and Move tool (W), drag the X arrow (red) of Axis gizmo to the left. As you move the Axis, the object becomes a bowl. See Figure 10.11.

FIGURE 10.11 Expand the Lathe modifier to reveal the Axis sub-object. Select the Axis and move it with the Select and Move tool.

12. In the Parameters rollout of the Lathe modifier, set the Degrees to 180, check Weld, and check Cap Start and Cap End. Now the bowl looks like half a bowl, which is exactly what we want. If there are odd artifacts at the pole of the retina (the bottom), maybe there is a dark spot or a tiny hole; move the Axis again until it disappears.

13. Press H and choose Shape4 from the Select Object dialog box. Shape4 will create the choroid layer of the eye and the iris. As with the retina, assign a color to the spline and rename it choroid or choroid/iris, then add the Lathe modifier. The Axis will probably need some adjusting to create the correct shape. However, this time, be very careful to move the Axis of the choroid only far enough so that it matches the outside edge of the retina. To be precise, toggle on the Absolute Transform Type-in button in the Status bar and select the Axis sub-object for the choroid. Then in the X field, enter -1.72. The Axis moves precisely so that it matches the retina. The X value for your model may be slightly

FIGURE 10.12 In the Parameters roll for the Lathe modifier, set the degrees to 180, check Weld, and adjust the Segments to 16.

different, but the point is that you can numerically position the Axis sub-object. See Figure 10.13.

FIGURE 10.13 Apply the Lathe modifier to the Choroid layer. Move the Axis to expand the choroid by either dragging the Axis gizmo or entering a value in the X axis of the Absolute Transform Type-in field.

14. Once you are done with the choroid, repeat the Lathe steps to create the sclera with the last spline, as seen in Figure 10.14. The value to move the sclera should be –1.875.

FIGURE 10.14 The sclera is created in the same way that the retina and choroid were created.

Drawing Splines with the Line Tool

Up to this point three main layers of the eye—the retina, the choroid, and the sclera—have been modeled by importing splines created in Adobe Illustrator and using the Lathe modifier to create the models. In the following steps, the 3ds max Line tool will be used to draw new splines for the lens capsule and then cornea. Becoming proficient with the Line tool is essential in working efficiently with 3ds max; many of the models that you will create in 3ds max start out as splines.

1. To begin this part of the modeling process, file eye_guide.max will be merged with the current scene. To merge the new file with the current scene, choose Merge from the File menu and browse to the file eye_guide.max in the Chapter 10 folder in the CD-ROM.

2. From the Merge dialog box object list, click on Guide from and then click on OK. See Figure 10.15. The guide object will then appear in the scene, as in Figure 10.16. The guide object is a plane primitive with a texture assigned to its surface. The texture is a drawing of the eye we are modeling. The black lines indicate the parts that are

already modeled, and the red lines are the parts that will be modeled. Namely, the lens capsule and the cornea. With the Select and Move tool, position the plane so that the drawing lines up with the actual models in the scene. Positioning the plane is best done in the Front and Top viewports. The plane should be the correct size for the models, but in case it is not, just use the Select and Uniform Scale tool to scale it up or down.

FIGURE 10.15 Click on the guide object to select it in the Merge dialog box.

3. Before continuing, hide the retina, choroid, and sclera. Press H and select the retina, choroid, and sclera in the Select Object dialog box by pressing Ctrl and clicking each object in the list once, then click Select. Back in the viewport, right-click to bring up the Quad menus and choose Hide Selection. See Figure 10.17. The retina, choroid, and sclera should disappear—at least temporarily.

4. Now press on the Min/Max toggle to hide all viewports except the current viewport, and press F to make sure you are in the Front viewport, as in Figure 10.18. Zoom in on the cornea and lens capsule lines.

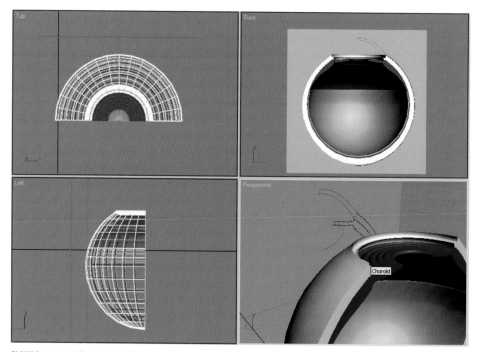

FIGURE 10.16 The guide object appears in the scene.

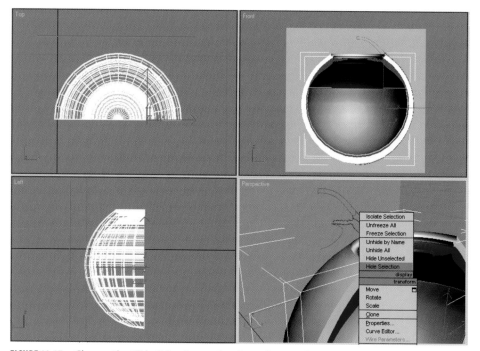

FIGURE 10.17 Choose the Hide Selection option from the Quad menus to hide the retina, choroid, and sclera.

FIGURE 10.18 Fill the screen with the Front viewport and zoom in on the cornea and lens capsule.

5. Now you will draw a spline with the Line tool to outline the cornea. In the Create panel, click on the Shapes icon. Click on the Line tool to activate it. In the Creation Method rollout, select Smooth for the Initial Type. The Smooth option will create rounded or curved lines. Try to place the vertices as you see in Figure 10.19 and make sure to close the line. To place vertices, position the mouse where you want to insert a vertex and click. To close the line, simply place the last vertex over the first or initial vertex and click once. 3ds max will ask you if you want to close the spline. See Figure 10.20. When you are ready to terminate the Line tool, right-click.

 If you are new to working with splines, it may take a couple of tries before you get the hang of it, but just keep trying; learning to use the Line tool is a very important step in mastering 3ds max. If you get stuck, save your work and open the file eye4.max to study the splines.

6. Click on the Modify panel in the Modifiers stack. Notice that there is an object named Line01; rename it Cornea. If the spline color is too dark, change it to a light color so that it shows up better against the guide's lines. The line that makes up the cornea has to be edited because the vertices that form the corners are smooth and create rounded corners, and sharp corners are needed. In the Modifiers stack, click on the plus (+) icon next to the cornea and select the Vertex sub-object.

FIGURE 10.19 With the Line tool, draw a spline that outlines the cornea.

FIGURE 10.20 When you get back around to the first vertex, place the mouse over the first vertex and click once. 3ds max will ask if you want to close the spline; choose Yes. To terminate the Line tool, right-click after the last vertex is in place.

7. Zoom in on the corners and mouse over one of the corner vertices. When you are over a vertex, the cursor changes to a cross; right-click to bring up the Quad menu. In the Quad menu, select the Corner option; the rounded corner changes into a sharp corner. See Figure 10.22. Repeat for the other corner.

FIGURE 10.21 Select the Vertex sub-object of the cornea object.

FIGURE 10.22 Place the mouse over one of the vertices that make up the rounded corners. Right-click to bring up the Quad menu and choose Corner.

FIGURE 10.23 The corners are now sharp instead of rounded. If necessary, move the vertices to create a straight vertical line between the corner vertices.

8. Next use the Line tool once again to outline the lens capsule, as seen in Figure 10.24.

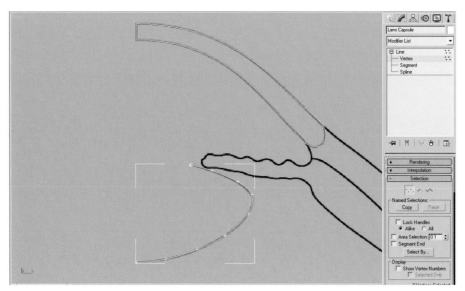

FIGURE 10.24 Outline the lens capsule with the Line tool.

9. If you are finished with the guide drawing, select and delete it. Press the Min/Max toggle to bring up all four viewports. Right-click to bring up the Quad menus and select Unhide All to reveal the hidden retina, choroid, and sclera. You will probably notice that the new outlines are not quite in the right place. In the Front viewport they look fine, but if you look at the Top viewport, they are far from the rest of the objects. Select the new lines and use the Select and Move tool to move them into the right position (Figure 10.25).

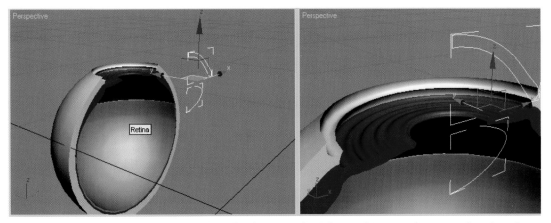

FIGURE 10.25 The new splines are not in the right place. Use the Select and Move tool to move them into the right position.

10. You have probably already figured out what comes next. Apply the Lathe modifier to the cornea and the lens capsule to create the 3D models. See Figure 10.26. If your lens capsule looks strange, like part of it is missing, go to the Customize menu and choose Viewport Configuration. In the Viewport Configuration dialog window, check Force 2-Sided. This forces 3ds max to show both sides of the polygons that make up the shape of the lens capsule.

You can see by now that with splines and the Lathe modifier, you can create the geometry of complex models, such as an eye (or at least half of an eye).

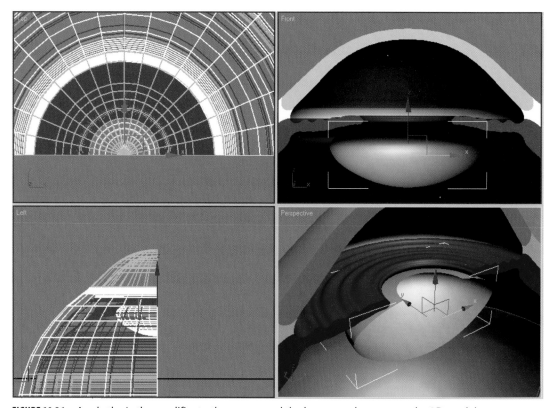

FIGURE 10.26 Apply the Lathe modifier to the cornea and the lens capsule to create the 3D models.

Modeling with Primitives and Modifiers

In the next steps, a few more details will be added to complete the eye model. Specifically, the processes of the ciliary muscle and the zonules will be modeled. The processes of the ciliary muscles form a ring around the lens and are part of the structure that acts to change the shape of the lens to focus light on the retina. For example, when you look at something close, the ciliary muscles contract releasing the tension on the zonules, and the lens thickens. When you look at something far away, the ciliary muscles relax, and the lens becomes thinner. The zonules are the suspensory ligaments that span from the ciliary processes across to the lens. In a real eye, there are dozens of individual ciliary processes and thousands of zonules. In our eye model, we will create considerably fewer processes and zonules but enough to give the impression that there are many. Also, in a real eye the zonules are very thin, almost invisible. In our eye model,

FIGURE 10.27 If your models look strange, try turning on the Force 2-Sided option in the Viewport Configuration.

we will use a little artistic license and make the zonules larger; after all, there is no point in modeling something that is invisible.

1. Click on the Create tab and click on the Shapes icon; from the list, choose the Sphere tool. Click and drag in the Left viewport; a new sphere primitive is created. With a little help from a couple of modifiers, this sphere will become a single ciliary process. It is important that you create the sphere in the Left viewport because the poles and polygons of the sphere will be oriented along the X axis and that will make editing with modifiers more effective. In the Parameters rollout for the Sphere, change the Radius to .3 and the Segments to 16. If you want to see the polygons (or edges) that make up the objects in the scene without having to switch to the Wireframe view, right-click on the Left label in the upper-left corner; from the drop-down menu, choose Edge Faces.

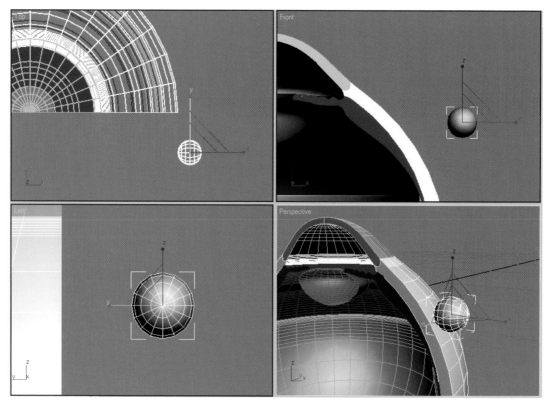

FIGURE 10.28 Create a small sphere with the Sphere tool.

2. Scale the sphere with the Select and Non-Uniform Scale tool so it becomes a long oval shape, as seen in Figure 10.29.
3. Next, from the Modifier List, choose the Taper modifier. In the Parameters rollout, set the Amount to –1, and in the Taper Axis, choose Z for Primary and XY for Effect. The oval is now tapered, as in Figure 10.30.
4. In this step, the EditMesh modifier will be used to continue the modeling process. From the Modifier List, add the EditMesh modifier to the Modifier stack of the ciliary process. Open the EditMesh modifier to reveal its sub-objects and click on the Vertex sub-object. See Figure 10.31. You should now see the vertices that make up the process. Use the Select and Move tool to move the vertices until the shape resembles Figure 10.32. When you are finished editing the vertices, deselect the Vertex sub-object and close the EditMesh modifier.

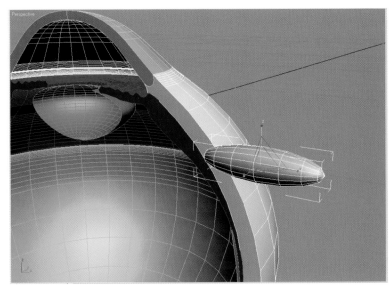

FIGURE 10.29 Scale the sphere so that it looks like a long oval.

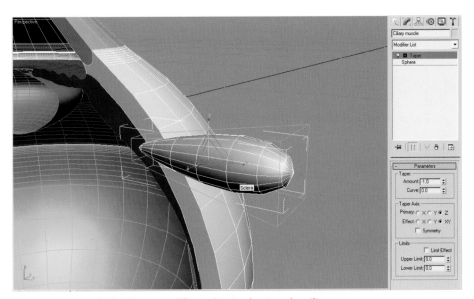

FIGURE 10.30 Apply the Taper modifier to begin shaping the ciliary process.

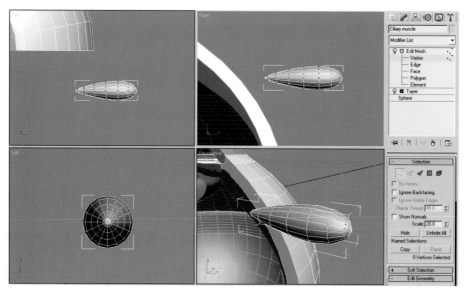

FIGURE 10.31 Add the EditMesh modifier to continue modeling the ciliary process.

FIGURE 10.32 Open the EditMesh modifier and select the Vertex sub-object. Move the vertices so that the ciliary process looks a little lumpy.

> 5. Scale down the ciliary process and use the Select and position the entire ciliary process, as seen in Figure 10.33.

FIGURE 10.33 Move the ciliary process as seen here.

Repositioning the Pivot

In the following steps, we will reposition the pivot:

1. The single ciliary process just created will be cloned roughly 30 times, and each instance will be positioned, so that all the instances form a ring around the lens capsule. This may sound like a tedious job, but it can be quickly done in just a few simple steps. Select the ciliary process and click on the Hierarchy tab, then click on the Affect Pivot Only button. Notice that the ciliary muscle now shows the pivot X, Y, Z gizmo. With the Select and Move tool, position the pivot as seen in Figure 10.34. When you are done positioning the pivot, click on the Affect Pivot Only button to turn it off. The position of the pivot is the center around which the ring of ciliary muscle processes will be created, so positioning the pivot as close to center as possible is important.

2. Now hide all viewports except the Top viewport. You may want to switch to Wireframe view and hide some of the objects (like the lens capsule, cornea, sclera, and retina) to get a better view of the ciliary process. This next step is a little tricky so pay close attention. With the

FIGURE 10.34 Reposition the pivot of the ciliary process.

ciliary process selected, choose the Select and Rotate tool, then hold the Shift key down and drag so the new ciliary process appears, as see in Figure 10.35.

FIGURE 10.35 In the Top viewport, hold the Shift key and rotate the ciliary muscle to create a

3. In the Clone Options dialog box choose Instance and enter 30 for the Number of Copies, then click OK. Thirty new instances of the ciliary

process appear in a ring around the lens capsule, as in Figure 10.36. If you entered 30 and came up short or long, try a different number. The correct number to create your ring of ciliary processes is based on the initial rotation distance and the size of the ciliary process. Figure 10.37 shows how the final ring of ciliary processes should look.

FIGURE 10.36 Choose Instance, and enter 30 for the Number of Copies to create a ring of ciliary processes around the lens capsule.

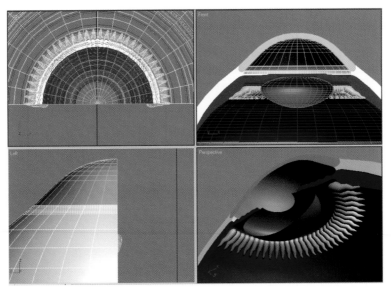

FIGURE 10.37 The newly formed ciliary processes around the lens capsule.

Instance was used instead of Copy to save on computer resources and to make future editing of the ciliary processes easier. An instance is not a copy; it is a representation of an object. In other words, the instances use the description of the original object to create clones, not copies. If you change the original object, all the instances will also change.

4. Press H to bring up the Select Objects dialog box. Select all instances of the ciliary process, as seen in Figure 10.38. From the Group menu in the Menu bar, choose Group. Name the group, as in Figure 10.39. This groups all the instances to keep them manageable.

FIGURE 10.38 In the Select Objects dialog box, select all the instances of the ciliary process and click on Select.

FIGURE 10.39 From the Group menu, choose Group to group all instances. Name the group.

5. Next the zonules will be modeled beginning with a single Cylinder primitive. Insert a cylinder in the Left viewport. Make its parameters Radius 0.02, Height 2.5, Height Segments 5, and Sides 10. Center its pivot by opening the Hierarchy tab, then clicking on Affect Pivot Only,

and in the Alignment section, click on Center to Object. See Figure 10.40. Rename the cylinder Zonule.

6. Apply the Bend modifier to the Zonule. In the Parameters rollout, set the Angle to -25 and the Direction to 90. In the Bend Axis section, choose the Z axis. The zonule should bend as seen in Figure 10.41.

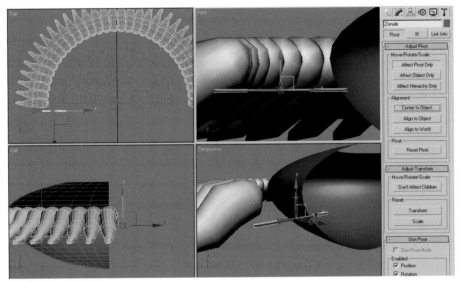

FIGURE 10.40 Insert a thin, long cylinder into the scene and center its pivot. Note: All objects except for the lens capsule and the ciliary group have been temporarily hidden to facilitate the modeling process.

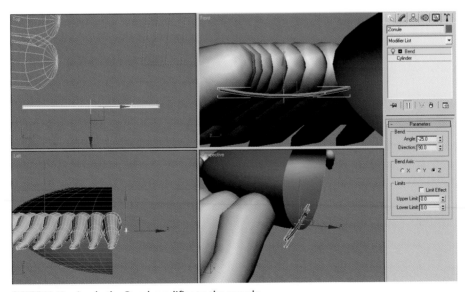

FIGURE 10.41 Apply the Bend modifier to the zonule.

7. Next use the Select and Move tool to position the zonule as in Figure 10.42.

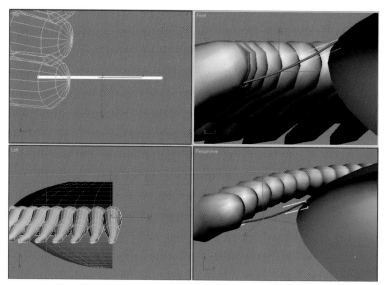

FIGURE 10.42 Position the zonule so that it spans across from the first ciliary process and touches the lens capsule.

8. Make a clone of the first zonule to create a second zonule. You can create the clone by right-clicking to bring up the Quad menu and choosing Clone. See Figure 10.43. From the Clone Options dialog box, choose Instance, set Number of Copies to 1, and click OK.

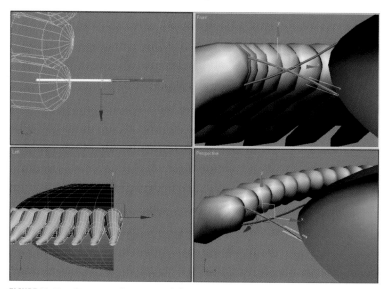

FIGURE 10.43 Create an instance of the original zonule and rotate it. Then group both zonules.

9. Select both zonules and group them. Remember that to group objects you simply select Group from the Group menu in the Menu bar, and when prompted, name the group.

10. To create the ring of zonules that span across from the ciliary processes to the lens capsule, repeat steps seven and eight in which you created the ring of ciliary processes. First, move the pivot of the zonule group to the center of the lens capsule along the X axis. Then create an initial instance of the zonule group by holding the Shift key and rotating. When 3ds max displays the Clone Options dialog box, select Instance and enter 30 to 35 for the Number of Copies. The result should look like Figure 10.44. Remember to group the new zonule groups.

FIGURE 10.44 The ring of zonules in place.

With the ciliary processes and the zonules the modeling is complete. By now you should be very comfortable using the Line tool to draw splines and with the Lathe modifier to create complex objects. You should also have a good understanding of the power of using modifiers such as Bend, Taper, and EditMesh to create models from primitives. At this point, the 3D eye model looks like Figure 10.45.

FIGURE 10.45 The 3D eye model so far.

REFINING THE EYE

You may have noticed that the eye's silhouette is not very smooth in some places. For example, if you look at the edges near the bottom, you can see corners. See Figure 10.46. This is very easy to correct by editing the base spline.

FIGURE 10.46 Notice the eye is not very smooth in some places. (See superimposed line.)

1. To make things simple, temporarily hide all objects except the sclera. To hide the objects, select the sclera and right-click to bring up the Quad menu. From the Quad menu, choose Hide Unselected. The only object left in the scene should be the sclera.
2. Press the Min/Max toggle to hide all but one viewport and press F to make sure you are in the Front viewport. Now in the Modifier stack, click once on the Editable Spline. Notice that the object is temporarily hidden except for the Editable Spline, as in Figure 10.47. This occurs because you are working below the Lathe modifier, and its effects are temporarily removed from the Editable Spline. However, if you really want to see the effects of the Lathe modifier while working on the Editable Spline, just press the Show End Result toggle located at the bottom of the Modifier stack window next to the Pin Stack button (thumbtack icon). However, leave it off for now so you only see the spline.

FIGURE 10.47 The spline that makes up the outline of the sclera becomes visible when you work on the Editable Spline in the Modifier stack.

3. Open the Editable Spline's stack to reveal its sub-objects and click on the Vertex sub-object. In the Geometry rollout, locate the Refine button and click on it once. See Figure 10.48.
4. Once you have clicked on the Refine button, mouse over the segments of the spline that are not smooth. The mouse cursor becomes a crosshair with two black lines; click once on each segment, as seen in Figure 10.49, to add vertices. Once you have added the new vertices, the spline segments become smooth.

FIGURE 10.48 Open the Editable Spline, select the Vertex sub-object, and locate the Refine button in the Geometry rollout.

FIGURE 10.49 Add two vertices to the spline segments to smooth the outline of the eye.

5. Click on the Lathe modifier in the stack or on the Show End Result toggle to see the smoother sclera. See Figure 10.50. When you are done refining the Editable Spline, turn off the Refine button, deselect the Vertex sub-object (just click in an empty area of the modifier stack), and close the Editable Spline.

FIGURE 10.50 The sclera now has a smoother outline.

If you notice that a distinct line appears in the object at the level where you added a vertex, simply select the vertex and from the Quad menu, switch from Bezier Corner to Bezier. This will make the line disappear. See Figure 10.51.

FIGURE 10.51 To correct any lines that appear as a result of adding vertices, change the vertex type from Bezier Corner to Bezier. Notice that all three layers have been smoothed.

You can refine the choroid and the retina just as you did the sclera so that they all appear smooth. One word of caution: refining an object by adding vertices to an Editable Spline increases the resolution or polygon count; only add enough vertices so that the object appears smooth. If you add too many vertices, you may end up with objects that are impossible to edit and take a long time to render. In the next few steps, the Editable

Spline that makes up the iris will be edited to open up the pupil and to reduce its polygon count.

1. Hide all objects except the choroid (Figure 10.52). That is the middle layer between the sclera and the retina. Change the object color of the choroid to a lighter color so that you can see its details easily, and turn on Edge Faces. To turn on Edge Faces, right-click on the viewport label (in the upper left corner) and choose Edge Faces from the menu.

FIGURE 10.52 Hide all objects except the choroid.

2. In either the Front or Perspective viewports zoom in on the iris. Notice that the top of the iris has a very high polygon count. Some of the vertices need to be deleted to reduce the polygon count. Open the Editable Spline's stack and select the Vertex sub-object. See Figure 10.53.
3. Scroll to the bottom of the Geometry rollout and locate the Delete button. Delete the vertices, as in Figure 10.54, by selecting the vertex and clicking on the Delete button. (You can Ctrl click several vertices to select a group of vertices, and click on the Delete button to delete them all at once.) By deleting about half of the vertices, the polygon

FIGURE 10.53 The top of the iris has a high polygon count.

count has been reduced considerably. The lower detail, seen in Figure 10.55, will not be missed, as later in the chapter we will be assigning a texture to the iris.

FIGURE 10.54 Delete about half of the vertices to reduce the polygon count.

FIGURE 10.55 The iris with fewer polygons. The lost detail will be replaced for the most part by a texture.

4. There is one final revision to the Editable Spline of the iris. The pupil is too small, so the inner edge of the iris, which forms the pupil, needs to move to open the pupil. To do this, select the vertices seen in Figure 10.56 and move them towards the right.

FIGURE 10.56 Move the vertices shown to the right to enlarge the pupil.

We are enlarging the pupil because in intraocular lens implantation the pupil is opened as much as possible with special drops, to allow easy access to the lens.

By working through the last few steps, you have learned that shape and resolution of Lathed objects can be edited by moving down the Modifier stack—in this case, to the Editable Spline—and changing the shape of

the initial object. This modeling concept is called construction history, because you are able to go back in to the history of an object, edit the initial object, and the edit is propagated up the Modifier stack—in this case, to the Lathe modifier. Keeping the construction history available for as long as possible during the modeling process allows you to easily make changes, but as we soon shall see, sometimes it becomes necessary to delete the construction history by collapsing the Modifier stack.

In the last step before moving on to texturing, we will collapse the choroid's Modifier stack by converting all the objects in the Modifier stack into an Editable Mesh. Then in the next part of this chapter, we will work with the sub-objects of the choroid's Editable Mesh to assign material IDs to facilitate texturing.

Click once on the choroid in the scene and from the Quad menu select Convert to:. From the sub-menu, choose Editable Poly. See Figure 10.57. Notice that the Modifier stack, the Lathe modifier, and the Editable Spline are gone and in their place is a single Editable Poly.

FIGURE 10.57 The very last thing before moving on to texturing is to convert the choroid/iris object into an Editable Poly.

CREATING MATERIALS AND MAPPING TEXTURES

So far, our 3D eye model looks great, but to complete the model we have to map a couple of textures and apply a few materials onto the eye. For example, the cornea and the lens capsule are transparent, and the iris needs a texture that looks like an iris. The following tutorial will introduce the Materials Editor, materials, UVW Mapping, and UnwrapUVW modifiers.

TUTORIAL

INTRODUCING THE MATERIALS EDITOR AND WORKING WITH UNWRAPUVW

We will first map a texture of blood vessels onto the inside of the retina. To do this, we will create a new material in the Materials Editor and use the UnwrapUVW modifier to map a texture of blood vessels to the inside of the retina.

1. Press M to bring up the Materials Editor. See Figure 10.58. The first material slot should already be selected; you can tell it is selected because it has a white outline all around it.

FIGURE 10.58 The Materials Editor.

2. Rename the first materials slot Retina Map in the input field below the slots window. See Figure 10.58.
3. Next click on the Maps rollout and click on the Diffuse channel to bring up the Material/Map Browser. See Figure 10.59. Select New in the Browse From section and then double-click on Bitmap. Browse to the file retina_map.jpg in the Chapter 10 folder in the CD-ROM.
4. Note that the retina_map.jpg texture is stored in the first materials slot, as seen in Figure 10.60. Name the map Retina Texture.

ON THE CD

Now drag the texture from the Materials Editor to the retina. In the Materials Editor, toggle on the Show Map in Viewport button to see the

FIGURE 10.59 Click on the Diffuse channel to bring up the Material/Map Browser and then browse to the retina_map.jpg file.

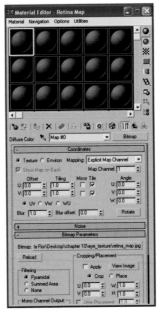

FIGURE 10.60 The first slot in the Materials Editor stores the retina_map.jpg file.

texture in the viewport. See Figure 10.61. Notice that the map appears on the retina, but it is not oriented correctly. The blood vessels should be on the bottom not the side. Also note that in the Materials Editor the selection box around the retina is dog-eared because the material is in the scene.

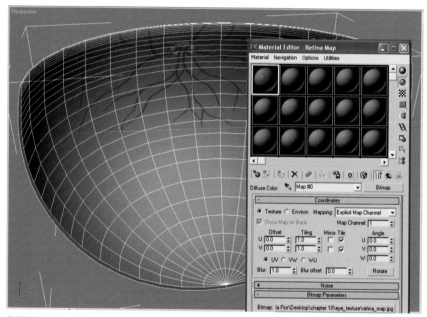

FIGURE 10.61 Without any UV information the texture is initially applied incorrectly.

WORKING WITH THE UNWRAPUVW MODIFIER

Now that the the retina has a material, the UnwrapUVW modifier will be used to map the texture so that it is oriented correctly on the inside of the retina.

1. From the Modifiers List, add UnwrapUVW to the stack of the retina. If you haven't already, turn on Edge Faces so that you can see the polygons that make up the retina.
2. Open the UnwrapUVW modifier to reveal the Select Faces sub-object.
3. In the Parameters rollout, click on the Edit button to open the Edit UVWs window. See Figure 10.62. You should see the mesh of the retina somewhere in the window. If you can't see the mesh in the Edit UVWs window, try zooming out. Once you see it, click on the Free Form Mode button and draw a box around all of the mesh and drag it inside the blue box.
4. In the Edit UVWs window, open the Mapping menu and choose Normal Mapping; click OK in the Normal Mapping dialog box. The retina object should now be mapped into two halves. See Figure 10.63.

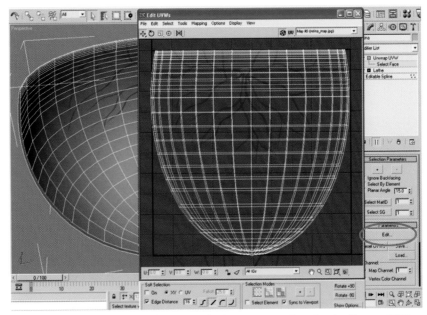

FIGURE 10.62 Click on the Edit button in the Parameters rollout for the UnwrapUVW modifier.

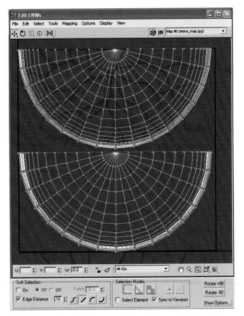

FIGURE 10.63 After applying Normal Mapping, the retina's mesh is mapped as two flat halves.

5. The next couple of steps requires a bit of patience, so follow closely. Make sure that in the Modifiers stack, the UnwrapUVW modifier is opened; click on the Select Faces sub-object. Now you are going to select some of the polygons on the inside of the retina, as seen in Figure 10.64. To select the polygons, simply hold the Ctrl key and click once on each polygon. When a polygon is selected, it will turn red. This may seem like a big job, but it only takes a couple of minutes to select all the polygons. Your polygon layout may look a bit different than the figure; nevertheless, the idea is to select some of the polygons in the bottom half of the retina.

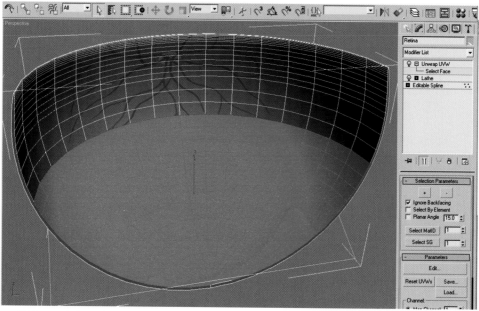

FIGURE 10.64 Select about half the polygons in the bottom of the retina.

6. Notice that in the Edit UVWs window some of the mesh is selected (it should be some of the mesh in the top half). In the Parameters rollout of the UnwrapUVW modifier, locate the Planar button and press it once. The selection in the Edit UVWs window is now flattened. It may be hard to see it because the rest of the retina is in the way. See Figure 10.65

7. Next in the Edit UVWs window, move the flattened part of the retina away from the rest of the retina. Carefully click on one of the vertices of the selected mesh in the Edit UVWs window and drag it away and place it somewhere else in the Edit UVWs window. See Figure 10.66.

8. Now select the remaining part of the retina's mesh (what is inside the blue lines) and scale it down with the Scale button so that it is out of the way. See Figure 10.67.

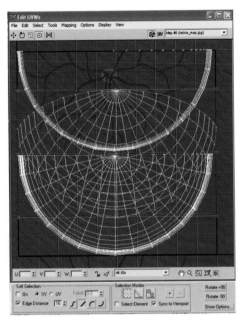

FIGURE 10.65 The flattened selection in the Edit UVWs window.

FIGURE 10.66 Move the newly flattened part of the retina's mesh outside the blue lines.

9. Finally, select and move the flattened part of the retina over the blood vessels inside the blue lines, as in Figure 10.68.

FIGURE 10.67 Scale down the remaining mesh and move it to a bottom corner.

FIGURE 10.68 Move the flattened part of the retina over the blood vessels in the Edit UVWs window.

10. Take a look at the viewport; you should now see that the texture is oriented correctly at the bottom of the retina, as seen in Figure 10.69. Save your work. Try experimenting by moving the flattened retina in the Edit UVWs window and notice how the texture moves.

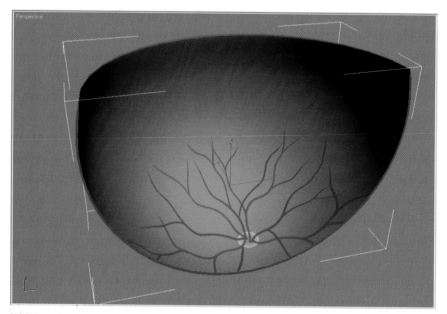

FIGURE 10.69 The retina texture in place at the bottom of the retina.

WORKING WITH MATERIAL IDS AND THE UVW MAPPING MODIFIER

In the next part of the texturing tutorial, the UVW Mapping modifier is used in conjunction with Material IDs to texture the iris and the choroid.

1. Hide all objects except the choroid/iris object.
2. Zoom in on the iris as in Figure 10.70. The first task is select the polygons that make up the top of the iris. But instead of selecting polygons one at a time, we will let 3ds max do most of the work.
3. Open the Editable Poly's stack and select the Edge sub-object. With the Select Object tool, select each edge, as seen in Figure 10.71. Remember that each selected edge will turn red, and to select multiple objects, just hold the Ctrl key and click once on each object. Be careful not to select any other edges, just the ones that show.
4. In the Selection rollout press the Loop button, and 3ds max will select all associated edges as in Figure 10.72.

FIGURE 10.70 Zoom in on the iris.

FIGURE 10.71 Select the first row of edges.

FIGURE 10.72 Press the Loop button to select the associated edges.

5. Bring up the Quad menu and choose Convert to Face. 3ds max now selects all the faces associated with the edges. See Figure 10.73.

FIGURE 10.73 Choose Convert to Face to select all the faces (polygons) associated with edges.

6. In the Polygon properties rollout, enter 1 next to the Set ID field and then press Enter. The set of polygons that make up the top of the iris is now ID 1; the polygons can now be selected or textured together, independent of the rest of the object. See Figure 10.74

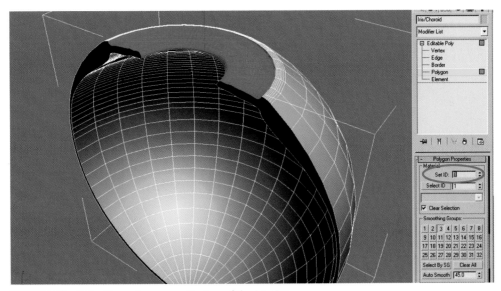

FIGURE 10.74 Make the polygons on the top of the iris ID 1.

7. In the Edit menu, choose Select Invert (Ctrl+I) to invert the selection, so now the iris (ID 1) is deselected but the rest of the object is selected, as in Figure 10.75. Set the ID for the selected polygons to ID 2.

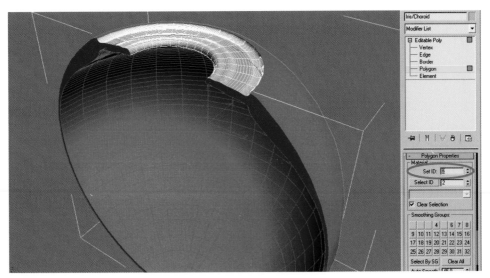

FIGURE 10.75 Invert the selection and make the new selection ID 2.

8. Now we have IDs but no materials with which to texture them, so let's create a couple of new materials for the iris and the choroid in the Materials Editor. Press M to bring up the Materials Editor. Select an empty slot in the Materials Editor and name it Choroid. Click on the Diffuse color chip and from the color picker, choose a light purple color (or any color that you like). See Figure 10.76.

9. Select another empty slot, name it Iris Texture, and click on the Maps rollout. Click on the Diffuse channel in the Maps rollout to bring up the Material/Map Browser. Click on Bitmap and browse to the file iris_map.jpg in the Chapter 10 folder in the companion CD-ROM. See Figure 10.77.

ON THE CD

FIGURE 10.76 Bring up the Materials Editor and create a new material.

FIGURE 10.77 Create another material, this time for the iris texture.

10. Create a selection from ID 1 by entering 1 next to the Select ID button and then clicking the Select ID button. Now from Materials Editor, drag the Iris Texture on to the selection of polygons that make up the top of the iris, as in Figure 10.78. Turn on the Show Map in Viewport property (red circle in figure) so that the iris texture will show up in the viewports. At this point, you will probably still not be able to see the iris texture on the iris in the viewports; we will fix that in just a moment.

FIGURE 10.78 Drag the Iris texture material on to the group of polygons selected by ID 1.

11. Invert (Ctrl+I) the ID 1 selection and drag the Choroid material on to the ID 2 selection. See Figure 10.79. By now it should be clear that by creating groups of polygons with distinct IDs, it is possible to assign different materials to different parts of the same object.

FIGURE 10.79 Drag the Choroid material on to the group of polygons selected by ID 2.

12. Even though materials are assigned to the choroid and iris, there is still a bit of work ahead to map the iris texture so that it is oriented correctly on the iris. Last time, we used the UnwrapUVW modifier to orient the retina's texture, but this time we will use the UVW Map modifier. So from the Modifiers List select UVW Map and add it to the Choroid's Modifier stack. (Note: In the Modifiers List look for the UVW Map modifier, however, when the modifier is added to the stack, its label changes to UVW Mapping—it's the same modifier.)

13. Before proceeding, go the Customize menu, select Viewport Configuration, and uncheck Shade Selected Faces. This will allow you to see the iris texture in the viewport. See Figure 10.80.

FIGURE 10.80 Uncheck Shade Selected Faces in Viewport Configuration.

14. After configuring the viewport, you should be able to see the iris texture, which might look similar to Figure 10.81. If it does not look exactly like Figure 10.81, don't worry because you will move, rotate, and scale the iris texture so that it is oriented correctly. The first task is rotate the texture 90 degrees. Open the UVW Mapping modifier and select the gizmo. Click on the Select and Uniform Rotate tool and in the X coordinate field in the Status bar enter 90. The texture should rotate, but it is still not quite right.

15. Now use the Select and Move and the Select and Uniform Scale tools to position and scale the texture so that it fits on the iris, as seen in Figure 10.82. The iris texture purposely has a red border so you can see the edges of the texture better. So if you see a red line, you have gone too far.

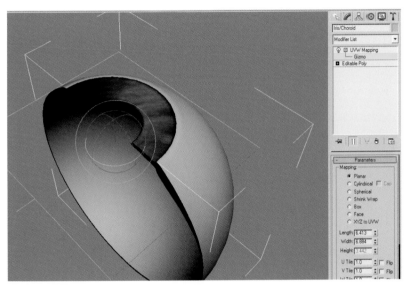

FIGURE 10.81 Rotate the texture by rotating the UVW Mapping gizmo.

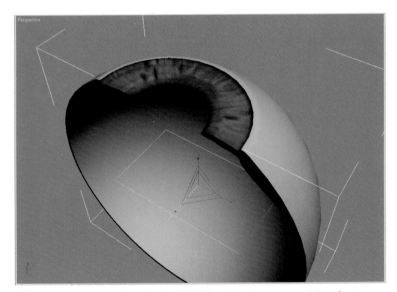

FIGURE 10.82 Move and scale the UVW Mapping gizmo to position the texture.

16. In the Materials Editor, select an empty slot, click on the Pick Material from Object button (the eyedropper), and click on the choroid/iris object in the viewport. You should now see the checkered pattern in the slot. Below the slots, the Multi/Sub-Object Basic Parameters rollout displays the materials assigned to the object. See Figure 10.83.

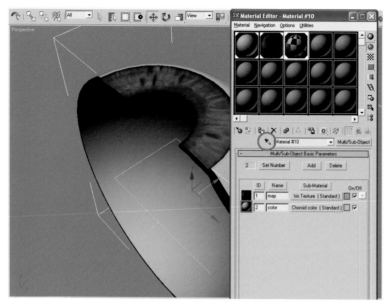

FIGURE 10.83 The choroid/iris object has multiple textures, so it is displayed as a Multi/Sub-Object material in the Materials Editor.

17. Next you will apply a transparent shader to the cornea. Once again, select an empty slot in the Materials Editor, name it Cornea, and click on the Background button to display the colored, checkered pattern in the slot. Enter this shader recipe: Diffuse color is light blue, Opacity is 35 percent, Specular Level is 105, and Glossiness is 72. See Figure 10.84. At this point, you should see a material that looks like glass. Now drag and drop the Cornea material onto the cornea object in the scene; the cornea object should become partially transparent.

18. However, to get a better feel for how the materials look, press Shift+Q to do a quick render, as in Figure 10.85. The quick render lets you see properties such as transparency, specularity, and bump mapping, among other things. To set the properties for the quick render, click on the Render button on the toolbar. One render property that you will want to turn on is Force 2-Sided, which will let you see the lens capsule better. Turn on Force 2-Sided and render one more time; notice that this time you can see the top of the lens capsule.

To complete the texturing of other objects such as the ciliary processes, the lens capsule, and the zonules, repeat the steps we have practiced. Namely, create a material in the Materials Editor and apply to the object in the viewport.

Here is a quick tip on texturing the ciliary processes and zonules: there are about 30 ciliary processes and about 60 zonules in the scene, and it would be terrible to have to apply materials to each one. However, since

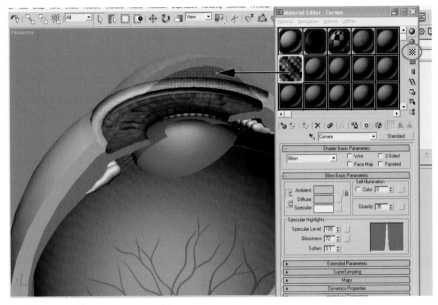

FIGURE 10.84 The cornea material.

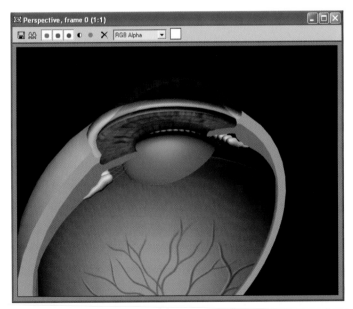

FIGURE 10.85 A quick render of the eye scene lets you see properties such as transparency, specularity, and bump mapping.

you have the processes and zonules in groups, all you have to do is create the material, select the group, drag the material from the Materials Editor, mouse over one of the objects in the group, and drop the material. 3ds

max will display the Assign Material dialog box and ask if you want to apply the material to the single object or to the entire selection (or group). Choose Assign to Selection and click OK. The material is assigned to all the objects in the group at once.

You have done a lot of work modeling and texturing, and your reward is a great looking 3D model of an eye. While all your work has produced awesome results, you need to switch your focus from modeling and texturing to lighting and rendering. After all, no one can see your work if you don't light it and create a 2D image that can be distributed. In the last part of this chapter, you will learn to add lights and cameras, and to render the scene.

LIGHTS, CAMERAS, AND RENDER

While modeling, 3ds max uses default lighting that is not really meant to be used as the final rendering light, because it cannot be moved or customized. The same goes for the viewport cameras: while they come in handy while modeling, they cannot be customized and should not be used for final renders. So in the last of the tutorials in this chapter, we will add two lights to the scene to create a custom lighting scheme, add a camera to frame the secne, and finally render the scene to a file.

ON THE CD

First you need to import or merge the 3ds max file that contains the model of intraocular lens. Once the lens is in the scene, position it as seen in Figure 10.86. If you don't want to bother with importing, just open the

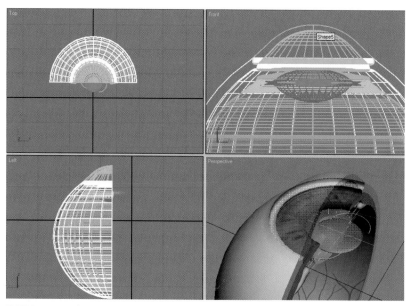

FIGURE 10.86 The intraocular lens in position.

file render_eye.max found in the Chapter 10 folder of the companion CD-ROM and go to step one.

Lighting the Scene

The focus of the illustration is the intraocular lens that is in the lens capsule. So to draw attention to the intraocular lens, add a Free Spotlight that points at it.

1. In the Create panel click on the Lights button. In the Object Type rollout, choose Free Spot. In the Top viewport (or any viewport), click once; the Free Spot light is added to the scene. Notice that any viewports set to Smooth + Highlights immediately become very dark. This is because the default lighting is now turned off, and the only light in the scene is coming from the Free Spot light and chances are that it is pointing in the wrong direction. See Figure 10.87.

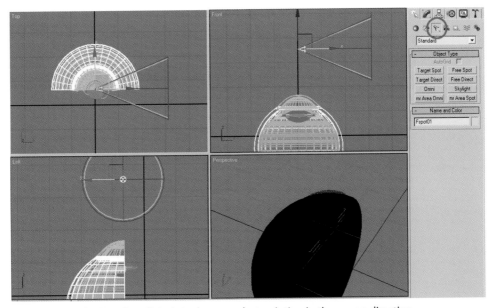

FIGURE 10.87 The Free Spot light is in the scene but pointing in the wrong direction.

2. After the light is in the scene, the next step is to move and rotate it into position. So position the Free Spot light as seen in Figure 10.88. But by all means, feel free to experiment with your own light arrangement. You can position the light with Transform tools such as Select and Move and Select and Rotate. However, you can also position the light by looking through it. To do this, all you have to do is right-click on the viewport label in the upper-left corner and choose

Views from the menu. Then select the light (probably named Fspot01) from the submenu. Once you are looking through the light, use the View tools to position the light.

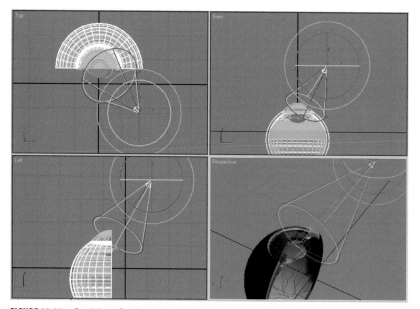

FIGURE 10.88 Position the Free Spot light so that it points at the intraocular lens.

3. The back part of the eye is very dark, so add a fill light to illuminate the eye better. From the Lights Object type rollout, choose Omni and place it behind and above the eye as in Figure 10.89. The Omni light emits light in all directions, thus it makes a good fill light.

4. In general, you want the main light to draw attention to the focal area of the illustration and the fill light just fills in the dark spots. However, since the scene has specular objects, the lights are also placed to create highlights on those surfaces. At this point, you will have to move the lights until you are happy with the lighting. Do quick renders by pressing Shift+Q or F9 to see how the lights are affecting the scene. Figure 10.90 is a test render.

5. To add depth to the scene, select the Free Spot light and in the Shadows section of the General Parameters rollout, check the On checkbox to turn on shadows and choose Area Shadows from the menu. Render the scene once again; note that this time soft shadows are cast throughout the scene. See Figure 10.91. If the shadows are too dark for your taste, scroll down to the Shadow Parameters and set the Dens. (Density) to less than 1.

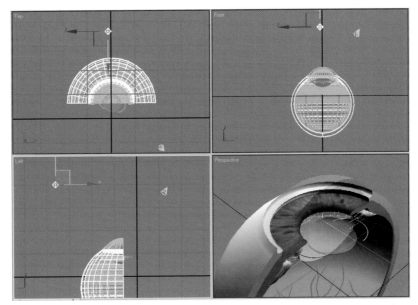

FIGURE 10.89 Place an Omni light in the scene. Move it so that it is almost directly behind the eye and above.

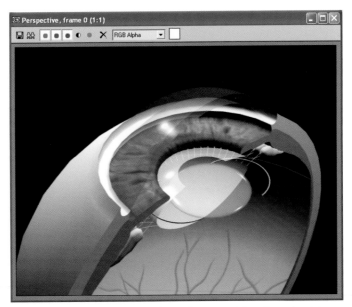

FIGURE 10.90 Place an Omni light in the scene. Move it so that it is almost directly behind and above the eye; this will create dramatic highlights on the specular surfaces.

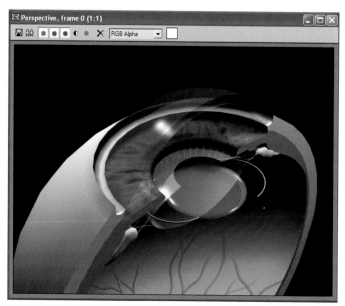

FIGURE 10.91 Turn on shadows to add depth to the scene.

6. You can control the intensity of the lights in the scene by opening the Intensity/Color/Attenuation rollout and increasing or decreasing the Multiplier value.

Adding a Camera

So far you have been viewing the scene through the viewport cameras. While the 3ds max viewport cameras are very good and you can even get good renders, it is better to become familiar with positioning and configuring cameras to render a scene. For example, cameras can be animated to produce flybys or to orbit around an object, whereas a viewport camera cannot.

1. In the Create panel, click on the Camera button and in the Object Type rollout, choose Free. Click anywhere in the scene to insert the camera. See Figure 10.92. In the Modify panel you can change the name of the camera from Camera01 to any name you like.

2. Choose a viewport (preferably the Perspective viewport) and right-click on the viewport label in the upper-left corner, select Views, and from the sub-menu choose Camera01. Now you are looking at the scene through the camera, which is probably pointing away from the eye, as in Figure 10.93. Notice that the View tools in the lower-right corner of the user interface have changed from the viewport View tools to the camera View tools.

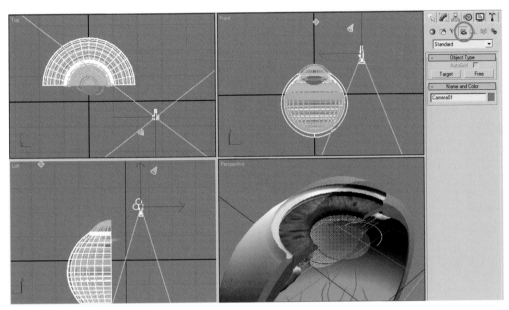

FIGURE 10.92 Insert a camera into the scene.

FIGURE 10.93 Switch one of the Viewports so that you are looking at the scene through the camera.

3. You can position a camera in many ways, but for now, we will do it two different ways. First, use the Select and Move and the Select and Rotate tools, in the Top, Left, and Front viewports to position the camera to so that it is looking at the eye, as in Figure 10.94.

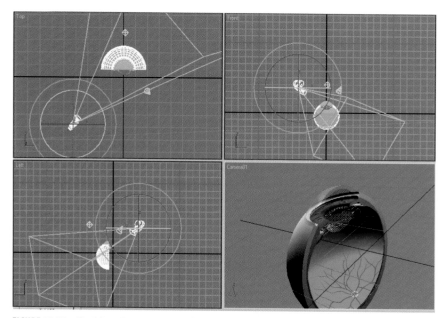

FIGURE 10.94 Position the camera so that it is looking at the eye.

4. Once the camera is generally looking at the eye, you can use the camera View tools such as Truck, Dolly, Roll, and Orbit to fine-tune the position of the camera. See Figure 10.95.

Rendering the Scene to a File

Now that you have created a lighting scheme with the Free Spot light and the Omni light and framed the scene with a camera, it is time to render the scene to a file. Rendering simply means that 3ds max will calculate the interaction between lights, objects, and environmental properties in the scene to produce a 2D image or animation. In the following steps, we will render the scene of the eye to a 300 dpi, color TIFF file.

1. Click on the Render Scene button in the toolbar to bring up the Render Scene dialog box. As you can see, there are many options, but for now the only thing to do is make sure that Force 2-Sided is checked, the Output size is set to Custom, Width is 640, and Height is 480. See Figure 10.96.

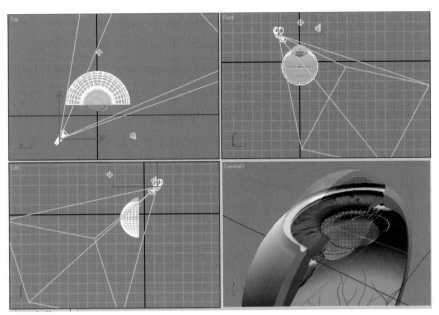

FIGURE 10.95 Fine-tune the position of the camera with the camera View tools.

FIGURE 10.96 Set the rendering options in the Render Scene dialog box.

2. Click on the Files button in the Render Output section of the Render Scene dialog box. This will bring up the Render Output File dialog box. In the File name: field, name your file; pay attention to where you are saving the file. Click on the Setup button and make sure the resolution is set to 300 dpi in the TIFF Image Control dialog box; click OK. In the Render Output File dialog box, click Save, and back in the Render Scene dialog box, click on Render. 3ds max renders the scene, as in Figure 10.97.

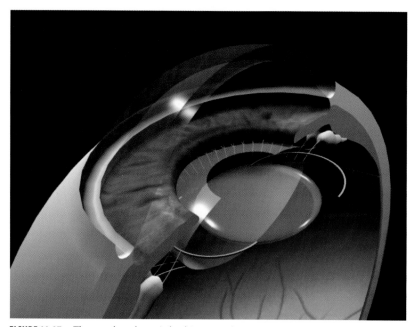

FIGURE 10.97 The rendered eye is looking good.

3. Before concluding, change the background color from black to blue. To do this open the Rendering menu in the Menu bar and choose Environment (8). In the Environment and Effects dialog box, click on the color chip in the Background section. From the Color Picker choose a dark blue color (or any color you like), click on Close, and render again. See Figure 10.98.

4. You may have noticed that the silhouette of the sclera and the cornea are a little blocky (red arrow). This is happening because the Segment value of the Lathe modifier is set to just 16. To smooth the silhouettes select each object and in the Parameters rollout of the Lathe modifier, increase the segments from 16 to 32 and render again. See Figure 10.99.

FIGURE 10.98 In the Environment and Effects dialog box, you can change the background color.

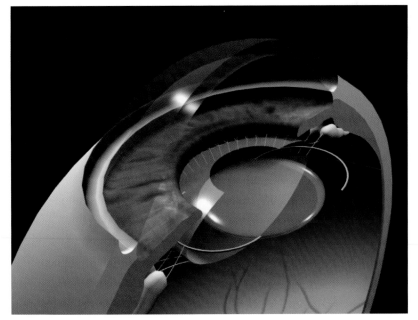

FIGURE 10.99 Even at this late stage in production, 3ds max allows you to refine the modeling of the objects in the scene.

CONCLUSION

If you have worked through all the tutorials in this chapter, congratulations are in order. So congratulations! At this point, you should have acquired enough skills with 3ds max to build models, texture, light, and to render them. So far you have modeled a human eye using imported splines and native 3ds max splines, primitives, and modifiers, and you have also learned to edit splines to refine objects. You have worked with sub-objects such as vertices, edges, and polygons, and have learned to create materials in the Materials Editor. You used the UnwrapUVW and UVW Mapping to map textures, and you created materials' IDs to control where materials are applied on an object. Along the way, you have become familiar with the 3ds max user interface by working with rollouts, input fields, configuring viewports, and the Quad menus. You have also had plenty of practice with the transform tools like Select and Move, Select and Uniform Scale, and Select and Rotate. In the next chapter, you will learn to model and animate cellular and molecular scenes.

11

MOLECULAR AND CELLULAR ANIMATION

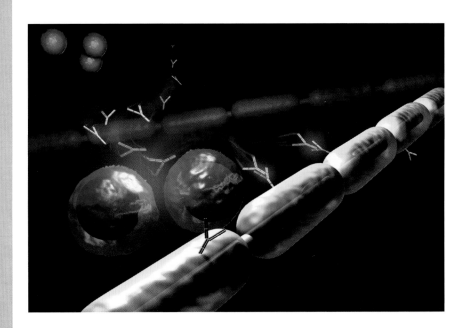

INTRODUCTION TO MOLECULAR ANIMATION

Until about 20 years ago if a researcher wanted to visualize a molecule to determine its structure or function, he either had to put pencil to paper and draw the structure of the molecule in 2D or build a real-world model to see it in 3D. See Figure 11.1. If the researcher was lucky and his institution had a computer department, he might have been able to reserve some time on the resident supercomputer to do his work. Today, scientists still draw molecules by hand and build models, but the preferred method is working with molecular visualization software, not on supercomputers but on desktop computers.

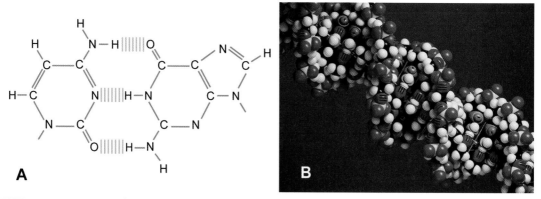

FIGURE 11.1 a) Drawing of DNA base pairs and b) DNA space fill model.

Molecular visualization was once the domain of researchers and scientists, but it is nowadays available to the public. If you want to take a look at the 3D structure of DNA, Aspirin, or Hemoglobin, all you have to do is download one of the thousands of public files from the Protein Data Bank, download a free copy of Rasmol or Chime (there are many more free molecular visualization programs), and in no time you will be exploring molecules in 3D right on your desktop. See Figure 11.2.

However, as useful as molecular visualization programs were to scientists, they were not of much use to artists. For some time, there was no way for medical artists to take the 3D data in the PDB files and import it into mainstream 3D applications like 3ds max to create illustrations or animations. The only way to create a 3D molecular model for illustration or animation was to model it atom by atom in a 3D modeling program, and depending on the type of visualization, the process could be grueling. However, programs like Accelrys DS ViewerPro™ and others allow the artist to prepare PDB files for animation in mainstream 3D animation programs. In addition, working directly from the same data that scientists use ensures accuracy in the molecular structures used for animation and illustration.

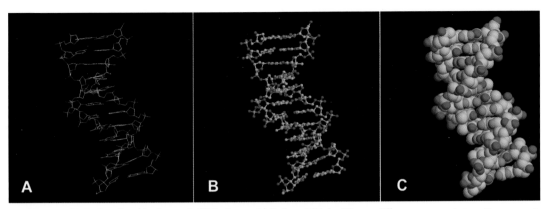

FIGURE 11.2 DNA visualized in Rasmol a) Wireframe b) Ball and Stick c) Space Fill. (Brown, T., et. al., *Crystal Structure and Stability of a DNA Duplex.* J. Mol. Biol. v. 207. pp. 455. 1989. The Protein Data Bank. PDB ID 111D.)

TUTORIAL

MOLECULAR ANIMATION—ANTIGEN BINDING WITH MHC CLASS I

PROJECT 1 OVERVIEW

In this first tutorial, we will create an animated sequence depicting an antigen binding with a Major Histocompatibility Complex (MHC) Class I protein. But before we get into the 3D animation, let's first learn a little about what we will animate.

WHAT IS AN ANTIGEN?

An antigen is any foreign matter that stimulates an immune response. For example, organisms like bacteria or viruses can be considered antigens, and inanimate substances like dust and chemicals can also be antigens. When bacteria infect your body, maybe through a cut, specialized cells in your tissues called antigen presenting cells (APC) will internalize and process the bacteria or parts of the bacteria. Inside the APC, the antigen is associated with an MCH Class I or Class II protein, depending on the type of APC. Then the antigen and the MHC protein are moved to the surface of the APC where the MHC-antigen complex is presented to other immune cells, such as T cells or T helper cells. T cells become stimulated when their surface receptors come into contact with the MHC protein and the antigen. The stimulated T cells then generate a chemical cascade that produces a cell-mediated immune response that works to destroy the invading bacteria.

WHAT IS A PROTEIN?

In general, proteins are special organic molecules that are essentially the builders and the workhorses of all life. Most tissues are made of proteins, like the collagen found in bones and skin. And specific proteins called enzymes catalyze the many biochemical reactions necessary for life. For example, the enzyme pepsin digests the proteins we eat.

Proteins are synthesized when chains of amino acids are assembled in a process called Translation. The assembled protein, known as polypeptide, naturally folds into a stable three-dimensional structure dictated by sequence of the amino acids in the chain. Though each protein is unique, the β-sheet (beta sheet) and the α-helix (alpha helix) are common folding patterns that repeat in most proteins. Combinations of _-sheets and _-helices form distinct domains. The protein we will be working with, the MHC Class I, has four domains, α1, α2, α3, and β1. See Figure 11.3. Because of the protein's special structures, proteins are often visualized as ribbons. The ribbons clearly show the characteristic sheets and helices formed by amino acids—just keep in mind that the visualizations styles simply help us see and understand the structures of molecules.

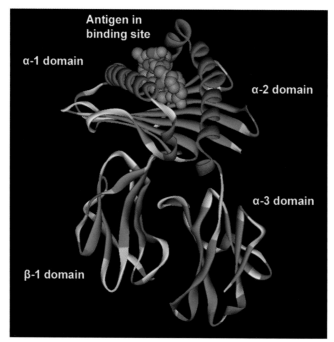

FIGURE 11.3 Solid ribbon view of the MHC Class I protein.
(Antigen is shown in space fill view.) (Rudolph, M.G., Wilson, I.A., High Resolution Crystal Structure of H-2Kb/Vsv8. The Protein Data Bank. PDB ID 1KPV.)

THE PROTEIN DATA BANK

To begin, we will download 3D dataset for an MHC Class I protein from the Protein Data Bank at *www.rcsb.org*. The Protein Data Bank is an online database of proteins and molecular data available to the public. Before downloading any data from the Protein Data Bank, please read the terms of use at *www.rcsb.org/pdb/info.html#PDB_Users_Guides*. Though the data in the Protein Data Bank is available at no charge, it is copyrighted. Once we have the 3D dataset for the MHC Class I protein, we will use Accelrys DS Viewer Pro to visualize the protein, then we will prepare it for export as a VRML file. Next we will import the VRML file into 3ds max and create a short animation. Now that we know what we are doing, let's get started.

DOWNLOADING THE MHC CLASS I PDB FILE FROM THE PROTEIN DATA BANK

Here are the steps in downloading the MHC Class I PDB file:

1. Point your Web browser to *www.rcsb.org*.
2. In the Search the Archive field, enter 1KPV for the PDB ID and click on the Search button.
3. The Query Result Browser page will display one or two datasets; look for the 1KPV dataset. To download the 1KPV dataset, click on the Structure Viewing Options button (it's an eye icon) to go to the Structure Explorer page.
4. On the Structure Explorer page, you will see a bulleted list; click on the Rasmol link to download the PDB file. When prompted, save the file to disk.
5. At this point, you should have the 1KPV.pdb file on your disk. This is the file we will work with to create the 3D model for the molecular animation later on. However, 3ds max cannot import PDB files so we have to convert the PDB file into a format that 3ds max can import.

CONVERTING THE PDB FILE TO VRML FOR IMPORT INTO 3DS MAX

Since 3ds max cannot import PDB files, we will use DS ViewerPro to open the PDB file, configure its display style, and then create a VRML file that 3ds max can import.

1. Launch DS Viewer Pro, go to the File menu, and choose Open, then locate the 1KPV.pdb file. Once in DS ViewerPro, the MHC protein is displayed in Line style (also know as Wireframe), as in Figure 11.4. That means that the atoms and the atomic bonds are represented as lines. Click anywhere in the window and drag; you should be able to orbit around the protein.

FIGURE 11.4 Once the PDB file is open in DS ViewerPro, the MHC protein is displayed in Line format.

2. Click on the Display Style button in the Atom panel and choose CPK. Now the atoms in the MHC protein are displayed as colored spheres. The colors represent specific atoms: red is oxygen, gray is carbon, blue is nitrogen, and yellow is sulfur. Atomic bonds are represented by the position of the spheres. See Figure 11.5. For example, an oxygen atom that is partially inside a carbon atom means that they share electrons thus creating a bond. Try the other display options, and remember that you can orbit around the molecule to get a better look by dragging the mouse around the window.

 File size can be a real problem when converting the data in PDB files into VRML files. For example, if you export the CPK display version of the MHC protein, you will end up with a VRML file that contains nearly 100,000 polygons. On the other hand, if you export the ribbon display version, you will end up with a VRML file that only has about 30,000 polygons. So be very careful when converting PDB files into VRML files so that you end up with a 3D file that is manageable.

3. Now let's prepare the MHC protein for export as a VRML file. Bring up the Display Style dialog box once more and turn off any options in the Atom panel by choosing the Off radio button. It is important to

FIGURE 11.5 The CPK display format shows the atoms as colored spheres.

turn off the Atom display because if you do not turn it off, the atom display may be hidden in the ribbon structure, thus creating objects we do not need in the VRML file and adding significantly to the overall file size.

In the Protein panel, choose Solid ribbons; in the Coloring section, choose Color By; and in the menu, select AminoAcidChain; click on OK. See Figure 11.6. We are using the AminoAcidChain color scheme because when exported to VRML, it uses standard material colors as opposed to vertex painting as with other color schemes.

4. Now in the File menu, select Save As. In the Save As dialog box, name your file (or just keep the 1KPV filename) and from the Save as type menu choose VRML World Files, as seen in Figure 11.7.

FIGURE 11.6 The MHC protein ready for export to VRML format.

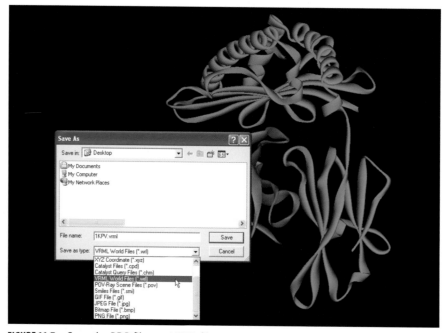

FIGURE 11.7 Save the PDB file as a VRML file.

Cleaning Up the VRML Model in 3ds max

In the following steps, VRM model will be edited so that it can be smoothed and textured.

1. DS ViewerPro has done its job at this point, so you can close it if you like. Launch 3ds max and import the VRML file you just created. In 3ds max, go to the File menu and choose Import. In the Select File Import dialog box, select VRML in the Files of type menu, browse to the 1KPV.vrml file, and click on Open. After a few moments, the MHC protein will be imported into 3ds max. See Figure 11.8.

FIGURE 11.8 The MHC protein in 3ds max.

2. The first task is to delete some extra data that we do not need. Press H to bring up the Select Objects dialog box. Select the objects seen in Figure 11.9 and delete them. The only objects left should be VIFS01, VIFS02, and VIFS03. Rename VIFS01 to alpha, VIFS02 to beta, and VIFS03 to antigen.

3. If you zoom in on the MHC you will see that model is faceted. In other words, it is not smooth, as seen in Figure 11.10. VRML files usually import with no smoothing information, but our model is actually a bit worse off than that, because all the polygons in the model are not welded together, which means that to smooth the model you first have to weld adjoining or superimposed vertices together to create one object. Luckily, this is very easy to do in 3ds max.

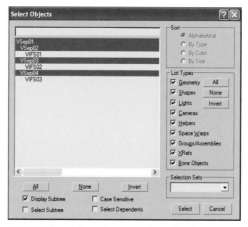

FIGURE 11.9 Delete the extra data that is not needed and rename the remaining objects.

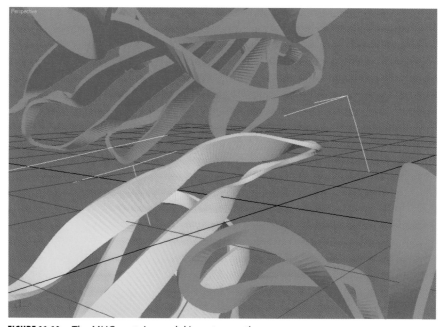

FIGURE 11.10 The MHC protein model is not smooth.

4. Select the beta object and the antigen and hide them so that you can work on the alpha object without any distractions. Remember: to hide an object you can simply right-click to bring up the Quad menu and then choose Hide Selected. See Figure 11.11.

FIGURE 11.11 Hide the beta domain and the antigen.

5. Open the Editable Mesh and select the Vertex sub-object. Then with the Select Object tool, draw a selection box around all the vertices or press Ctrl+A to select all vertices. Once selected, all the selected vertices turn red (Figure 11.12).

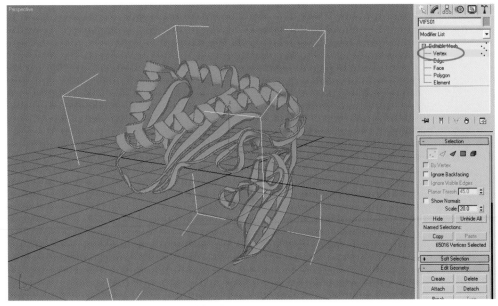

FIGURE 11.12 Select all vertices in the alpha domain.

6. Next the vertices that are very close together or superimposed will be welded. Welding the vertices will form one continuous object that can be smoothed. In the Edit Geometry rollout, locate the Weld section. Enter the value .1 in the input field and click on the Selected button. See Figure 11.13. It may take about 30 seconds to a minute, but 3ds max will weld all vertices that are within .1 inch or less of each other.

FIGURE 11.13 Weld all the vertices that are within .1 inch or less of each other.

7. As soon as the welding operation is done, the faceting will disappear and the object will become very smooth, as seen in Figure 11.14. A great benefit of welding vertices that are very close to each other is that the number of vertices is reduced thus reducing the file size.

8. Next, you will define at what angle creasing will occur so that the ribbons in the model will have some edges. In the Modifier stack, open the Editable Mesh and select the Polygon sub-object. Then select all polygons by pressing Ctrl+A. See Figure 11.15.

FIGURE 11.14 Once the welding operation is done, the object is very smooth.

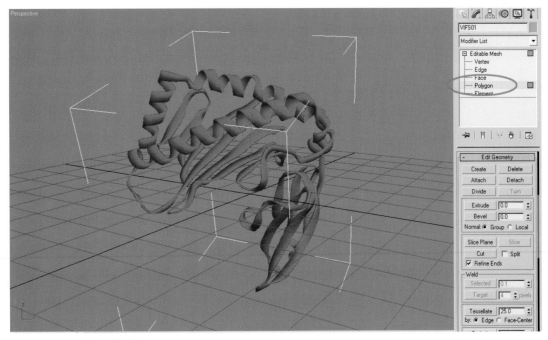

FIGURE 11.15 Select all polygons.

Press Auto Smooth. Notice that the ribbons now have some definition and look more like boxes than blobs. See Figure 11.16. Unhide the beta object and repeat steps 5–8 to weld, smooth, and define it out as we did with the alpha object.

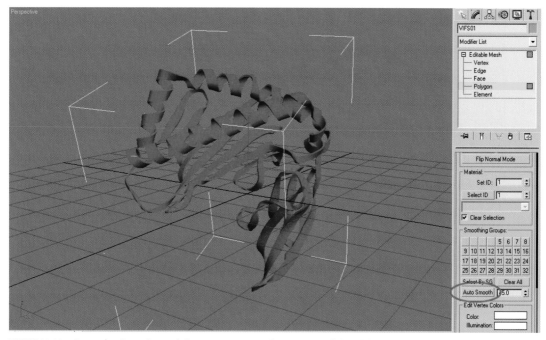

FIGURE 11.16 Press the Auto Smooth button to crease the corners of the ribbons.

EDITING MATERIALS

In the following steps, the materials of the alpha and beta objects will be edited:

1. The current color of the alpha object is not very good and it makes it hard to see details. So in the next couple of steps, you will quickly edit the materials of the alpha and beta objects to change their color and surface properties.
2. Press M to bring up the Materials Editor. To display the material properties of the light blue alpha object, select the Pick Material from Object tool in the Material Editor and click once on the light blue alpha object in the scene, as in seen in Figure 11.17. The first slot in the Materials Editor now contains the material information of the alpha object.

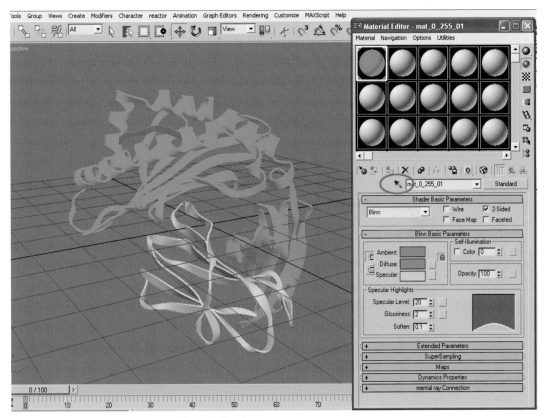

FIGURE 11.17 Sample the material of the alpha object.

3. Now in the Materials Editor, click once on the Diffuse color chip and in the Color Selector, choose a medium gray-blue color (or any color you like). See Figure 11.18.

4. In the Specular Highlights section, reduce the Specular Level to about 15.

5. The yellow-gold color of the beta object looks great with the blue alpha, but you may want to reduce its Specular Level also. Have some fun and experiment with the objects' colors. You can even assign color IDs (see Chapter 10) to the different parts of the alpha object to assign different colors to the helices and the beta sheets, but for now, you are done. Try doing a quick render test by pressing Shift+Q to see how the objects look and possibly catch any problems in the geometry, as in Figure 11.19.

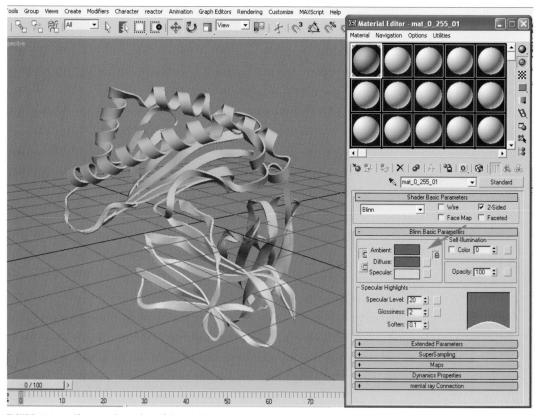

FIGURE 11.18 Change the color of the alpha object to a medium blue.

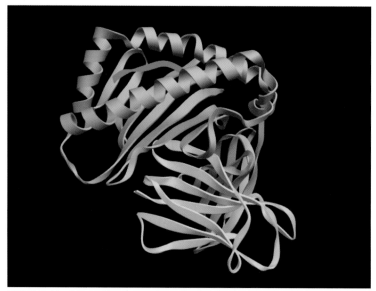

FIGURE 11.19 The yellow beta object looks good with the blue alpha object.

PLACING A SPACE FILL ANTIGEN MODEL INTO THE MHC'S BINDING SITE

In the following steps, a space fill antigen model will be placed into the MHC's binding site:

1. The antigen that imported with the MHC and is bound to the binding site (between the helices) is represented as short ribbon. See Figure 11.20. We want a more interesting representation of the antigen, so select and delete the green antigen object.

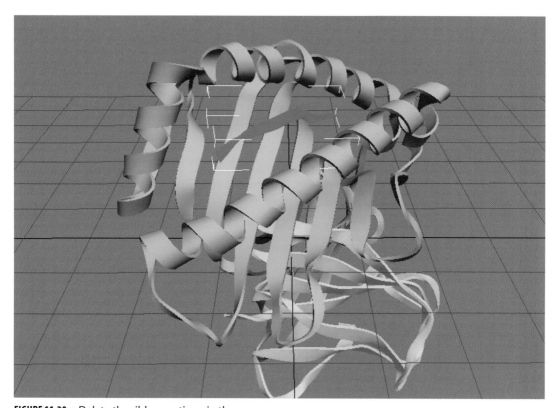

FIGURE 11.20 Delete the ribbon antigen in the scene.

ON THE CD

2. From the File menu, choose Merge and browse to the file antigen.max in the Chapter 11 folder of the companion CD-ROM. In the Merge dialog box, choose the Antigen group, as in Figure 11.21.

3. The antigen will probably appear in the scene in the wrong place, but positioning it is easy. The antigen should be positioned in the MHC's binding site, which is between the two helices. Use the Select and Move and the Select and Rotate tools to position the antigen, as seen in Figure 11.22. Moving the antigen into the binding site works best if you use the four viewports.

FIGURE 11.21 Merge the Antigen group into the current scene.

FIGURE 11.22 The antigen in the MHC binding site.

ADDING A LIGHT AND A CAMERA

At this point, the MHC-antigen complex is completed. The next task is to add a light and a camera in preparation to animate.

1. Select the alpha, beta, and antigen objects and rotate the objects together so that the whole complex is more upright. Then move the objects towards the center of the scene; use the grid to guide you. See Figure 11.23.

FIGURE 11.23 Rotate the MHC and the antigen into a more upright position and move the objects towards the center of the scene.

2. In the Create panel, click on the Lights button, choose Omni, and position the new Omni light at about X 53, Y 55, Z 65. See Figure 11.24. Feel free to experiment with different lights or light positions.
3. Now click on the Camera button and add a Target Camera to the scene. To place the Target Camera in the scene, switch to the Top viewport and click once around the 3 o'clock position and then drag towards the center of the MHC model. The first click places the camera in the scene, and the dragging motion positions the camera target, as seen in Figure 11.25. Try moving the camera (not the target) with the Select and Move tool. Notice that the camera always points towards the target no matter how you move the camera.

FIGURE 11.24 Add an Omni light to the scene.

FIGURE 11.25 Add a Target Camera to the scene.

CREATING THE MOLECULAR ANIMATION

So far you have prepared models of the MHC protein, the antigen, and you have created a scene with a light and camera. You have everything you need to animate except a plan, so let's go over the action in the animation. In this brief animation, two things will occur: first the antigen will dock with the MHC protein, and once the docking has occurred the camera will complete one orbit around the MHC-antigen complex.

1. The first thing you will do is configure the timing for the animation. To do this, click once on the Time Configuration button on the right side of the Status bar. Set the following properties in the Time Configuration dialog box: in the Frame Rate section, select Custom and set the FPS (Frames per Second) to 12; by default the Time Display is set to Frames; in the Animation section, the Start Time is 0, the End Time is 120, the Length is 120. To clarify, the animation is being measured in frames not seconds, so if the FPS is 12 and the Length is 120, the animation length is 10 seconds. See Figure 11.26.

FIGURE 11.26 It is important to set the Time Configuration properties before animating.

2. Next you will prepare 3ds max so that we can set the keys for the MHC-antigen docking sequence. Click once on the Auto Key button. The bar above the timeline will turn red, as in Figure 11.27. When Auto Key is turned, 3ds max will automatically create keys on the timeline that reflect changes in the scene. For example, if an object moves in the scene, 3ds max will record the starting point and ending point with keys.

FIGURE 11.27 Turn on Auto Key.

3. Make sure that the Time Marker is set to frame 0, and move the antigen up along the Y axis (viewport coordinates) about 50 units. Notice that a red key has appeared in the Track Bar at frame 0. See Figure 11.28.

4. Now move the "Time Marker" to frame 20 and move the antigen back down to its original position, as seen in Figure 11.29. Once again, 3ds max has placed a new key at frame 20 to reflect the antigen's change in position. Preview the animation by moving the Time Marker back and forth between the keys. Reset the Time Marker back to frame 0. For now, you are done with the antigen; next you will animate the camera.

5. Creating a camera that orbits around a scene is a common animated effect. In this animation we will use the Path Constrain to constrain the camera's motion along a circular path. In the Create tab select Shapes, and then Circle. Make sure the circle's Creation Method is set to Center. In the Top viewport place the cursor over the camera's target and drag outward to create a circle, as in Figure 11.30.

FIGURE 11.28 Move the antigen up at frame 0.

FIGURE 11.29 At frame 20, move the antigen back down to set a new key.

FIGURE 11.30 Create a circle.

6. Select the camera and open the Animation menu, choose Constrains, and from the sub-menu, select Path Constrains. As soon as the menus close, you will see a dotted line that originates from the camera and follows the mouse. Click once on the circle to constrain the camera to the circle. See Figure 11.31.

FIGURE 11.31 Constrain the camera to the circle in the scene.

7. To see the camera in motion, switch to the Top viewport and press the Play button. The camera should orbit once around the MHC. The camera's orbit has been evenly spaced out in the 120 frames of the animation so that at frame 0 the camera is at the start of its orbit, at frame 60 it is halfway, and at frame 120 it is back at the start.

 At this point, you have the basic motion of the animation done, but it needs to be refined. For example, switch any viewport to Camera01 so you can see what the camera is looking at and press Play. What you see is probably just the middle of the MHC protein and not much else. Since the camera is constrained to the circle, we cannot reposition the camera using the Select and Move tool or any other transform tool. To reposition the camera, we have to change the circle.

8. To widen the view so you can see more of the MHC, select the circle and do one of two things: either increase the Radius in the Parameters rollout or enlarge the circle using the Select and Uniform Scale tool. Whichever method you use, notice that the camera moves back and the view now includes more of the MHC. See Figure 11.32.

FIGURE 11.32 Enlarge the circle to move the camera back so that more of the scene is in the camera's view.

9. Make sure that one of the viewports is set to Camera01 and play the animation once more. Now you should be able to see the antigen move down.

10. Even though we have improved the view through the camera, you still need to see more of the MHC and the antigen. However, this time move the camera's target up so that it is positioned near where the antigen will stop. To move the camera's target, press H and in the Select Objects dialog box, select Camera01.Target. Now with the Select and Move tool, move the target up, as in Figure 11.33.

FIGURE 11.33 Move the camera's target up to get a better view of the antigen as it docks.

11. Play the animation once more. This time you should be able to see more of the antigen as it travels down.

At this time, the camera orbits around the MHC at the same time that the antigen moves down into the MHC's binding site. In the next few steps, you will improve the action so that the antigen travels down into the MHC's binding site, and only then will the camera begin its orbit. To time the start time of the camera's orbit, you will use the Track View : Curve Editor.

12. Select the camera in the scene and right-click to bring up the Quad menu. In the Quad menu, choose Curve Editor. Since the camera was selected before opening the Curve Editor, the camera's properties are displayed in the Curve Editor. The straight green line that spans between frame 0 and frame 120 represents the path that the camera takes as it orbits. The camera's keys are represented by white/gray squares at the start and end of the green line. See Figure 11.34.

FIGURE 11.34 The Curve Editor displays the keys in a graphical format.

13. If the Percent property under Path Constrain is not selected, click on it to select it. To make the camera start orbiting after the antigen is in the binding site, you have to move the key at frame 0 to frame 23. To do this, click and hold on the Move Keys button on the Curve Editor's button bar; when the hidden Move Keys Horizontal button appears, select it. Then click on the key at frame 0 and move it to frame 23, as in Figure 11.35. Close the Curve Editor and play the animation once more. This time, the antigen travels down into the binding site and only then does the camera orbit around the MHC.

FIGURE 11.35 Move the key at frame 0 to frame 23 to delay the camera's orbit until after the antigen has docked.

Take some time to experiment with the Curve Editor. For example, select the antigen and open the curve editor, and try refining the motion of the antigen by changing the shape of the curve that represents its path. All objects in the scene have properties that can be animated, including the light, the camera, and all the objects.

RENDERING THE ANIMATION

With the animation complete, you can switch our focus to rendering the scene. Rendering the 3D animation to a 2D movie is a fairly simple process that requires setting a few properties in the Render Scene dialog box and then letting 3ds max do its job.

1. Click on the Render Scene button to bring up the Render Scene dialog box. Set the render properties as follows: in the Time Output section, select Active Time Segment and make the output size 320 width and 240 height. See Figure 11.36.

FIGURE 11.36 Set the render properties.

2. In the Render Output section of the Render Scene dialog box, click on the Files button. In the Render Output dialog box, make the Save as Type MOV Quick Time File and click on Save.

3. Back in Render Scene dialog box, click on Render, and 3ds max begins the rendering process. Since this is an animation, 3ds max will render each frame one at time. When 3ds max is finished, open the QuickTime movie and play it. You have just completed your first molecular animation in 3ds max!

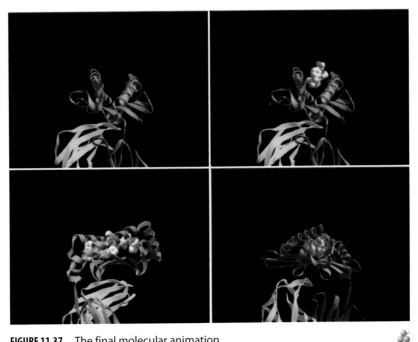

FIGURE 11.37 The final molecular animation.

INTRODUCTION TO CELLULAR ANIMATION

Cellular illustration and animation is used to illustrate how living cells breathe, communicate, work, metabolize food, defend themselves, reproduce, and die. Cellular illustration is not just about the cells in human bodies, but encompasses a wide range of cell types, including single cell organisms, bacteria, and plant cells. Universities and pharmaceutical and biotechnology companies use cellular illustration and animation to depict new drug therapies or mechanisms of action (MOA) in education materials and marketing materials. See Figure 11.38

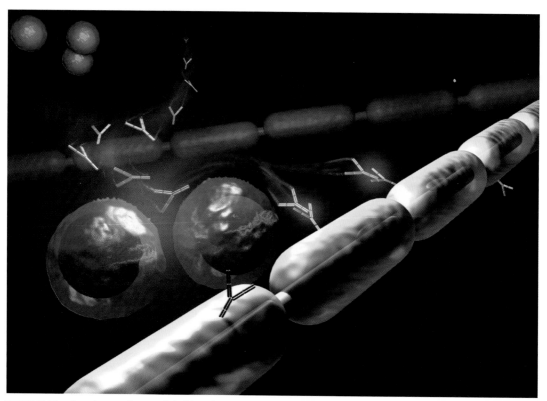

FIGURE 11.38 Autoimmunity, modeled in 3ds max by Scott Holmes. © 2004 Reprinted with permission from Scott Holmes.

Because from a macroscopic level cells are very, very tiny, usually colorless, and often appear to be nothing more than specks of cytoplasm, and because at a microscopic level cells are enormous and complex organisms, covered with different types of proteins acting as receptors and channels, and an inside packed with hundreds of organelles, including the nucleus, cellular illustrations are almost always conceptual. That means that the graphic representation of cells in illustration or in animation is loosely based on the actual appearance of living cells. Instead, cells are depicted in a simplified and stylized fashion that makes conveying the information about the cells much clearer. See Figure 11.39.

FIGURE 11.39 Stained photomicrograph of a liver lobule. Illustration of liver lobule. © 2004 Illustration reprinted with permission from John Karapelou.

TUTORIAL	**CELLULAR ANIMATION: MITOSIS**

PROJECT 2 OVERVIEW

In the following tutorial, you will create a short animation that conceptualizes mitosis: the process of cell division. With few exceptions, the cells in all living organisms have to be replaced as they become damaged, diseased, or aged. During mitosis, a single cell will duplicate itself to produce two identical daughter cells.

Mitosis is a complex process that involves all parts of the cell; creating an animation that faithfully reproduces all the action during mitosis would be a daunting task. In this animation, we will conceptualize the process of mitosis by only showing the cytoplasm division called cytokinesis and representing the division of genetic material by splitting the cell nucleus.

ANIMATING MITOSIS

The 3ds max scene in which the animation takes place is already complete: the background, lights, and camera are already in the scene. The

main thing you will focus on is modeling the cells, assigning materials, and animating. But before we do any animation, let's go over the action we will animate.

At the start of the animation, the camera will focus on a single cell. As the camera pans around, the cell shows some activity and then begins to split into two cells. The cytoplasm and the nucleus of the cell will split at about the same time and in the final scene, there will be two cells. The entire animation will be about five seconds in length.

MODELING THE CELLS

To simulate the process of a single cell splitting into two cells, we will use a type of compound object called BlobMesh. BlobMesh creates spheres that connect to each other as if the spheres were made of a viscous fluid. When the spheres are close together they connect; when they are far apart, they form spheres again.

ON THE CD

1. Open the file cell1.max found in the Chapter 11 folder in the companion CD-ROM. Notice that the scene contains a plane with a texture (which serves as the background), a target camera, and three lights (two omni and one spotlight). If you press the Play button, you will see that the camera is already animated. See Figure 11.40.

FIGURE 11.40 The scene contains a background, a camera, and lights.

2. The BlobMesh object needs some type of standard geometry to create the blobs. In this case, we will use a Line. So from the Create panel, click on the Line button and add a line near the camera's target, as in Figure 11.41. The Top viewport is probably the best place to draw the line.

FIGURE 11.41 Create a line.

3. In the Create panel, click on the Geometry button and from the menu, select Compound Objects. From the Object Type rollout, click on BlobMesh. Click once anywhere in the scene to insert the BlobMesh. See Figure 11.42.

4. Next make sure the BlobMesh is selected and click on the Modify panel. Locate the Blob Objects section in the Parameters rollout. Click once on the Pick button and then click on the line in the scene. Notice that there are now two blobs in the scene, one on each vertex of the line, as in Figure 11.43. Remember that 3ds max needs some type of geometry to create functional blobs.

5. Before doing anything else, move the cells (let's refer to the BlobMesh as cells from now on) so that the first cell, the one to the left as seen from the top, is near the camera's target. See Figure 11.44. To move the cells, either move the line that they are attached to or move the cells themselves. In either case, the line and the cells should move together. This is a good time to rename the BlobMesh01 object to Cells.

6. Now let's make the cells merge into each other and see if the BlobMesh is working. Select the line and in the Modifier stack, open

FIGURE 11.42 Insert a BlobMesh object in the scene.

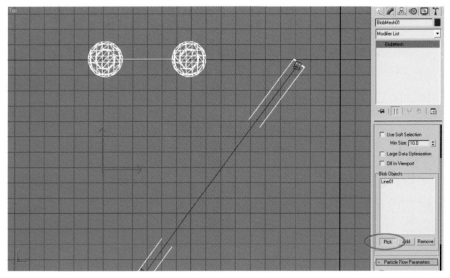

FIGURE 11.43 Attach the BlobMesh to the Line.

the line's stack, and select the Vertex sub-object. This next step might be easier in the Wireframe display in the Top viewport. Select one of the vertices of the line and move it towards the other vertices, so that the line gets shorter. Notice that as the spheres get close to each other, they blend together. See Figure 11.45. If you are having trouble getting the cells to merge, take a look at cell2.max in the Chapter 11 folder in the companion CD-ROM.

ON THE CD

FIGURE 11.44 Move the cells near the camera's target.

FIGURE 11.45 When the cells are close together, they merge into one object.

ANIMATING THE CYTOPLASM DIVISION

Now that it is clear that BlobMesh is working, let's go ahead and create part of the animation.

1. Make sure the Time Marker is at frame 0 and click on the Auto Key button in the Status bar. Click on the Time Configuration button and set the FPS to 12, the Start Time is 0, the End Time is 50, and the Length is 50. See Figure 11.46.

FIGURE 11.46 Configure the animation duration.

2. In the Modifier Stack, select the line's Vertex sub-object and position the vertices so they are very close together or superimposed. You should now have one large parent cell, as in Figure 11.47
3. Move the Time Marker to frame 45 and then move the last vertex of the line far enough away from the first vertex so that the daughter cells are separate spheres, as in Figure 11.48. Notice the new Position key in the Track Bar. Now click on the Play button to see the animation.

ANIMATING THE NUCLEUS DIVISION

Now that the single parent cell is dividing into two daughter cells, let's create the nucleus division.

1. Set the Time Marker back to frame 0. Switch all viewports to Wireframe display, so that you can see inside the cells. Press H to bring up the Select Objects dialog box and select the Cells.

FIGURE 11.47 The parent cell is created by moving the vertices of the line very close to each other.

FIGURE 11.48 The daughter cells are created by moving the line vertices apart.

2. To create the nucleus, right-click in any viewport and select Clone. In the Clone dialog box, select Copy and name the new object Nucleus. See Figure 11.49.

FIGURE 11.49 The nucleus is created by copying the cell.

3. With the nucleus selected, go to the Parameters rollout and change the Size to 15. The nucleus should appear as a small sphere inside the large cell sphere, as in Figure 11.50.
4. Now play the animation once more. This time you should see the cell cytoplasm and the cell nucleus divide. See Figure 11.51. If you are having a little trouble with synchronizing the cytoplasm and nucleus division, simply move the Time Marker to frame 45 and then move the vertices of the second line until the second nucleus appears inside the second cell at frame 45.

ASSIGNING MATERIALS

Now materials will be assigned to the cytoplasm and nucleus. The cytoplasm will have a shiny transparent material and the nucleus will have an alien cellular material. But to make things more interesting, the Smoke procedural will be animated in the cell's Bump channel to give the cell a sense of movement.

FIGURE 11.50 Scale down the nucleus.

FIGURE 11.51 The cytoplasm and the nucleus divide to complete the mitosis animation.

1. Press M to bring up the Materials Editor. The first slot should be high-lighted with a red border. Since the cytoplasm's material will be transparent, click on the Background button to display a checkered background in the material slot. Name the material Cell and create the following material recipe: Diffuse: Red 170, Green 150, Blue 200 (or any color you like); Opacity: 45; Specular Level: 65; and Glossiness: 50.
2. Open the Maps rollout, check the Bump channel, and click on the None button to bring up the Material/Map Browser. In the Material/Map Browser double-click on the Smoke procedural. Set the following properties for the Smoke procedural: Size: 10 and Phase: 2.0. See Figure 11.52.

FIGURE 11.52 Apply the Smoke procedural to the Bump channel.

3. Now move the Time Marker to frame 50 and set the Phase to 10. Changing the Phase value from 2 at frame 0 to 10 at frame 50 animates the procedural so that it appears to crawl along the surface of the cytoplasm. Notice that when you changed the Phase value, the spinner displays a red border; this indicates that the value is animated. See Figure 11.53. Drag the material you just created from the Material Editor to the cells in the scene. If you do a test render (Shift+Q), you can see the effects of the new material. See Figure 11.54.

FIGURE 11.53 At frame 45, change the Phase value of the Smoke procedural to animate the effect in the Bump channel.

FIGURE 11.54 A quick test render shows that material is working fine.

4. Next the material for the nucleus will be created. Reset the Time Marker to frame 0 and in the Material Editor, select the material slot next to the one we just created. Click on the Maps rollout and check Diffuse then click on the None button. In the Material/Map Browser, double-click on the Cellular procedural. Enter the following Cellular procedural recipe: Cell color: Light blue; First Division color: Dark blue; Second Division color: Dark red; and in the Cell Characteristics adjust Size to 5.0. See Figure 11.55.

Drag the new material on to the nucleus in the scene. However, since the cell is in the way, either hide the cell temporarily and then drag and drop the material, or select the nucleus and click on the Assign Material to Selection button in the Material Editor. Run another test render to see your work.

FIGURE 11.55 The material for the nucleus.

RENDERING THE CELLULAR ANIMATION

Now that the cell(s) are created, the animation is done, and materials are assigned, let's render to a movie. Before we create the final render, select the cells and the nucleus (one at a time) and in the BlobMesh Parameters

rollout, increase the Evaluation Coarseness' Render setting to 8. This will smooth the cells' appearance in the final movie.

1. Bring up the Render Scene dialog box and set the Time Output to Active Time Segment, the Output Size to 320 x 240, and then click on Files in the Render Output section, as in Figure 11.56. In the Render Output dialog box, set the Save as type: to MOV Quick Time and click on Save. Back in the Render Scene dialog box, click on Render, and 3ds max will render the animation to a Quick Time movie.

FIGURE 11.56 Set the render properties and the file output type.

2. Look for the movie where you saved it and play it. It should look something like Figure 11.57.

Try experimenting with the settings for the BlobMesh object; for example, you can animate the Tension property to change how the cells interact, or change the settings for the animated Smoke procedural. You can also change the camera's path or animate the lighting. The tutorial we just worked through is meant to give you a taste of what can be done in 3ds max when it comes to medical and scientific animation.

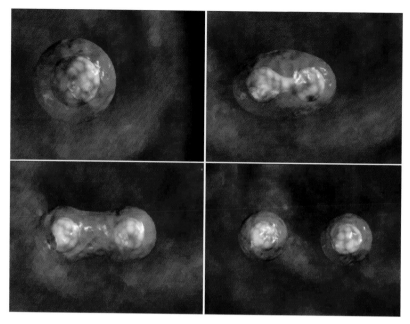

FIGURE 11.57 The final cellular animation.

CONCLUSION

Medical artists create molecular and cellular animations so that researchers and the public alike imagine and explore those things that can't be seen with the unaided eye. Molecular and cellular animations take us into the world of cells, molecules, and even the atom, where we can see how the building blocks of life are formed, behave, and keep us alive. As science delves deeper into the microscopic world—even beyond atoms—and as companies develop amazing nanotechnologies, there will be an increasing demand for artists to visualize what can't be seen.

A

CONTRIBUTING AUTHORS

BRIDGETTE MONGEON (CHAPTER 1, 2, 3, AND INTERVIEWS)

Bridgette Mongeon is a freelance writer, journalist, and artist. She also teaches and lectures on creativity, writing, and art. Ms. Mongeon is also a sculptor and is known for her sculptures of entertainers such as B.B. King, Willie Nelson, and Bill Monroe, as well as her numerous bronze and clay portraits of children. She and her husband, the author, live in Houston, Texas where they enjoy collaborating on creative ideas and projects. Visit *www.creativesculpture.com* for more information.

LEE ROSE (TECHNICAL REVIEWER)

Lee Rose has an extensive background in medical illustration. He has been employed as a medical illustrator by the University of Texas Medical Branch in Galveston, Texas; AV Corporation/WBS Post Production and Baylor College of Medicine, both in Houston, Texas; and the Medical College of Georgia in Augusta, Georgia. He has also been a medical illustration consultant for the *Texas Heart Institute Journal.*

Mr. Rose earned both a bachelor's degree and a master's degree in medical illustration from the Medical College of Georgia. He currently resides in Houston, Texas.

SCOTT WELDON (CHAPTER 4)

Scott Weldon is the medical illustrator for the Division of Cardiothoracic Surgery of the Michael E. DeBakey Department of Surgery at Baylor College of Medicine. In addition to this position, he provides his award-winning

services to clients from a wide range of medical specialties throughout the Texas Medical Center and beyond. He has recently illustrated *Top Knife: The Art and Craft of Trauma Surgery* and contributes medical visual content for clinical texts, surgical atlases, medical journals, patient educational materials, and presentations.

Scott is an active professional member in the Association of Medical Illustrators and has been involved in committees as a student and professional member. He was a freelance artist for over 10 years before receiving a master of arts degree in biomedical communications from the University of Texas Southwestern Medical Center at Dallas in 2002. In 2001, the Vesalius Trust bestowed him the honor of Vesalian Scholar for his master's thesis work on developing multimedia interactive training materials for neurosurgeons. In addition to medical illustration, Scott continues to produce wildlife and sporting art paintings and sculpture.

B

COPYRIGHTS QUICK REFERENCE

The following is copyrights quick reference for artists. Understanding copyrights is essential for the illustrator, animator, or any artist creating works in any media. From the start the United States government recognized the significance of the arts and enacted copyright laws to protect original intellectual property. As the creator or author of a work, it is important to understand copyright laws and know how to manage or transfer copyrights. Copyrights afford you the right to dictate how, when, and where your work is used. Works in any medium can be copyrighted, as long as they are original. You cannot, however, copyright an idea, only things that are in a "tangible" medium, such as a painting, a written work, or a recording.

DISPLAYING THE COPYRIGHT NOTICE

Prior to 1989 artists were required to display a copyright notice on all of their work to assure that it was protected under copyright laws. Now work is copyrighted by its very creation and the copyright notice is not required to receive full protection under copyright laws. However, it is strongly recommended that artists *always* display a copyright notice on their works. Displaying the copyright notice lets others know that you are aware of your copyrights, that you take protecting your copyrights seriously and it acts as a deterrent to those that may knowingly or unknowingly infringe on your copyrights.

A copyright notice is usually comprised of the symbol © followed by your last name and the year the work was created. For example, © Smith 2004. Some artists also add the phrase "All Rights Reserved."

COPYRIGHT REGISTRATION

Though it is not necessary to register your works with the Copyright Office, it is strongly advised that you do because copyright registration affords several significant advantages. First, registration provides a public record of copyright ownership. Second, if your work is registered and your copyrights are infringed you may collect statutory damages and attorneys' fees. And last, if you plan to sue someone for copyright infringement you must first register your copyrights before you can file suit in federal court.

To register your work visit the United States Copyright Office online at *http://www.copyright.gov*. The fee to register your work is $30. Under certain circumstances you can register a collection or a series of illustrations for $30. It can take up to four to five months to receive your certificate from the Copyright Office.

TRANSFERRING COPYRIGHTS

There are different types of copyrights that an artist can transfer or license to an art buyer. Transferring all copyrights to an art buyer is not standard; instead, the artist should typically license the use of the work for a certain amount of time, geographic location, and medium. Maintaining certain copyrights gives the artist control over the use of the work and the opportunity to resell the work to generate additional income.

When transferring or licensing copyrights it is important that you use a signed written agreement that clearly stipulates what copyrights are being licensed, for how long, what geographical location, and what media.

Below is a list of common copyright terms that describe different forms of licensing:

ONE-TIME RIGHTS

One-time rights allow the art buyer to license the use of the work one time only. The license usually stipulates the geographical location and the media in which the work can be published. For example, a medical illustration for publication in a journal or magazine is typically licensed for one-time usage. The artist retains copyright ownership and can resell the work once the one-time rights agreement ends.

FIRST-TIME RIGHTS

Similar to one-time rights, in this case the art buyer has the right to use the work first. The artist retains copyright ownership and can resell the work once the first-time agreements ends.

EXCLUSIVE RIGHTS

Exclusive rights give the art buyer the right to use the work exclusively for their market. The artist retains copyright ownership and can sell the work in a different market.

ELECTRONIC RIGHTS

Electronic rights gives the art buyer the right to publish your work in electronic media such as CD-ROMs, DVDs, television, and the Web. The licensing agreement should specify in which electronic media the work will be published. Often, electronic rights are part of other licensing agreements. For example, an art buyer may want to license one-time rights for print and Web.

WORK-FOR-HIRE OR WORK-MADE-FOR-HIRE

Work-for-hire typically refers to work created while working as an employee. For example, any art that a medical artist creates while employed at a medical school belongs to the medical school and not the artist. Under work-for-hire terms the artist relinquishes all copyrights to the work he creates. His signature can be removed from the work, he receives no credit at all, the work can be altered or reused without additional compensation to the artist, and can be resold or even destroyed.

While work-for-hire may be standard in employment situations, it is not typical for contractual agreements; for example, when working on a freelance project. If the art buyer insists on a work-for-hire agreement, in essence purchasing all copyrights to the work, you must be compensated accordingly. Most art buyers understand that if they want all copyrights to the work, they are expected to pay considerably more then if they were licensing the work.

Unfortunately, more and more art buyers are insisting on work-for-hire agreements with freelance artists, but are not willing to pay more to buy out all copyrights. If you are a freelancer be very careful about entering into work-for-hire agreements.

REFERENCE

United States Copyright Office *http://www.copyright.gov/*
Graphics Artist Guild *http://www.gag.org/*
Volunteer Lawyers and Accountants for the Arts

FURTHER READING

Graphic Artists Guild Handbook: Pricing & Ethical Guidelines (most recent edition)
Artist's and Graphic Designer's Market
Writer's Market

BIBLIOGRAPHY

Adams, Stephen B. and Fessler, John F. *Atlas of Equine Surgery*. W.B. Saunders. Philadelphia. 2000.

Alberts, Bruce, et al. *Molecular Biology of the Cell*. Second Edition. Garland Publishing. New York. 1989.

Benschoter, Reba A. "Can the Biomedical Communications Unit Survive?" *The Journal of Biocommunication*. Volume 21, Number 1 (1994): pp 7–9.

Clemente, Carmine D. *Anatomy: A Regional Atlas of Human Anatomy*. Second Edition. Urban & Schwanrzenberger. Munich. 1981.

Maingot, Rodney. *The Relationship of Art and Medicine*. History of Medicine, Ltd. London. 1974.

Male, David. *Immunology: An Illustrated Outline*. Second Edition. Gower Medical Publishing. New York. 1991.

Morton, Richard. "Communication in Medical Education: The Future for Specialist Services." *The Journal of Biocommunication*. Volume 22, Number 3 (1995): pp 8–11.

Nakamura, Julia and Massy. *Your Future in Medical Illustration: Art and Photography*. Richards Rosen Press. New York. 1971.

Saunders, J.B. deC.M. and O'Malley, Charles D. *The Illustrations from the Works of Andreas Vesalius of Brussels*. Dover Publications. New York. 1973.

Shapiro, Ron, et al. *Renal Transplantation*. First Edition. McGraw Hill/Appleton & Lange. Stamford. 1997.

Singarella, Thomas. "The Evolution of Modern Technology and Its Societal Impact on Biocommunications in Academe." *The Journal of Biocommunication*. Volume 25, Number 1 (1998): pp 2–11.

Stapling Techniques: General Surgery with Auto Suture ® Instruments. Third Edition. United States Surgical Corporation. Norwalk. 1988.

Tortora, Gerald J. *Principles of Anatomy and Physiology*. Ninth Edition. Wiley Text Books. New Jersey. 2001.

REFERENCED WEB SITES

www.ami.org
www.alconlabs.com
www.vision-surgery.com/cataract-procedure.html
www.allaboutvision.com/conditions/cataracts.htm
www.stlukeseye.com/Conditions/Cataracts.asp
www.medem.com
www.abiomed.com
www.texasheartinstitute.org/abiocor.html
www.heartpioneers.com/abiocorfaq.html
www.rcsb.org

About the CD-ROM

The companion CD-ROM contains all of the files necessary to complete the tutorials in this book. It also contains incremental files that illustrate specific steps in the tutorials.

- All of the figures in the book are included at full size, and are organized by chapter.
- To complete the tutorials in Chapters 5 through 8 you will need a copy of Photoshop CS. For your convenience a free 30-day trial version is included on the CD-ROM.
- To complete the tutorials in Chapters 9 through 11 you will need a copy of 3ds max 6. You can download a free 30-day trial version of 3ds max 6 at *www.discreet.com.*
- Chapter 9 requires a copy of Anark Studio 2.5. A free 15-day trial version of Anark Studio 2.5 is available at *www.anark.com* .
- To work through the molecular animation tutorial in chapter 11 you will need a copy of DS ViewerPro 5. A free 30-day trial version of DS ViewerPro 5 is available at *www.accelrys.com/dstudio/ds_viewer/.*

All tutorial files are organized by chapter and can be found in the appropriate folders on the CD-ROM. For example, all tutorial files for Chapter 5 are located in the chapter05 folder.

Photoshop® CS System Requirements

Intel® Pentium® III/4 processor or equivalent processor
Microsoft® Windows® 2000 with Service Pack 3 or Windows XP
192 MB of RAM (256 MB recommended)
280 MB of available hard-disk space
Color monitor with 16-bit color or greater video card
1,024 x 768 or greater monitor resolution

CD-ROM drive

3DS MAX™ SYSTEM REQUIREMENTS

Intel® or AMD® processor at 300 Mhz minimum. Dual Intel Xeon or dual AMD Athlon recommended.

Microsoft® Windows® 2000 with Service Pack 3, Windows XP Pro, XP Home

DirectX9 or OpenGL

512 MB RAM minimum. 1 GB RAM recommended.

Graphics card supporting 1,024 x 768, 16 bit color, with 64 MB RAM. OpenGL and Direct3D hardware acceleration supported.

Color monitor with 16-bit color or greater video card

CD-ROM drive

ANARK STUDIO 2.5 SYSTEM REQUIREMENTS

Microsoft Windows 2000 or Windows XP

Pentium III processor @ 600 MHz (or better)

256 MB of RAM or more

Microsoft DirectX 7 or later

Windows Media Player 7 installed

Minimum of 200 MB of free disk space

DS VIEWERPRO 5

Microsoft Windows 98, NT, 2000, or Windows XP

Pentium III processor @ 300 MHz (or better)

128 MB of RAM or more

MEDICAL GLOSSARY

The following are brief definitions of the medical terms found in the book.

Amino acid An organic molecule composed of the amino groups and carboxyl groups essential for protein synthesis.

Acute Sudden onset of disease, usually lasting a short time.

Anastomosis The connection of blood vessels or other tubular structures.

Antigen Foreign matter that stimulates an immune response.

Aortic aneurysm A constrained bulging of the aorta.

Antigen presenting cell (APC) A specialized cell that processes antigens and presents them on the cell surface on MHC I or MHC II proteins.

Artery A blood vessel that transports blood away from the heart to other parts of the body.

Arterial Pertaining to arteries.

Articular cartilage A type of cartilage that forms upon joint surfaces.

Atherosclerosis The deposition of lipids on the interior of arteries resulting in plaques.

Atom The smallest chemical unit of matter.

Atrium One of the two upper chambers of the heart.

Bacteria (Bacterium, *singular*) Various types of single-celled organisms that exist as free-living cells or parasites.

Bifurcation Separation into two parts.

Brain stem The part of the brain connecting the forebrain and the spinal cord.

Cadaver A dead human body.

Catalyst A substance that influences the rate of chemical reactions.

Cartilage A dense connective tissue that makes up most of the infant skeleton and parts of the adult skeleton.

Cataract Loss of transparency in the lens, resulting in partial or complete blindness.

Cell The smallest unit of living matter.

Cell receptors Specialized structures on the cell surface that transmit information.

Cellular Relating to cells.

Cerebellar Pertaining to the cerebellum.

Cerebellum The part of the nervous system that mainly controls equilibrium and coordination.

Cerebrum The brain excluding the brain stem and the cerebellum.

Choroid The middle vascular layer of the eye.

Chronic Slow progressing condition that persists over a long period of time.

Ciliary muscles The muscles in the eye that move the ciliary processes to change the shape of the lens.

Ciliary process The folds of the ciliary body that secretes aqueous humor and provide an anchor for the zonules of the lens.

Colic Relating to the colon.

Collagen A structure made of protein that provides support to the connective tissues like skin and bones.

Comminution A type of fracture where the bone is broken into many small pieces.

Congenital Present at birth.

Cornea The clear part of the outer eye that refracts light.

Cytokinesis Division of the cytoplasm.

Cytoplasm The substance inside the cell membrane but outside the nucleus.

CT scan Computer tomography scan is a type of diagnostic imaging.

Dendrobates azureus A species of rainforest frogs commonly known as poison dart frogs.

Distal Furthest away from a given point.

DNA Acronym for deoxyribonucleic acid, the molecule responsible for encoding genetic information.

Domain A region along a protein that has a specific structure and function.

Donor An individual who donates tissue, such as an organ, for transplantation into another individual.

Duct A tube or channel.

Duodenojejunal Relating to the connection between the duodenum and the jejunum.

Duodenum The first part of the small intestine between the stomach and the jejunum.

Embryology The study of development of the embryo.

Equine Relating to the horse.

Enzyme A protein that acts as a catalyst to speed up biochemical change.

Esophagus The muscular tube that connects the pharynx with the stomach.

Exophthalmic A protrusion of the eyeball.

Fascia A sheet of connective tissue.

Fracture The breaking of bones.

Fissure A groove or slit.

Foramen (foramina *pl.*) A natural opening through bone or other tissue.

Forceps A surgical instrument used for grasping.

Fundus The farthest part of a hollow organ from an opening.

Gall bladder A sac that stores bile, situated under the liver.

Gastric bypass A surgical procedure that reduces the size of the stomach and bypasses part of the small intestine.

Gyrus (gyri *pl.*) A convolution of the brain.

Hemmimustard repair A surgical procedure that repairs congenital heart defects, such as transposition of the great arteries.

Histology The study of the microscopic structures of tissues.

Hypogastric artery A branch of the common iliac artery, also know as the internal iliac artery.

Hysterectomy A surgical procedure where the uterus is removed.

Iliac fossa The medical depression formed by the ilium.

Iliac vessels The blood vessels found in the pelvis.

Immune cells The specialized cells of the immune system like B cells or T cells.

Incision A surgical cut.

Intraluminal Any form of imaging, like video, done inside an artery or vein.

Intraocular lens (IOL) An artificial lens surgically placed inside the eye.

Iris The colored part of the eye between the cornea and the lens.

Jejunum The section of small intestine between the duodenum and the ileum.

Keratin The protein present in hair, nails, horns, feathers, and scales.

Kidney One of two small organs located behind the peritoneum, on either side of the spine, that serve to regulate water balance and discharge metabolic wastes.

Laparoscopic Visualizing the content of the abdomen through an endoscope.

Leadbetter-Politano A type of renal transplant surgical technique.

Lens The transparent, spherical structure in the eye that focuses light on the retina.

Ligament Fibrous tissue that connects bones.

Liver The largest glandular organ in the body. The liver produces bile and plays an important role in metabolism.

Lobe A rounded structure such as the lobe of the ear.

Lobular Pertaining to lobes or being lobed.

Medial Relating to the middle or towards the median plane of the body.

Medulla oblongata The oblong portion of the brain stem that extends to the spinal cord.

Metabolize Referring to the biochemical processes occurring in living tissues.

Metacarpal The bones in the hand between the carpus and phalanges.

MHC Major Histocompatibility Complex, a class of proteins which are involved in the presentation of antigens to T cells.

Molecule The smallest unit of a substance composed of two or more atoms, that still retains the general qualities of the substance.

Molecular Relation to molecules.

MRI Magnetic Resonance Imaging, a type of high resolution diagnostic imaging.

Mucosa The inner lining of a cavity.

Muscularis The muscular layer of a structure or organ such as the stomach.

Nucleus The part of the cell that contains the chromosomes.

Organelle A specialized structure inside the cell that performs a specific function.

Osteoporosis A chronic disease of the bones due to a lack of bone matrix.

Palmar Relating to the palm of the hand.

Pancreas A lobular gland that sits behind the stomach and secretes digestive enzymes and also produces hormones like insulin.

Papilla A nipple-like orifice.

Parenchyma The tissue type of an organ or gland.

Pastern The second phalanx in a horse's foot.

Pathology The study of disease.

Periosteum The tough membrane that covers bones.

Peritoneum The membrane that surrounds the viscera and lines the abdominal and pelvic cavities.

Phalanx A bone in a finger or toe.
Physiology The study of the functions of living organisms.
Pons The part of the brain located between cerebrum and the spinal cord.
Polypeptide A compound with two or more amino acids.
Protein Large organic molecules that are fundamental in the structure and biochemistry of all living organisms.
Prostate A gland that secretes a milky fluid during ejaculation.
Proximal Closest to a given point. Near the point of origin.
Pulmonary Pertaining to the lungs.
Pupil The circular opening in the iris that controls the amount of light entering the eye.
Pyloric sphincter The ring of muscles that controls the flow of food between stomach and the duodenum.
Pylorus The opening between the stomach and the duodenum.

Recipient The individual that receives transplanted tissue, like an organ.
Reflected Bent back from a normal position.
Renal Relating to the kidneys.
Retina The innermost layer of the eye consisting of the nerve cells that send image information to the brain.
Retractor A surgical instrument used to move apart the edges of a wound.
Ruga (Rugae *pl.*) A fold.

Sclera The tough outer layer that covers the eye.
Serosa A smooth membrane that covers most organs like the intestines.
Spiral fracture A bone fracture that follows a spiral path.
Sphincter A circular ring of muscles that opens and closes a body opening.
Sterile technique A procedure that surgical personnel follow to ensure aseptic conditions in the surgical room.
Sulcus (Sulci *pl.*) A groove or furrow.
Suture Stitches used during surgery to join tissues.

T cell An immune system cell that originates in the thymus.
Torsed The condition of being twisted or turned.
Translation The process where genetic information is translated into a sequence of amino acids during protein synthesis.
Transplant The transfer of tissue, as in an organ transplant.

Ureter The muscular tube that carries urine from the kidneys to the urinary bladder.

Ureteroneocystostomy The surgical procedure that implants the ureter into the bladder.
Urinary bladder The muscular sac that stores urine.
Vascular clamp A type of surgical clamp that cuts off blood flow during surgery.

Vein Blood vessels that carry blood towards the heart from all parts of the body.
Venous Relating to veins.
Venous anastomosis The surgical connection of two veins.
Ventricle A cavity, usually one of the two lower chambers of the heart.
Virus An intracellular, infectious parasite, capable of living and reproducing only in living cells.

Zonules The zonules of zin are the suspensory ligaments of the eye.

INDEX